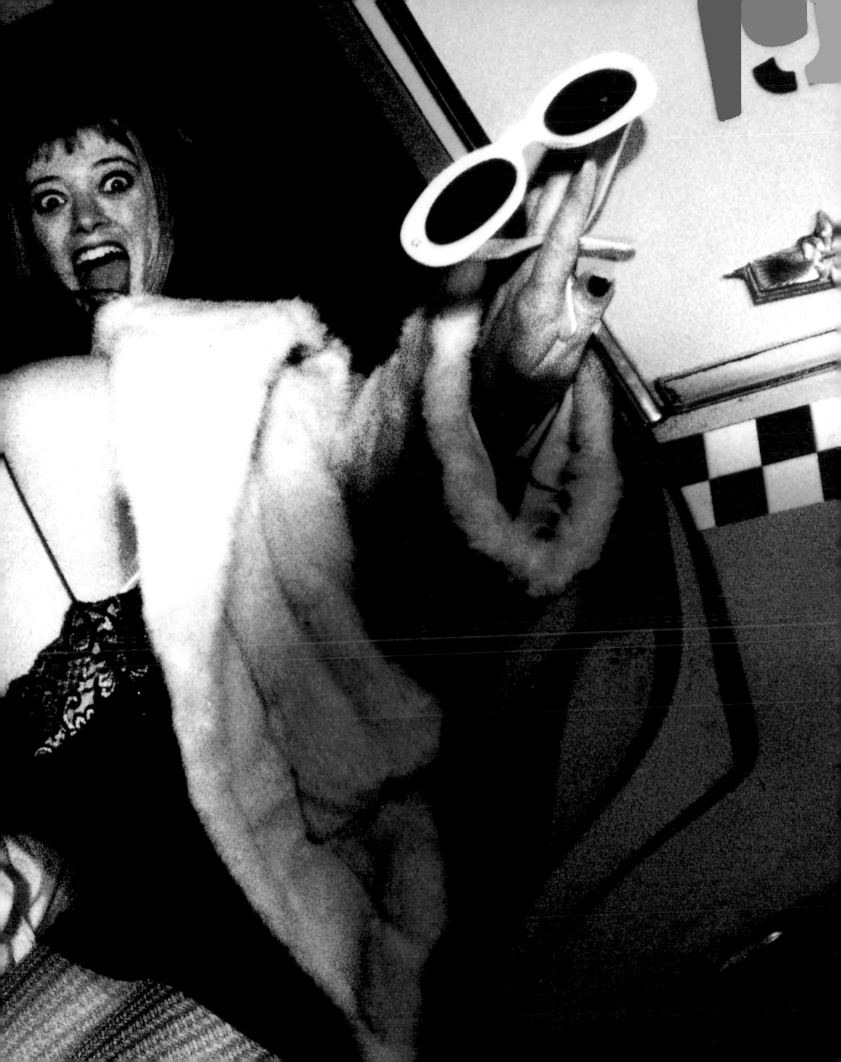

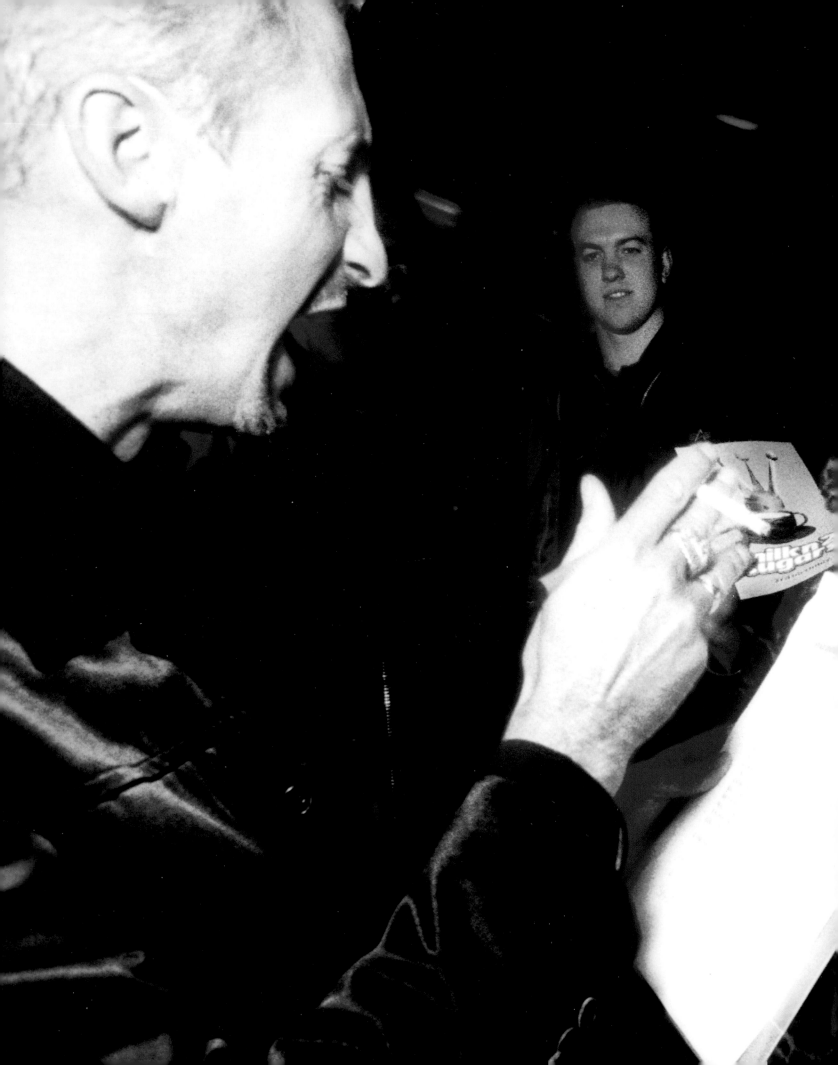

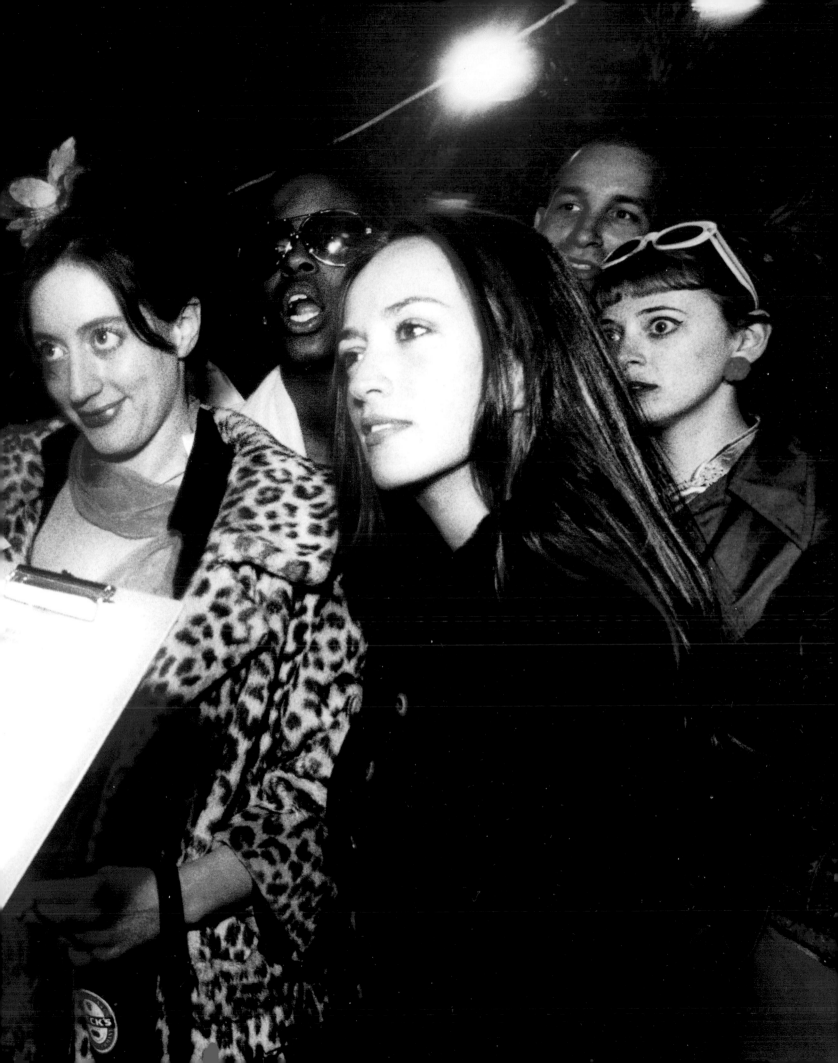

PUBLISHED © 1998 BY BOOTH-CLIBBORN EDITIONS
12 PERCY STREET LONDON W1P 9FB
FIRST PUBLISHED IN PAPERBACK 2000
COPYRIGHT © BOOTH-CLIBBORN EDITIONS
COPYRIGHT © PHIL BEDDARD
DESIGN & ART DIRECTION PHILIP CASEY. CLAIRE BERLINER

ISBN 1 86154 169 4

DISTRIBUTED WORLD-WIDE AND BY DIRECT MAIL THROUGH INTERNOS BOOKS

info@internos.co.uk
www.booth-clibborn-editions.co.uk

PRINTED IN HONG KONG

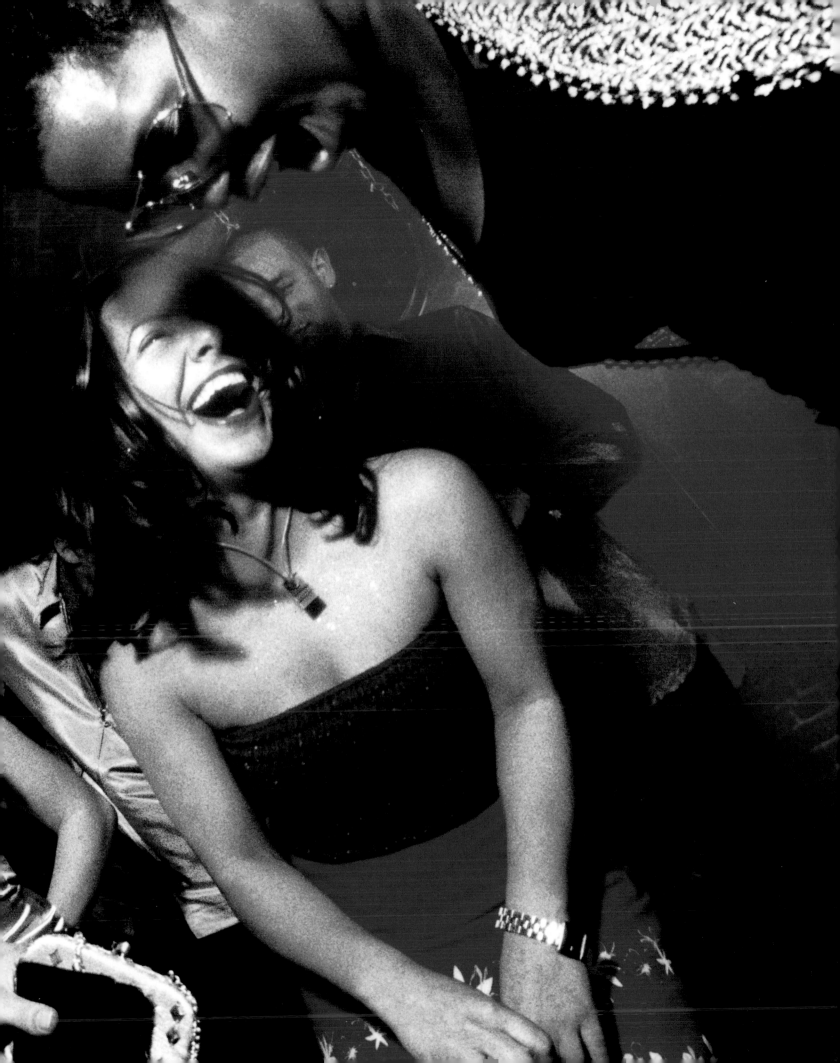

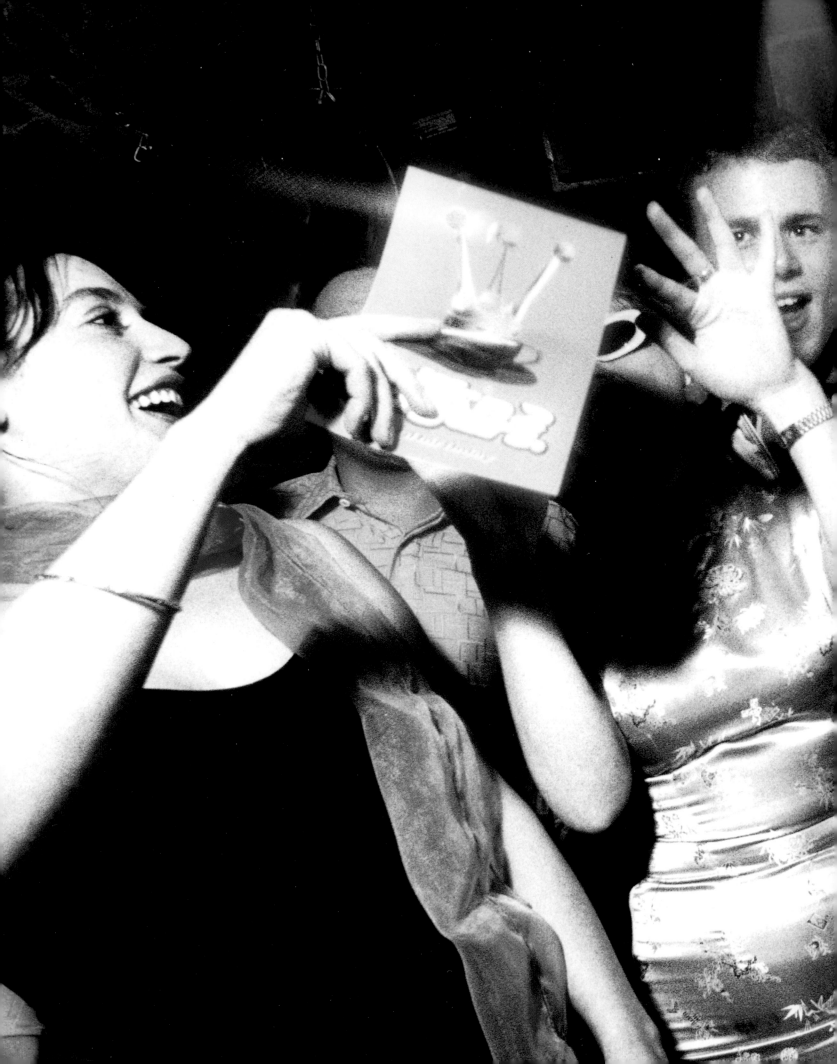

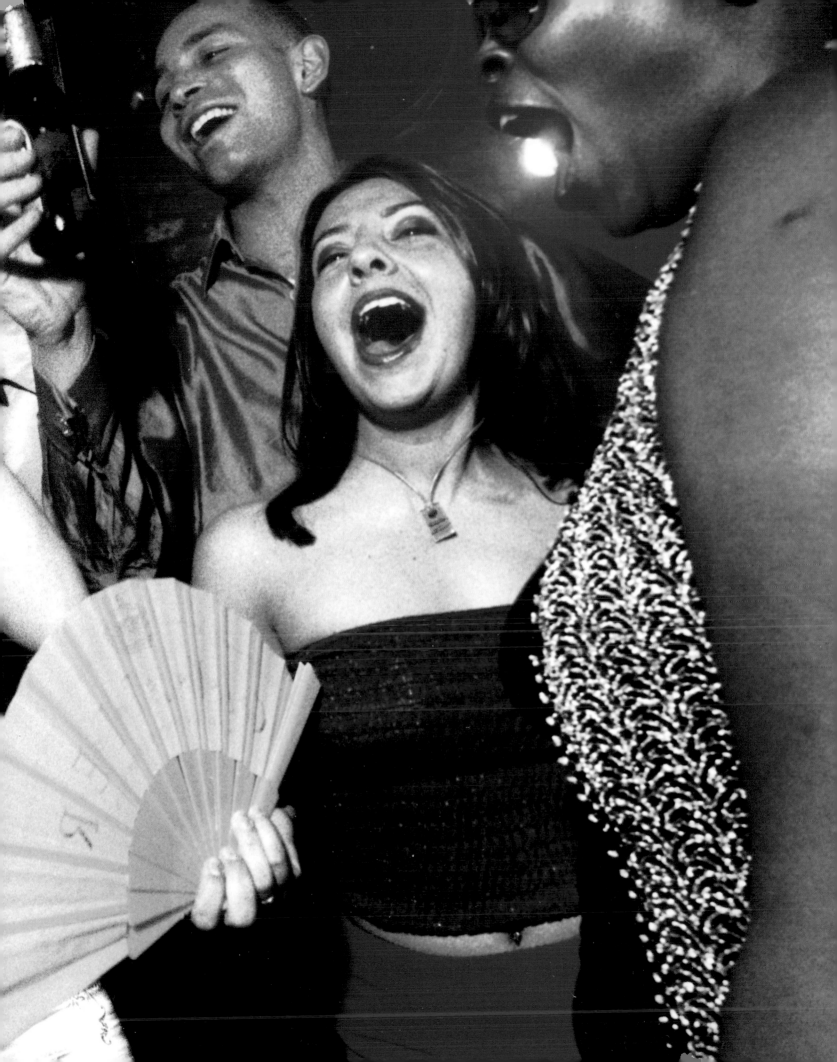

NOCTURNAL
PROJECT CO-ORDINATOR PHIL BEDDARD
DESIGN & ART DIRECTION PHILIP CASEY. CLAIRE BERLINER
PUBLISHED BY BOOTH-CLIBBORN EDITIONS

SPECIAL THANKS TO
LIZ FARRELLY. HELENE STOREY. JOHN PANNELL AND ALL @ THE CROSS
SPARK DESIGN ASSOCIATES. FAÇADE DESIGN

PHOTOGRAPHY ADAM LAWRENCE
PHOTOGRAPHER'S ASSISTANT KIM WATSON
STYLIST TIMNA ROSE
MAKE-UP ARTISTS LIBERTY SHAW. ANGIE MUDGE
MODELS KARIME KENDRA. SHIRAZ AL SHOWK. LOUISA FORD. ALEX ROFAILA
LOUIS GLICKMAN. BEN GLICKMAN. DAVE WATERMAN. LAURA COSTA
FEONA LITTLE. GEMMA SHAW. JESS COUSINS

ACKNOWLEGDEMENTS
BENJAMIN @ FUSE. EWAN AND EVAN GREEN. JUHA PONTEVA. ANDREW ING. LOPETZ HEINZ
WIDMER. SAMUAL WALKER. SUE NOLAN. PETE POLANYK. MARKUS WEISBECK. JASON TRUE
GIANFILIPPO CERASELLI. ALISTAIR PAUL. CHARLIE THORNLEY. ALF SHARIF. RUPERT GODDARD
KARALIUS. BILLY ATYEA. BRUCE GAMBLE. VANESSA FAIRFAX. LYNN MACDONALD. JON FORSS
KARL KONINGS. GUENTER SCHOLZ. YUKI MIYAKE. KOLKO. NIKOLAUS SCHWEIGER. ANDREAS
LAUHOFF. STEPHAN LAUOFF. UELI HINDER. NIK SCHLATTER. STEFAN FEUZ. KOLKO Z. TODD
BALDWIN. PAUL MILLER. ANDY BENNET @ HIT. LISA WILKINSON. RETO GEHRIG. DANIEL DONATI
M B RUNNER. ANDREAS VITT. ARNOLD MEYER. PIERRE GAMBART. MIKKEL TOGSVERD. PETE
FOWLER. THOMAS KOCH. GRAFISCHER GESTALTER. BILLY MELNYK. NINA AND CORINNE. RIO
GRAFIK. JOANNA LEMMON. ALEX PENNYCUICK. MICHEL POULAIN. ALAN CLAUDE. KENNETH
PAUL. DARRYL DENNIS. RADLEY MARX. YUAN FUNG. MATT CHAMBERS. KARIN CONN. PEEKING
PUSSY. AIRICK HEATER. ROCKIE RACOON. ERIC THOMPSON. ALBAIR. NICK HAVAS. BRIAN WALLS

CLOTHES AND ACCESSORIES SUPPLIED BY
OSWALD BOWTANG. IAN BATTEN. PAZUKI. RED OR DEAD. TOP SHOP. LESLEY SILWOOD
MISS SELFRIDGE. STUDIO MASSIIMO. G-SHOCK. SHELLEY'S. PATRICK COX. BOLLÉ
WOLFORD. TIE RACK. SARAH JORDAN. JANET FITCH. DREAM CARS

CORRESPONDENCE AND FLYERS FOR FUTURE EDITIONS SHOULD BE SENT TO:
PHIL BEDDARD. C/O BOOTH-CLIBBORN EDITIONS. 12 PERCY STREET. LONDON W1P 9FB

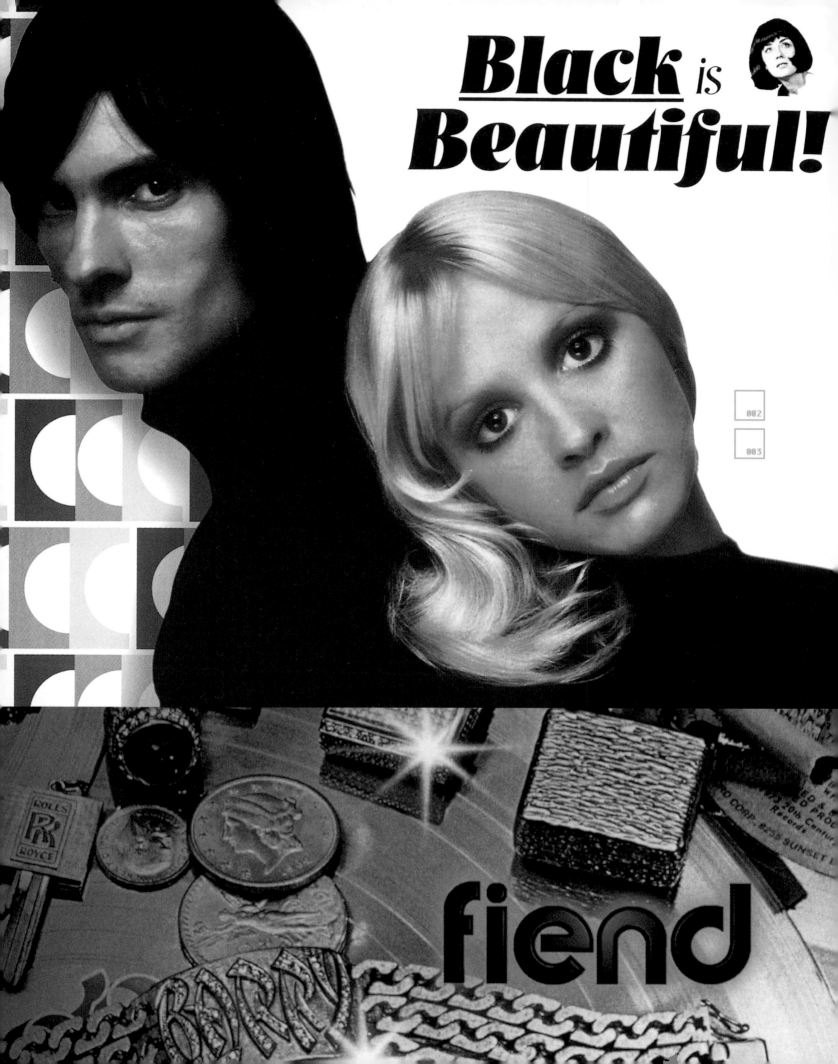

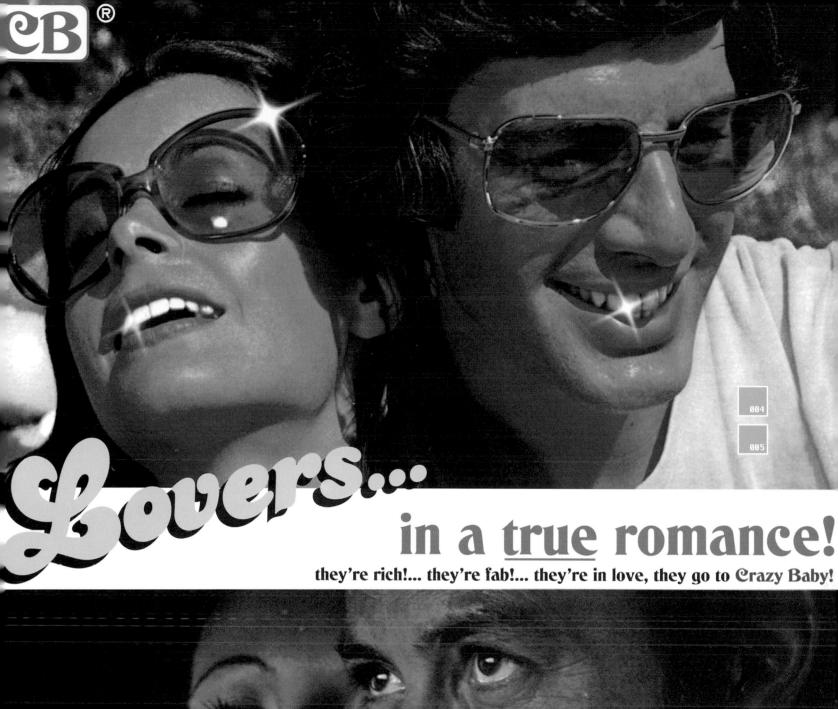

®

*Lovers...*

## in a true romance!

they're rich!... they're fab!... they're in love, they go to Crazy Baby!

004
005

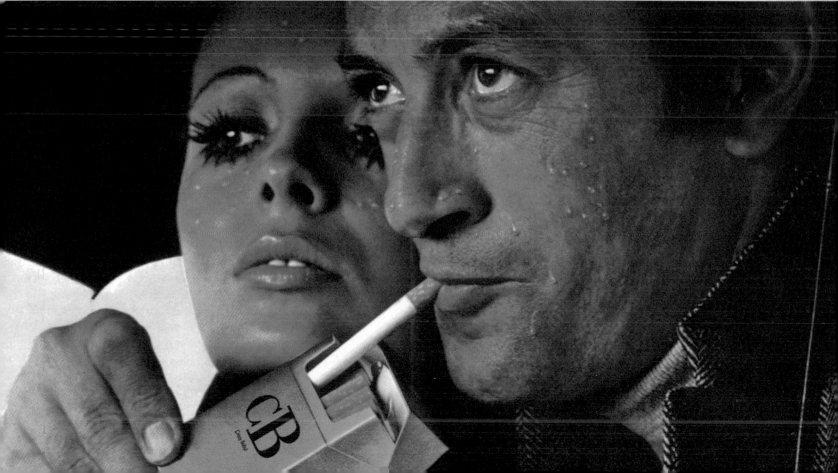

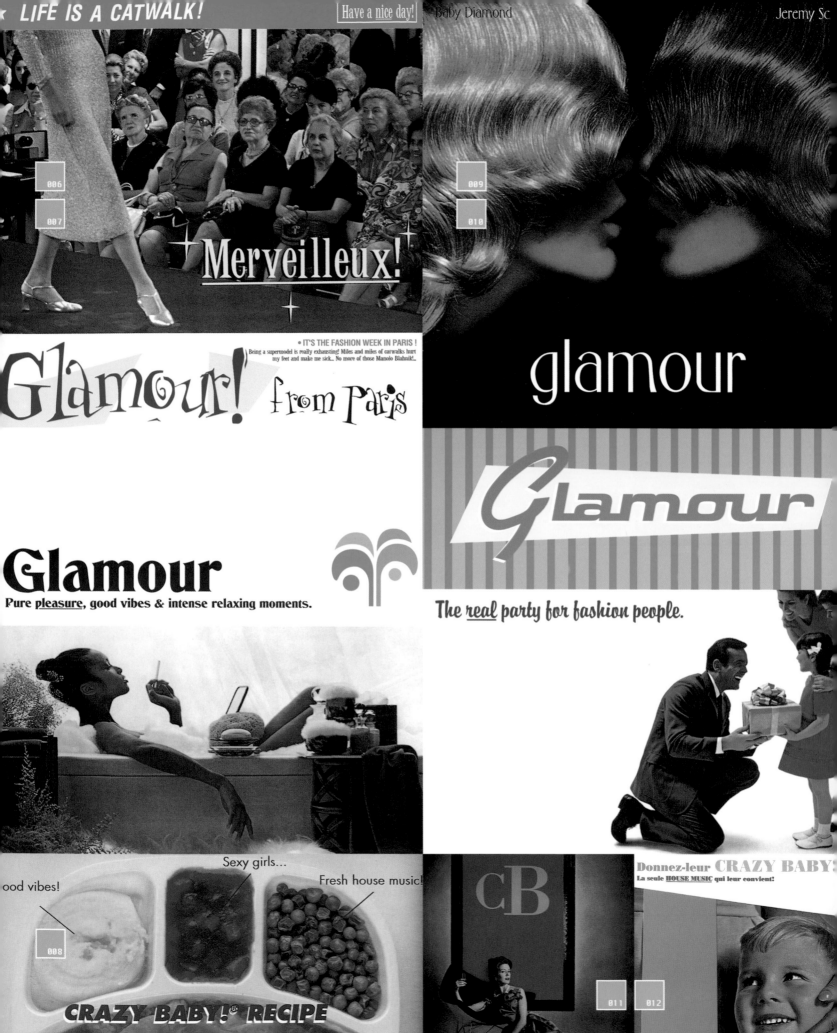

*Glamour!* productions present :

# Kitchen panic!

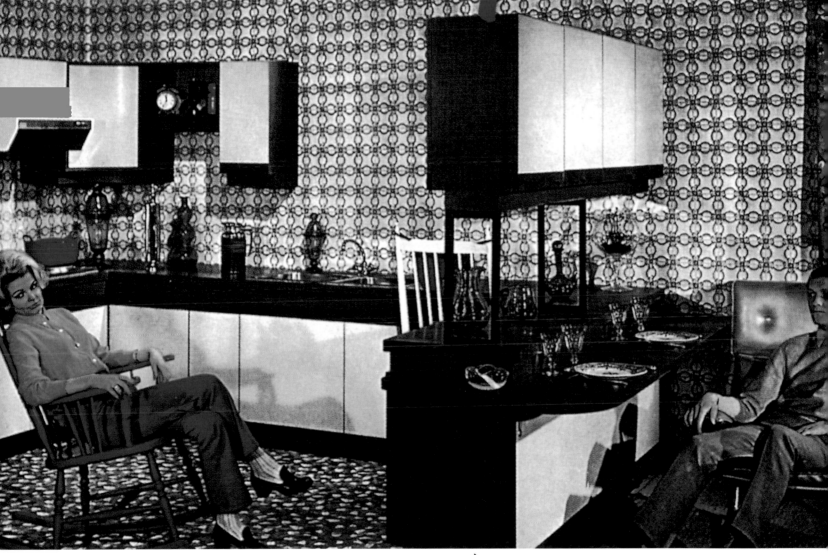

013

014 015

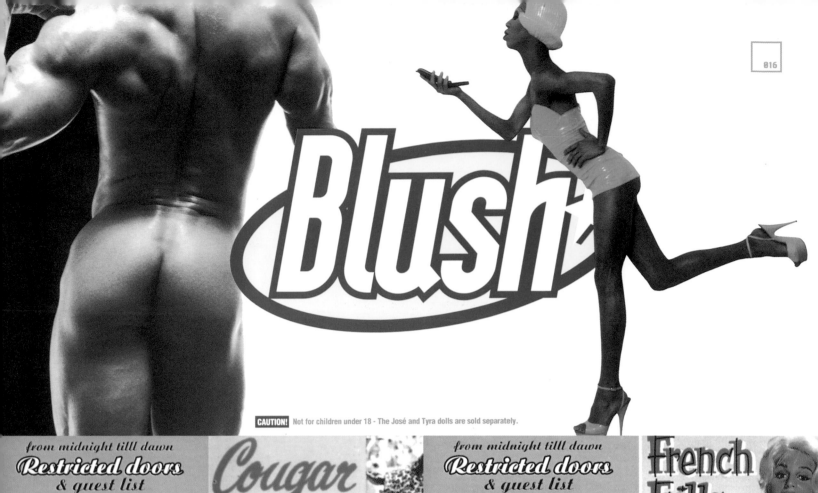

from midnight tilll dawn
**Restricted doors**
*& guest list*

★ 1

★ *Folies Pigalle* ★

11, place Pigalle Paris 9è

DA & RP : Axel (42.49.69.17)

*Cougar*

Vol. 3. No. 3

from midnight tilll dawn
**Restricted doors**
*& guest list*

★ 3

★ *Folies Pigalle* ★

11, place Pigalle Paris 9è

DA & RP : Axel (42.49.69.17)

# French Frills

**NYMPH IN PARIS**

THE COUNT, THE COUNTESS AND
**LUCKY PIERRE**

THE SHAPE IN THE
MAD CHAPEAUX

FELICE--BACKSTAGE

BISTROS, BEDROOMS,
AND BROTHELS

LADY FROM THE LEFT BANK

ADULTS ONLY

from midnight tilll dawn
**Restricted doors**
*& guest list*

★ 2

★ *Folies Pigalle* ★

11, place Pigalle Paris 9è

DA & RP : Axel (42.49.69.17)

**NICE GUYS**

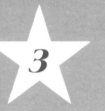

from midnight tilll dawn
**Restricted doors**
*& guest list*

★ 4

★ *Folies Pigalle* ★

11, place Pigalle Paris 9è

DA & RP : Axel (42.49.69.17)

6 $

# BLACK NYLO

VOL. 1
ISSUE 2

COLLEC

ADULTS ONLY

BLACK

ITALI

SO
WILD

THE VELVE

ASE IN THE

PLEASURE

MILES OF

Jelly

Drink

TM

1,5 ℓ of pure Garage!

© La Shampouineuse

# Jelly ™

INVITATION X2

Jeudi 27 octobre

à partir de minuit

Dj's : Kimo, T. Scordel

FOLIES PIGALLE, 11pl Pigalle Paris 9è

DA: Axel / Call 424 969 17 - DT: Fabrice

100% Garage

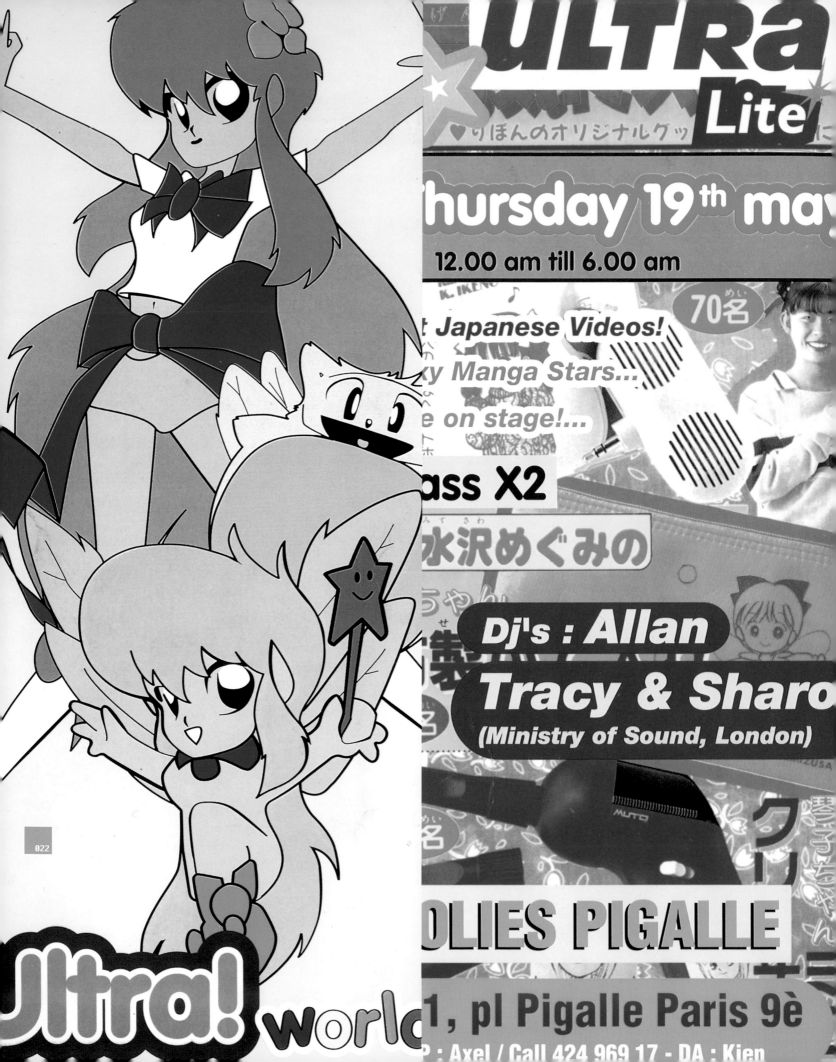

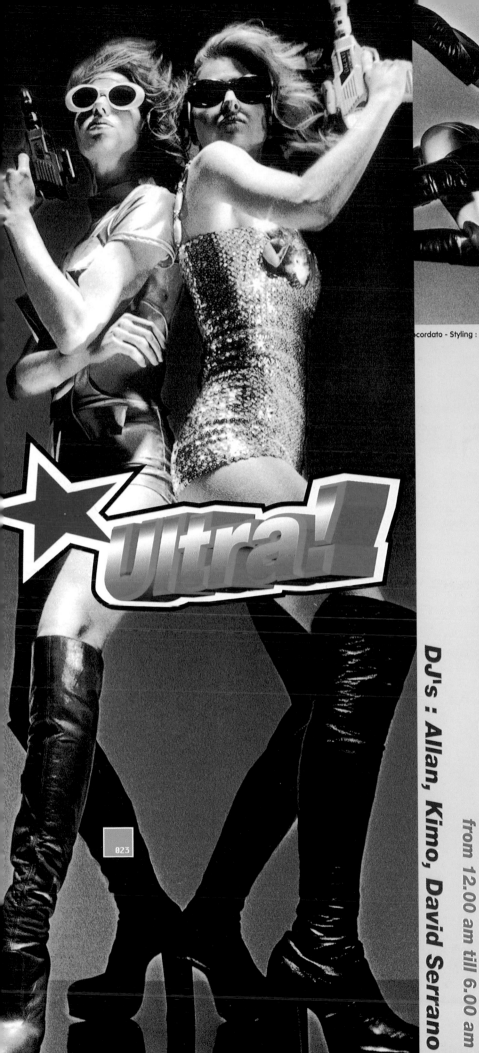

cordato - Styling : Tim Bargeot    © La Shampouineuse, 1994.    Be A Star #17

**Ultra!**

023

**Ultra!**

**Ultra! Dreamgirls**

PASSx2

Thursday 5th may

with fifty hysterical girls coming from
the Who's Who's Follies parties of
Mirano Continental - Brussels

from 12.00 am till 6.00 am

DJ's : Allan, Kimo, David Serrano

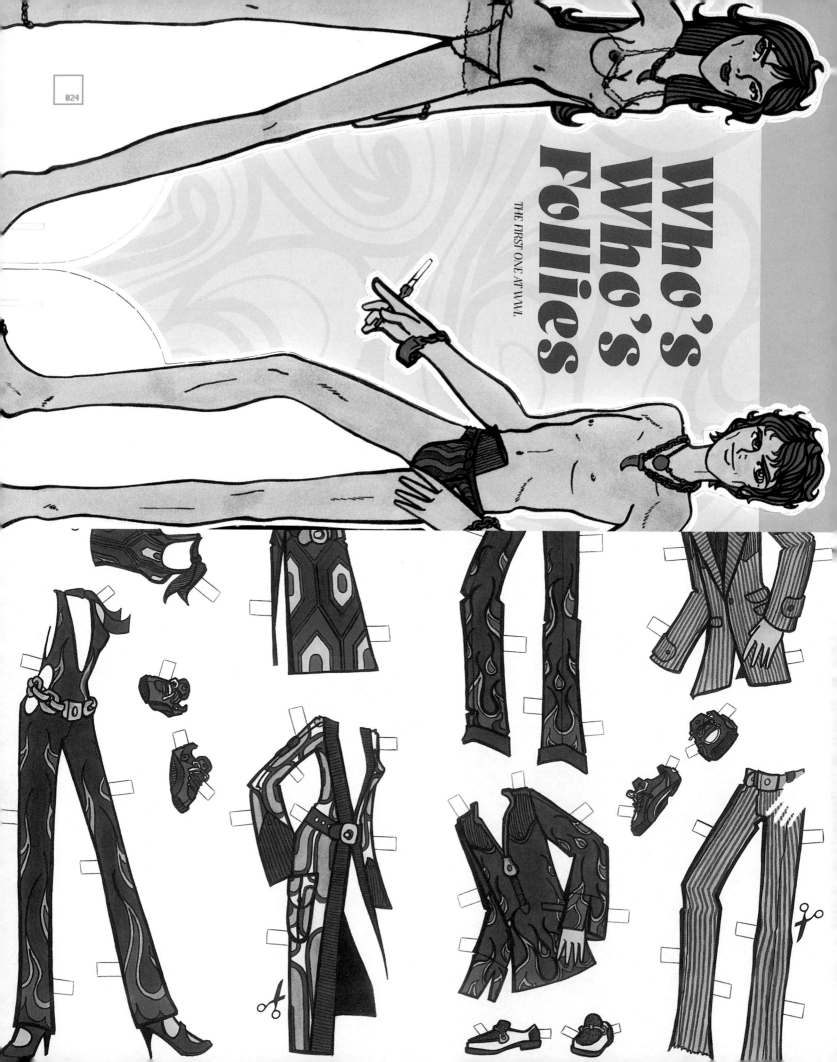

Who's
Who's
Follies

THE FIRST ONE AT WWL

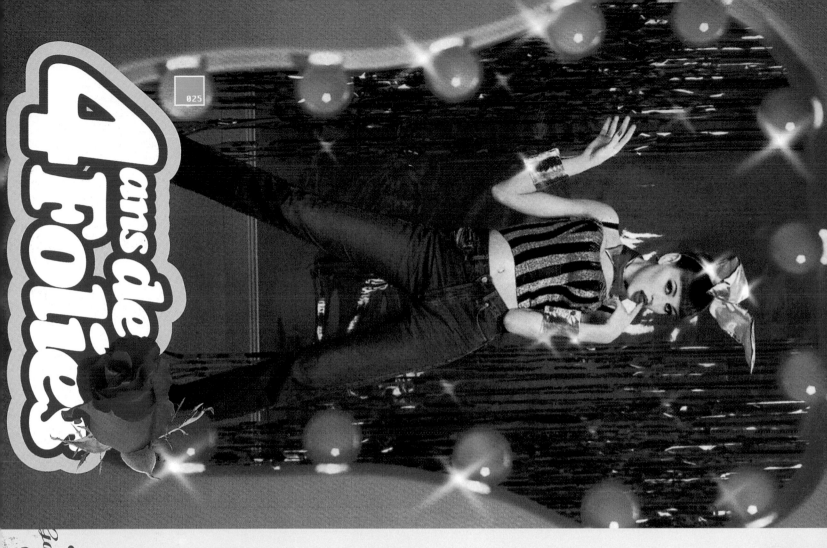

# 4 ans de Folies

## Be a playgirl!

### Les Bunny girls

Aurore ★ Aurélie ★ Casey ★ Diane ★ Francesca ★ Gaëlla ★ Gwénola ★ Eloïse ★ Ida ★ Isis ★ Jeehyung ★ Julie ★ Laure ★ Lee ★ Maëva ★ Sarah ★ Simone ★

026

*Flashe* PARIS

027

OLIVER BOSCOVICH & NADIA CHRETIENNE PRE

**Flashe**

DJ'S ROUSSIA
KMO

JEUDI 15 DÉCEMBRE 1979

FOLIES PIGALLE
11 pl Pigalle Paris 9è

Invitation X2

**Flashe**

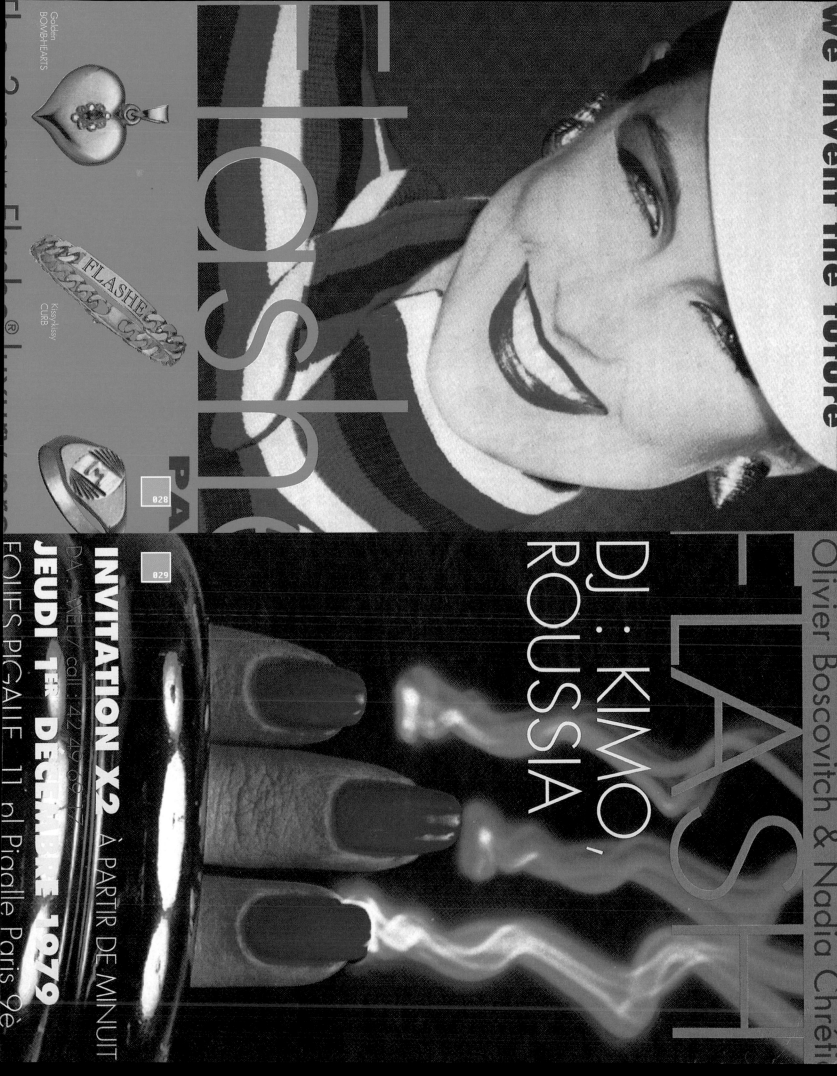

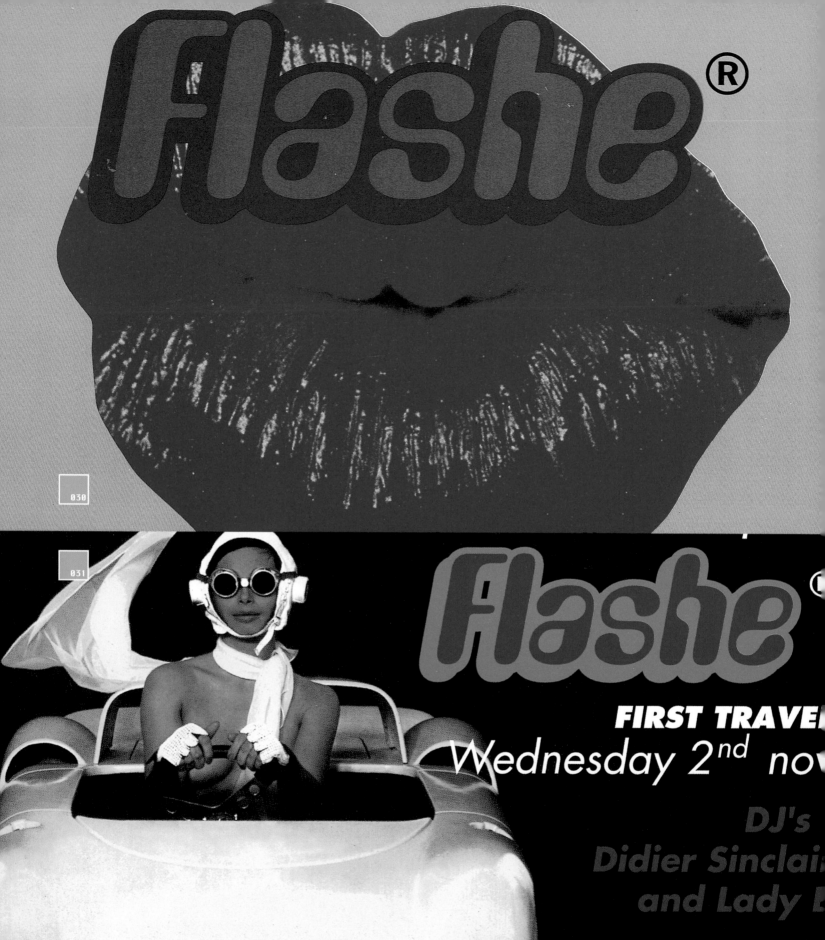

# ★PLASTIC★ DREAMS

032

tic brushing

Blue baby eye

Glossy make-up

Cherry lips

- Hi sweetie!
1 Vanilla Vagina...

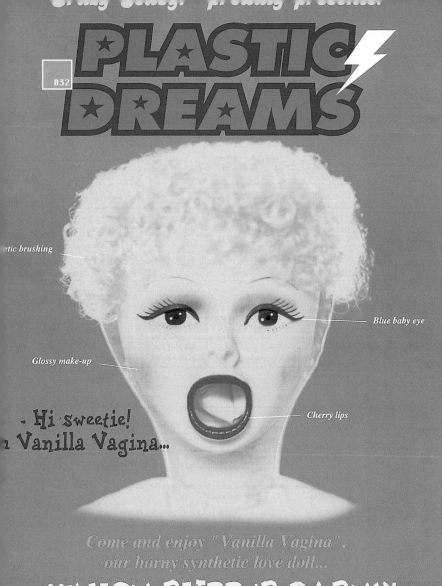

Come and enjoy "Vanilla Vagina",
our horny synthetic love doll...

100% HOT RUBBER PARTY!
at Folies Pigalle

fly with ULTRA!

033

034

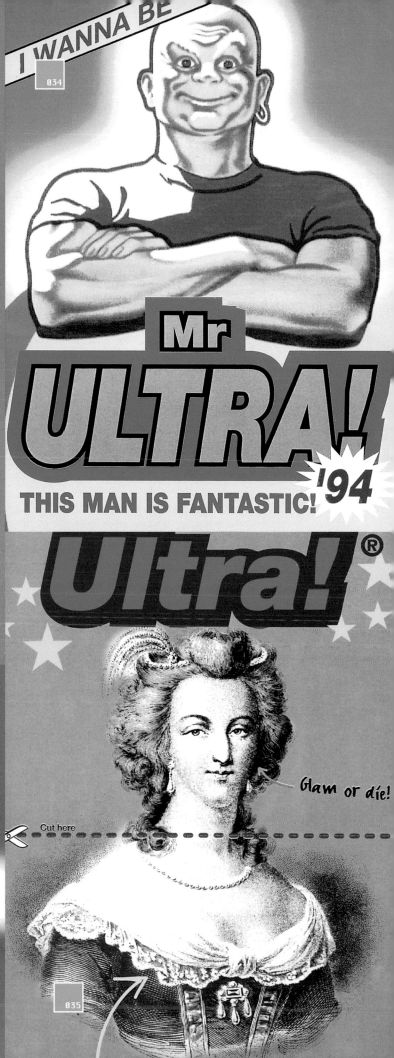

# Mr ULTRA!

'94

### THIS MAN IS FANTASTIC!

## Ultra! ®

Glam or die!

✂ Cut here

035

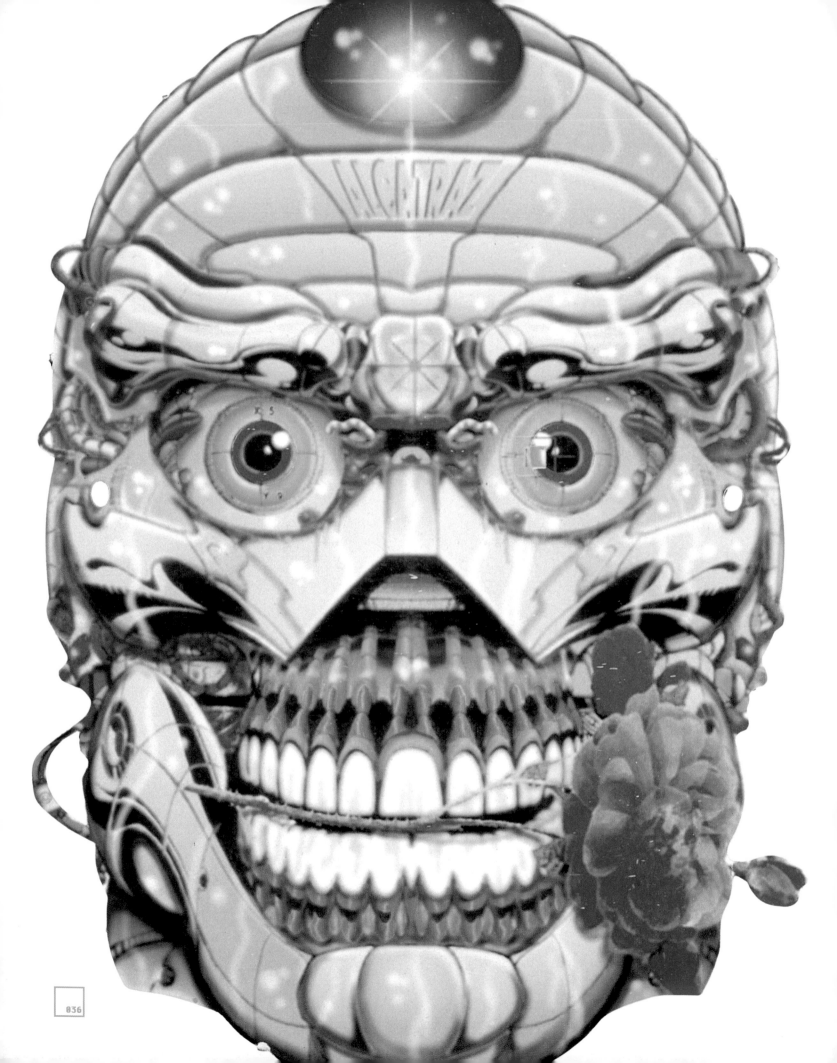

JOHN WAYNE
SECURITY GUARD

'LAST WEEK I WENT TO
**MANUMISSION** AND I
DISCOVERED THAT MEN
GIVE BETTER BLOWJOBS.
NOW I'VE LEFT THE WIFE
AND KIDS, AND LIVE
WITH MY BOYFRIEND
TOM.'

HEALTH WARNING : MANUMISSION COULD
SERIOUSLY DAMAGE YOUR REPUTATION AS
AN INSECURE HETEROSEXUAL MALE

MANUMISSION IS OFFICIALLY RE████NISED
AS THE BEST FRIDAY NIGHT IN THE COUNTRY
( source : DJ magazine )

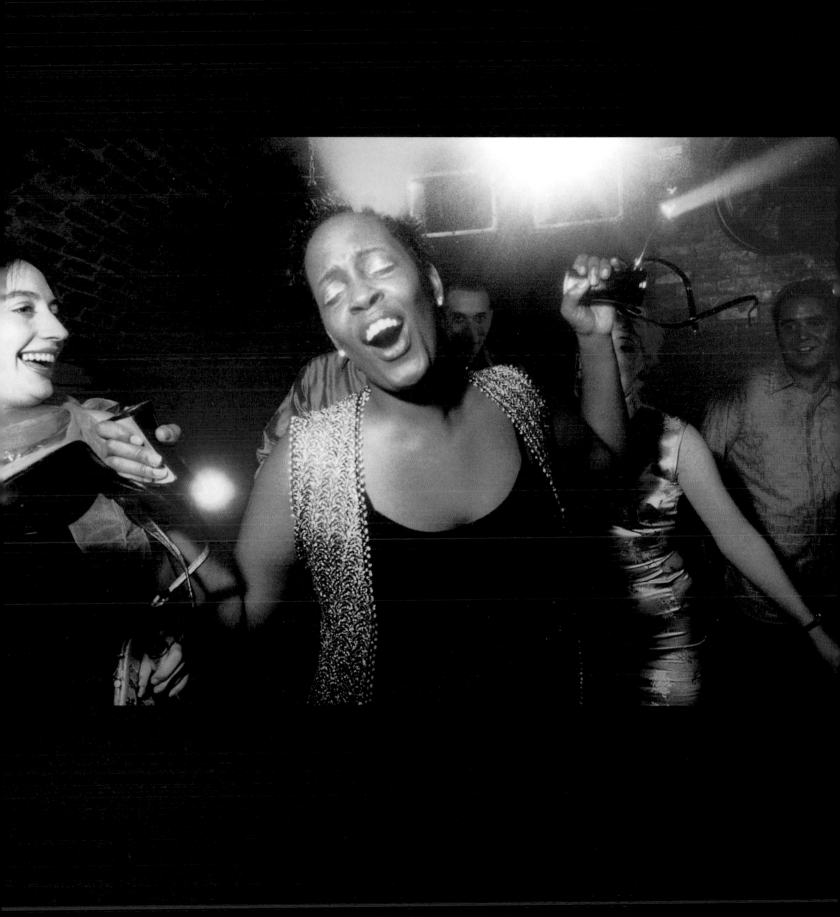

The Love Garage

Live the Life
Love the Music

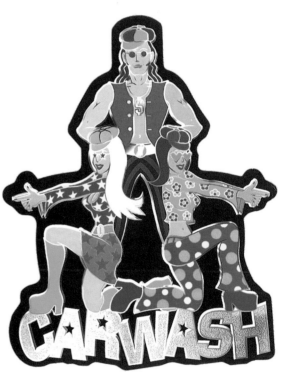

CARWASH

The Love Garage

038

039    040

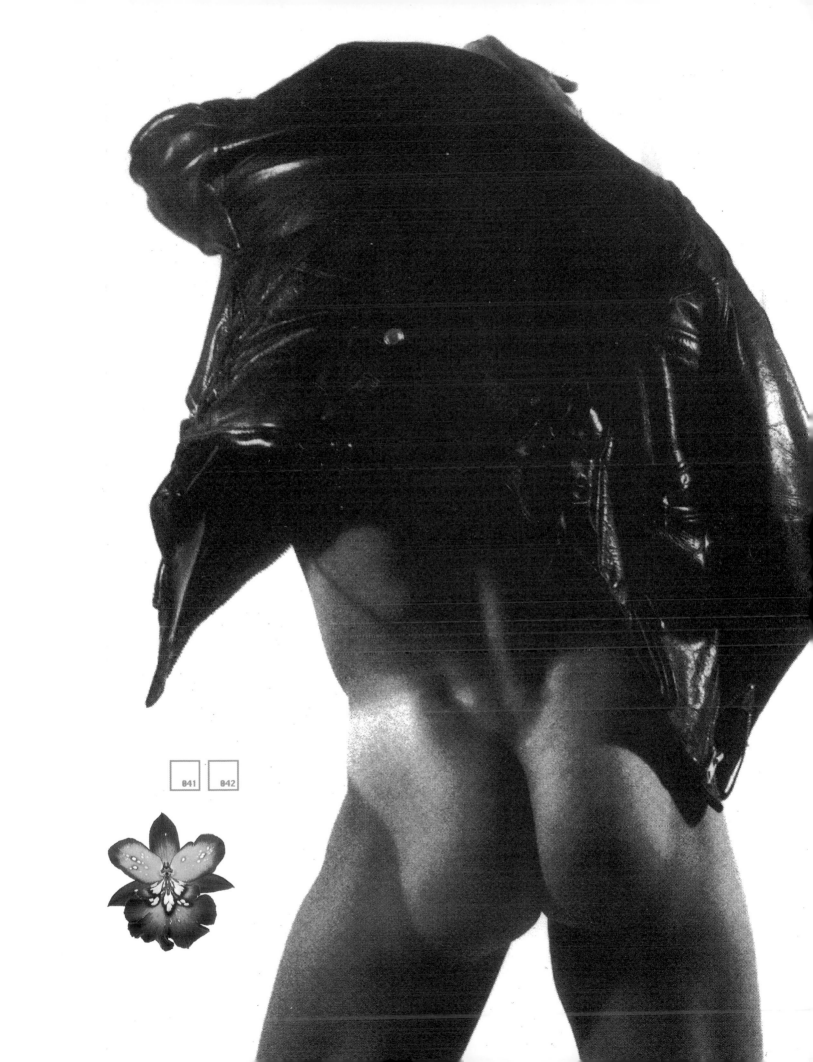

041  042

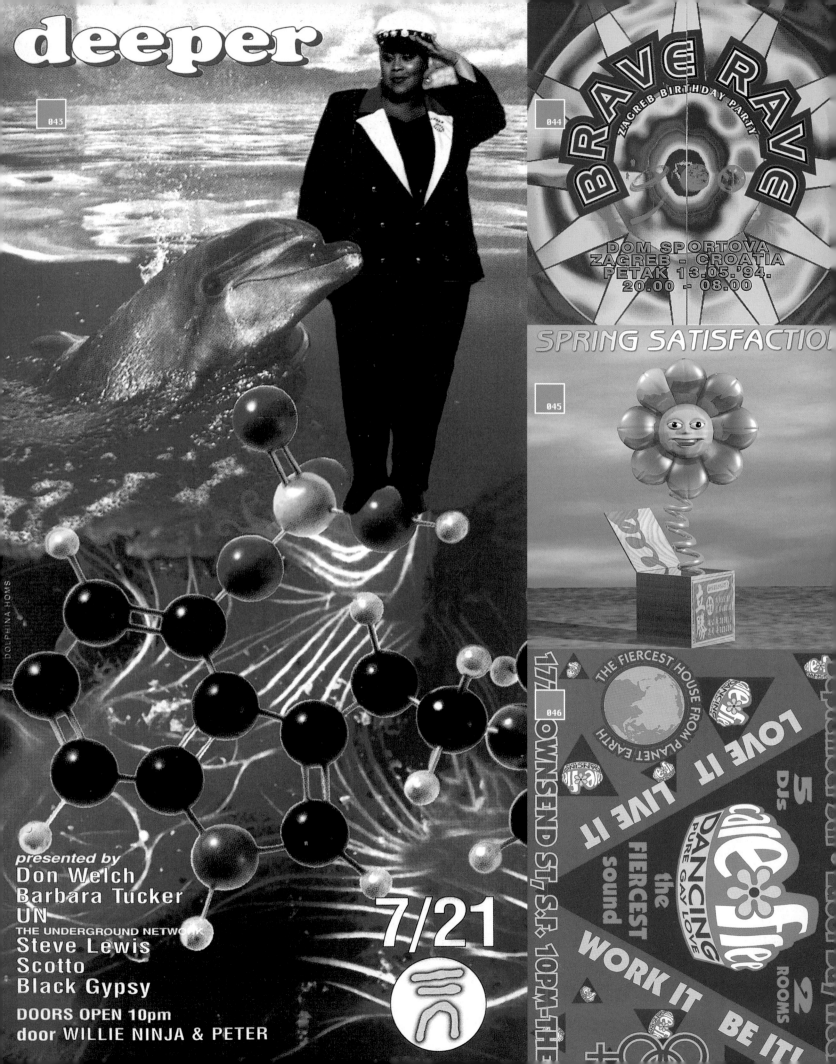

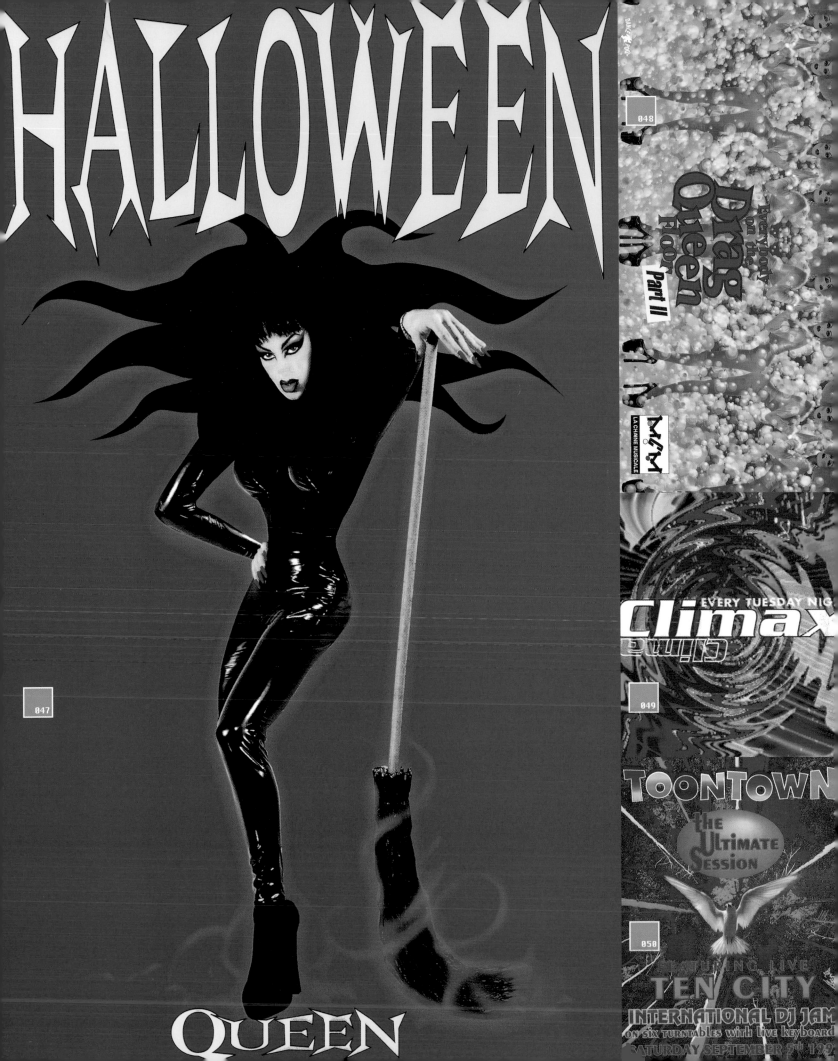

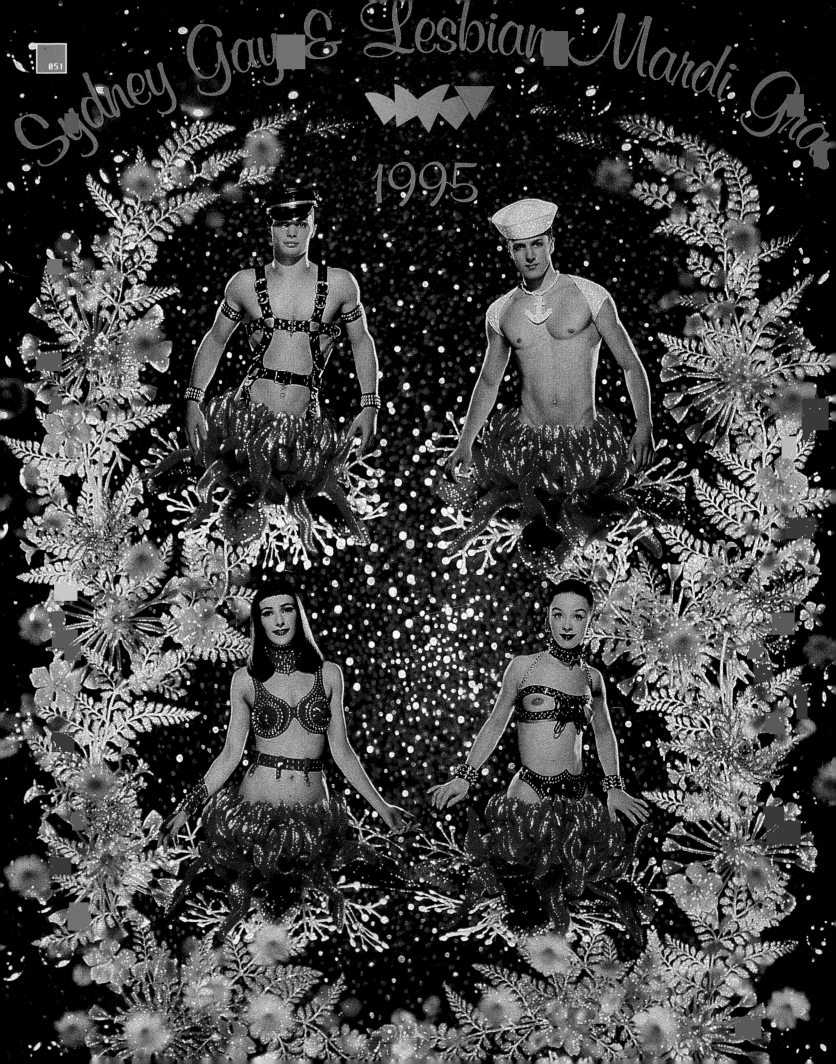

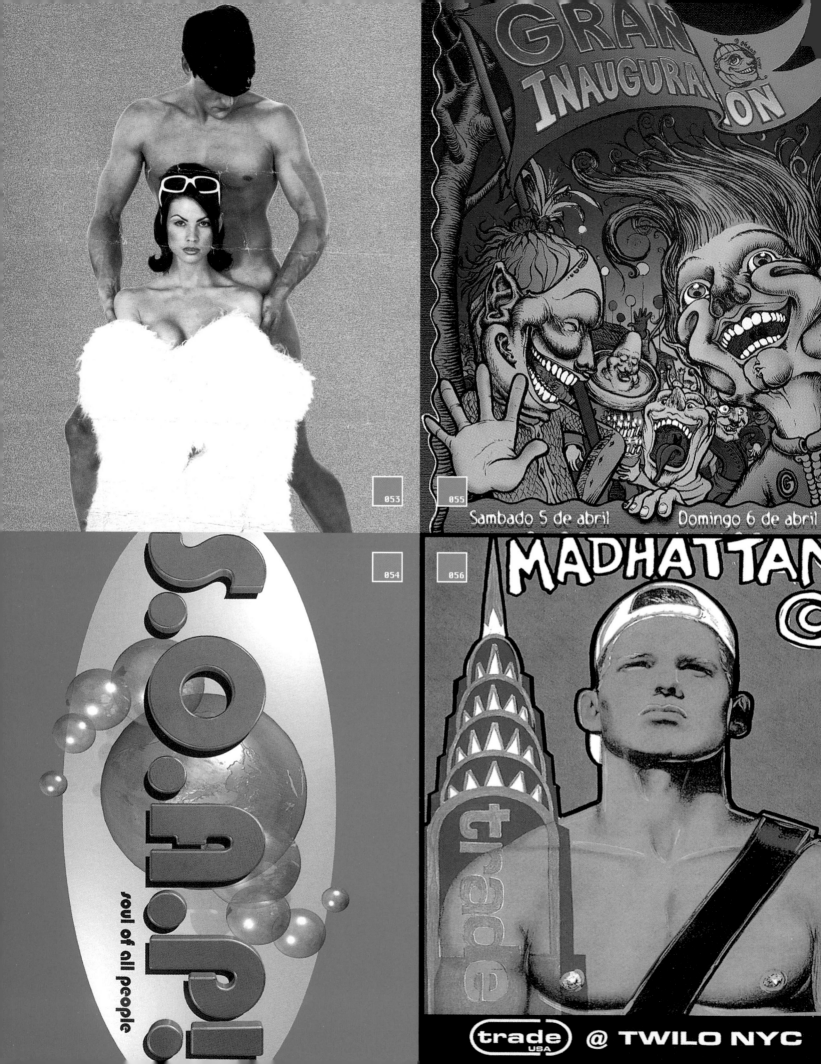

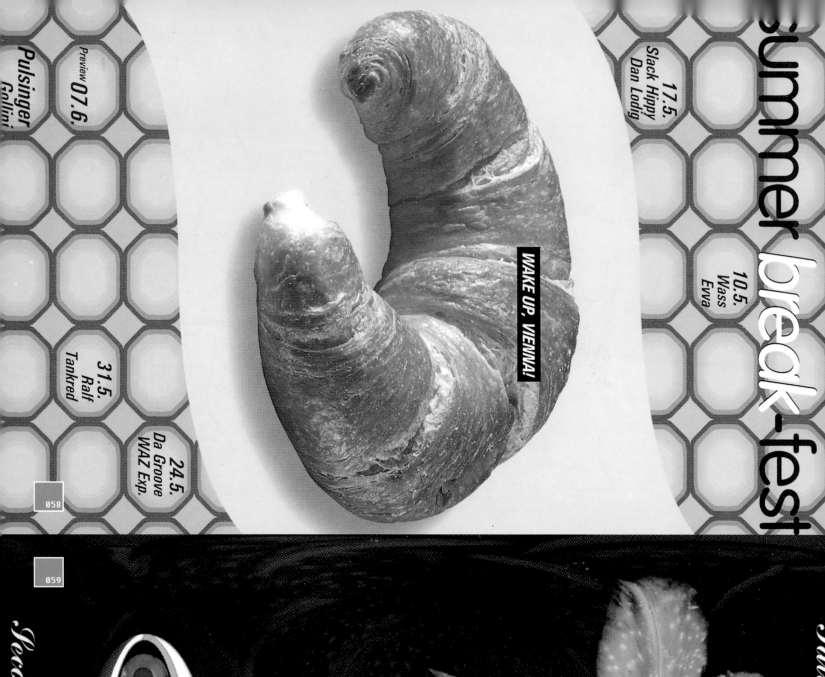

summer break-fest

17.5.
Slack Hippy
Dan Lodig

10.5.
Wass
Ewa

31.5.
Ralf
Tankred

24.5.
Da Groove
WAZ Exp.

Pulsinger
Gollini

Preview
**07.6.**

WAKE UP, VIENNA!

organic

*Second Year Anniversary*

*Saturday March 11, 1995*

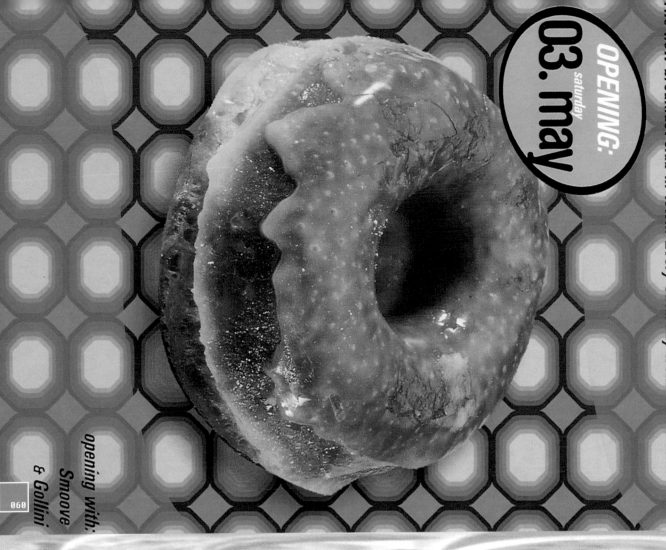

# summer break-fest

The new breakfast-club in town! Every saturday from 06:00 a.m.

**OPENING:**
saturday
**03. may**

opening with:
Smoove
& Gollini

im *evergreen-garden*
der

060

061

# organic

*Saturday March 11, 1995*

*Second Year Anniversary*

# Vitamin S

**062**

## SUNDAY
**00 - 0200**

VITAMIN S & FRIENDS
80'S DANCEFLOOR
KREUZSTRASSE 24 ZH

## DISCO

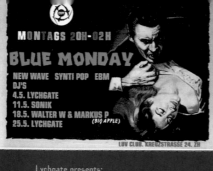

## BLUE MONDAY

MONTAGS 20H-02H

NEW WAVE    SYNTI POP    EBM
DJ'S
4.5. LYCHGATE
11.5. SONIK
18.5. WALTER W & MARKUS P (BIG APPLE)
25.5. LYCHGATE

LUV CLUB, KREUZSTRASSE 24, ZH

## Science Fiction Jazz Night

DIENSTAGS 20 — 02 H
Drum 'n' Bass/Abstract
Trip Hop/Big Beats ......
RESIDENT DJ: MINUS 8
& 5.5. DJ HAM-STAR
12.5. DRIFT, 19.5. KING-
SIZE (NY), 26.5. LED TAMPI
LUV KREUZSTR.24.ZH.

## L'AUNDRY-D

6.5. SENSER & DJ WJO 13.
20.5. DJ PETE G. 27.5. BI

## MITTWOCHS 20-02

---

**nnerstag**
**2000 - 0200h**

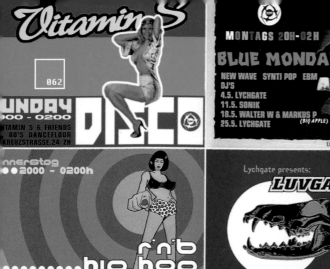

r'n'b
hip hop
pitsch morko pluto ag pimp
luv club    dj's:
kreuzstr.24.zh

## LUVGATE

Lychgate presents:

Fr 08.5. 21-04uhr
Gothic/Electro/NewWave/Industrial/EBM/Darkwave
LUV CLUB. KREUZSTR.24.ZH mit dem Lychgate - Dj - Team

## SENSER

LAUNDRY DAY
KONZERT
Mi 08.5.98
BAR 20H
START 2130H
& MOKE (GB)

LUV CLUB
KREUZSTR.24.ZH  Vorverkauf: Ticket Corner

## PETER & THE TEST TUBE BABIES (GB)

Cutting Edge of Rock Konzer
BAR 21h. Konzert 21:30h
Ansch. Psychohead
(VynilPirate) Garage Punk etc
LUV Kreuzstr 24    SA.9.5.

---

Do 14. 05.
BAR 20H. START 2130H
**nf Sterne deluxe**

Special Guests:
Dynamite deluxe
Doppelkopf
MC Ferris
Vorverkauf: Ticket Corner
**lub Kreuzstrasse 24 ZH**

## LoliPop

Schlagerparty Fr 15.5. 21-04h
Hossa!

Udo
Costa        Petra
Heino        Heintje
Rex    Gildo

DJ's Tom & Joachim
LUV Kreuzstr.24 ZH

## DRUM'N'BASS

Science Fiction Jazz-Night
Minus 8 &
DJ Kingsize
19.5. NY usa
KREUZSTR.24.ZH

Fat Tracks &
Manga Records

## STEREO TOTAL

Fr 22

STA
France
Brea
A
Party Antico
oder Disco
Feat. DJ's Bu

(IG Tons meets S
LUV Kreuzstrasse 24 ZH

---

## NE NIGHT STAND

Hp Comedy mit dem Trio Eden: Helmi Sigg, Midi Gottet, Guy Landolt

MO: 25.5./ 29.6./ 27.7./ 31.8.
BAR 20H / START 21H / FR.10.
mit Überaschungsgast & Newcommer des Monats
LUB KREUZSTR.24. ZH. Anschliessend: Blue Monday

## MONSTER MAGNET

26. 05. 19h- 21h Plattenpräsentation: "Powertrip"
Polygram & Luv laden ein
LUV Club Kreuzstrasse 24 ZH

## LAUNDRY DAY KONZERT:

BIF (CAN)

Mi 27.5.
BAR 2000
START 2130H
LUV CLUB
KREUZSTR 24 ZH   ANSCHL. DJ MAIK

## STARFACT

Sa 30.5.98
Bar 21h Start 2
Ska mit Les Congelate
& Tom Hogan Moto
LUV Club Kreuzstr.24

in Begleitung von DJ Benno (Leech Rec.) Der Talentschuppen m

---

## NO ENERGY

So rich...
so moist...
so quickly gone!

## WED.STUFF

**neu** **jedenMITTWOCH**

22
bis
0200h

SOUL FUNK ACID JAZZ
WAS QUE NADA
DJ's:
Sir-Joe (Crazy Beat), Jean, Tom Brown
LUV. KREUZSTR. 24 ZH

## RICO

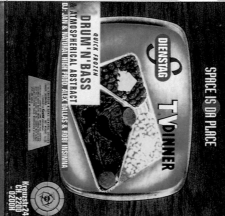

ALLES WAS DAS OHR BEGEHRT UND MEHR
JAMA, Helvetiaplatz & Niederdorf
LUV. Kreuzstr./24 ZH

## JAVA

NEU: JEDERN MONTAG AB 22.00
REC. STORE FEAT.
MIT DJ's: Mark'i & Batchbas 5/19.8.
Michael K. 12.8
Promilo 26.8.

SA.31.8.DJ:3in
FR.30.8.DJ:Ernie, The World's Worst DJ, & M.T. Robo Fridge Monster
FR.16.8.Hiphop-Ragga:DJ:Junior Indian & The Roots Operator
SA.17.8.DJ:Jonas Shark' / SA.24.8.DJ:Mech LasSharn
FR.2.8.DJ:Marko.1/SA.3.8.DJ:Tom
FR.9.8.DJ:UJO
HIPHOP-RAGGA
(DJ:Junior Indian &
The Roots Operator)

LUV Club, Kreuzstr./24, 8008 ZH

---

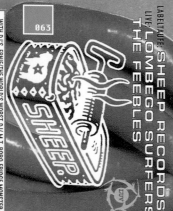

## SHEEP
SHEEP RECORDS
LIVE! LOMBEGO SURFERS
THE FEEBLES

WITH DJ'S ERNIE/THE WORLD'S WORST DJ / M.T. ROBO FRIDGE MONSTER

LABELTAUFE
roped by
Dj Pitsch, Dj 69 Pimp
Dj Marko, Dj Pluto
Kreuzstr. 24. zh

## Dessert

Donnerstag
2200 - 0200
Fresh feeling music

House & Hip Hop

GLITSCHI

## TV DINNER

DIENSTAG
QUICK FROZEN
DRUM 'N' BASS
& ATMOSPHERICAL ABSTRACT
DJ-JAM & NATURAL HIGH PROD: ALEX DALLAS & ROBI INSIGNIA
SPACE IS DA PLACE
Kreuzstr.24
2200
-0200h

## GLAMOUROTHEK
Disco Inferno
DJ VITAMIN S. 22-0200

LUV, KREUZSTR.24, ZH

**063**

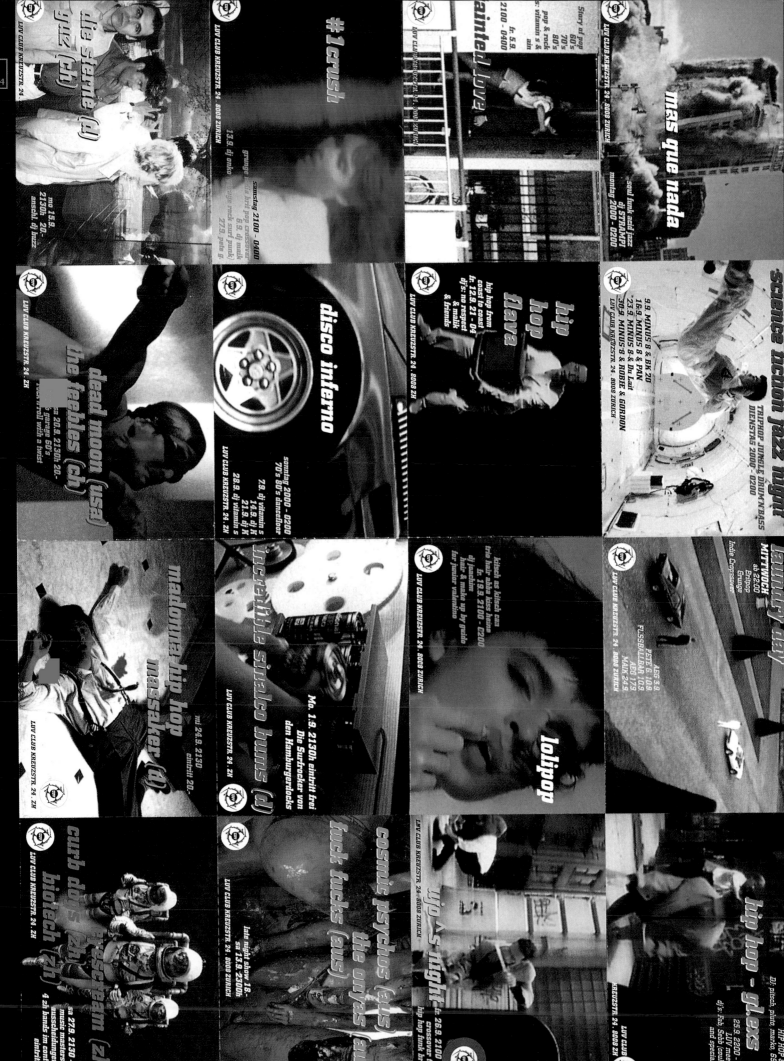

064

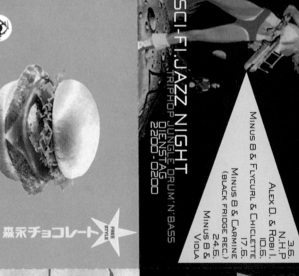

LUV

Ab. 21:30H

CHEWY & SINNER DC.

DAN & STELLA
(d) & (ch)
KONZERT
SA 21.6.
2130H

GLITSCHI EXCESS

DONNERSTAG ab 21:30
HipHop RnB
DJ's Pitch, Marko, Pluto, 96Pint G.

2100 - Freitag - 0400

DJ STRAMPI. SOUL FUNK ACID JAZZ
Mas Que Nada am Montag 2100 - 0200

6.6. LAUNDRY NIGHT.
13.6. MONSOON
20.6. SCI-FI. JAZZ NIGHT 2002
27.6. LOLI-POP

SPOOKEY RUBEN & KING COBB STEELIE

LUV CLUB. Kreuzstr.24.Zh
anschl. DJ's Pete G. & Maik
Bush Everclear Cake Skunk Anansie...

SCI-FI. JAZZ NIGHT
TRIPHOP JUNGLE DRUM 'N BASS
DIENSTAG 2200 - 0200

BEAST OF BURBON
LUV Kreuzstr 24
27.97
2130

MONSOON

SAMSTAG

ROB PLAYFORD (GB)
20.6 2200

SCI-FI.JAZZ NIGHT 2002 MIT -8 & SPECIALGUEST

2002

disco

LAUNDRY DAY

MITTWOCH ab 2200
Britpop Grunge
IndieCrossover
LUV CLUB KREUZSTR.24.ZH

WWW.HUGO.CH.CLUBS
TELBAR:01.2624
OFFICE: 01.2624
FAX: 01.2519

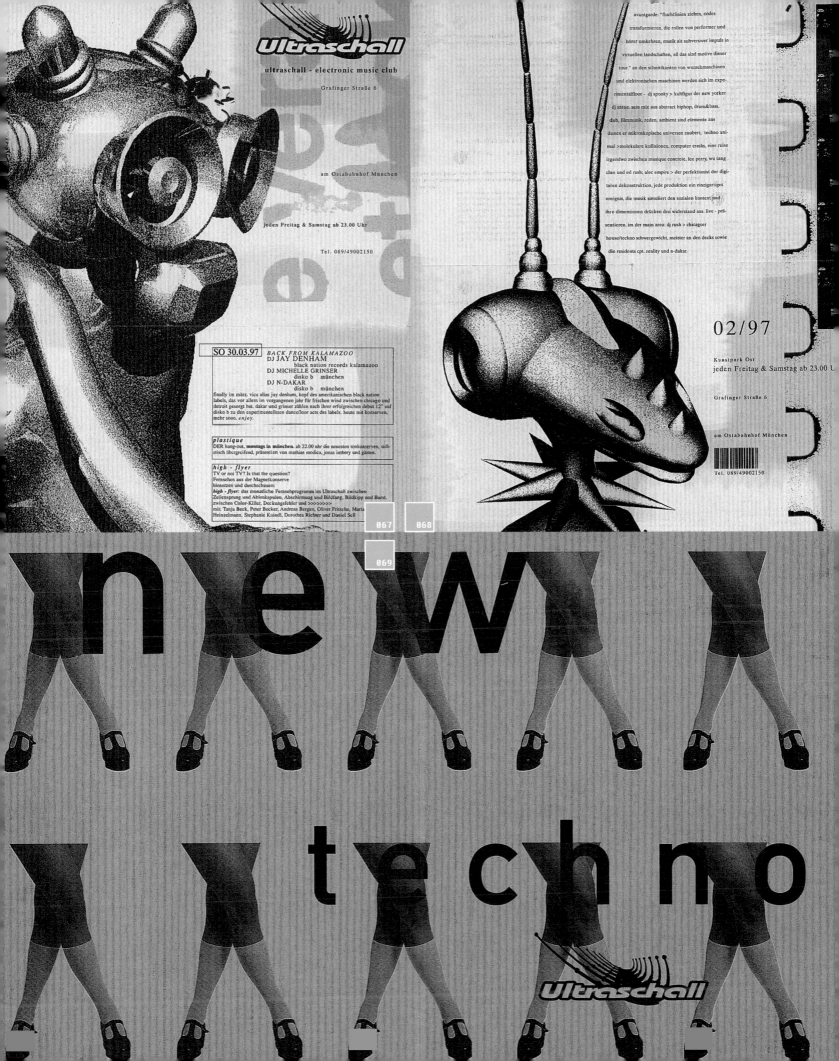

# ultraschall

ultraschall - electronic music club

Grafinger Straße 6

am Ostabahnhof München

jeden Freitag & Samstag ab 23.00 Uhr

Tel. 089/49002150

avantgarde: "fluchtlinien ziehen, codes transformieren, die rollen von performer und hörer umkehren, musik als subversiver impuls in virtuellen landschaften, all das sind motive dieser tour." an den schnittkanten von wunschmaschinen und elektronischen maschinen werden sich im experimentalfloor - dj spooky > kultfigur der new yorker dj szene. sein mix aus abstract hiphop, drum&bass, dub, filmmusik, reden, ambient sind elemente aus denen er mikroskopische universen zaubert; techno animal >molekulare kollisionen, computer crashs, eine reise irgendwo zwischen musique concrete, lee perry, wu tang clan und ed rush; alec empire > der perfektionist der digitalen dekonstruktion, jede produktion ein einzigartiges ereignis, die musik simuliert den sozialen kontext und ihre dimensionen drücken den widerstand aus. live - präsentieren. im der main area: dj rush > chicagoer house/techno schwergewicht, meister an den decks sowie die residents cpt. reality und n-dakar.

## 02/97

Kunstpark Ost

jeden Freitag & Samstag ab 23.00 U

Grafinger Straße 6

am Ostabahnhof München

Tel. 089/49002150

---

**SO 30.03.97** *BACK FROM KALAMAZOO*
**DJ JAY DENHAM**
          black nation records kalamazoo
**DJ MICHELLE GRINSER**
          disko b    münchen
**DJ N-DAKAR**
          disko b    münchen

finally im märz. vice alias jay denham, kopf des amerikanischen black nation labels, das vor allem im vergangenen jahr für frischen wind zwischen chicago und detroit gesorgt hat. dakar und grinser zählen nach ihrer erfolgreichen debut 12" auf disko b zu den experimentellsten dancefloor acts des labels. heute mit konserven. mehr soon. *enjoy.*

---

*plastique*
DER hang-out, **montags in münchen.** ab 22.00 uhr die neuesten tonkonserven, stilistisch übergreifend, präsentiert von mathias modica, jonas imbery und gästen.

---

**high - flyer:** TV or not TV? Is that the question?
Fernsehen aus der Magnetkonserve
hinsetzen und durchschauen:
**high - flyer:** das monatliche Fernsehprogramm im Ultraschall zwischen Zeilensprung und Ablenkspulen, Abschirmung und Bildfang, Bildkipp und Burst, zwischen Color-Killer, Deckungsfehler und >>>>>>>>
mit: Tanja Beck, Peter Becker, Andreas Bergen, Oliver Fritsche, Maria Heinzelmann, Stephanie Kuindl, Dorothea Richter und Daniel Sell.

**067**    **068**

**069**

# new

# techno

# ultraschall

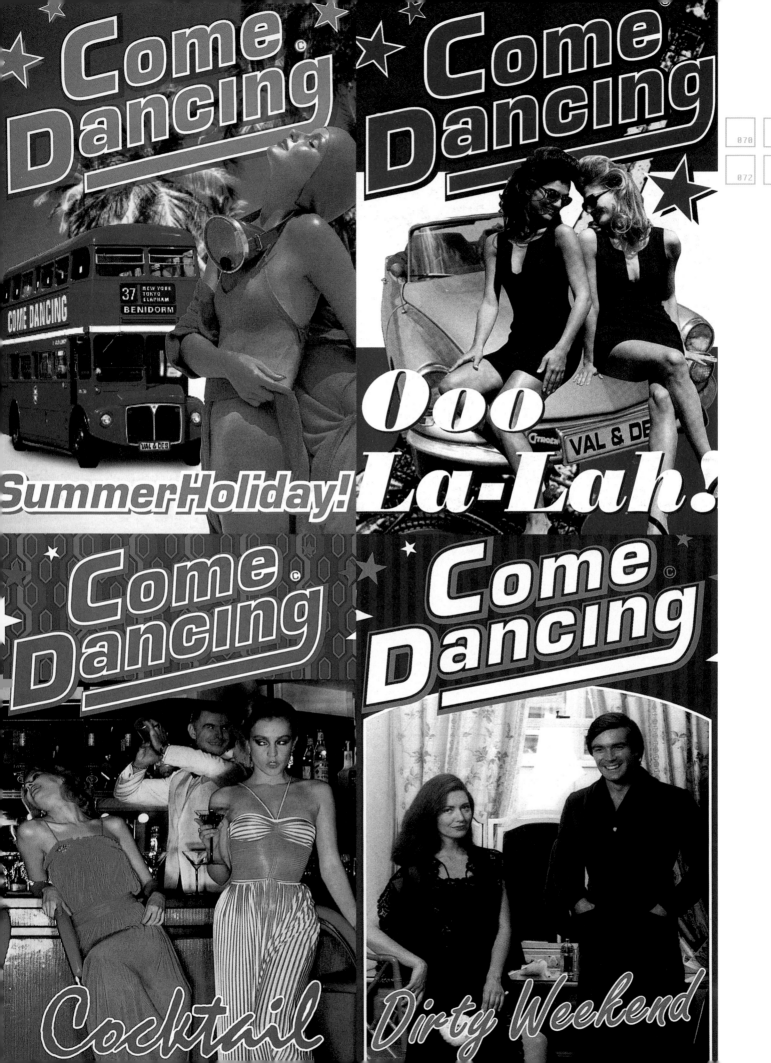

# Come Dancing

074

Yes Boss, it's...

# Fantasy Island

# NOWHERE

075

076

singular | elegant | drum | & | bas

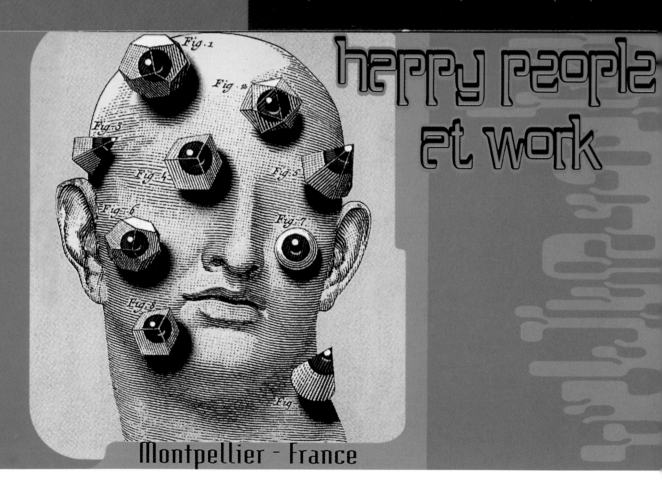

happy people at work

Montpellier - France

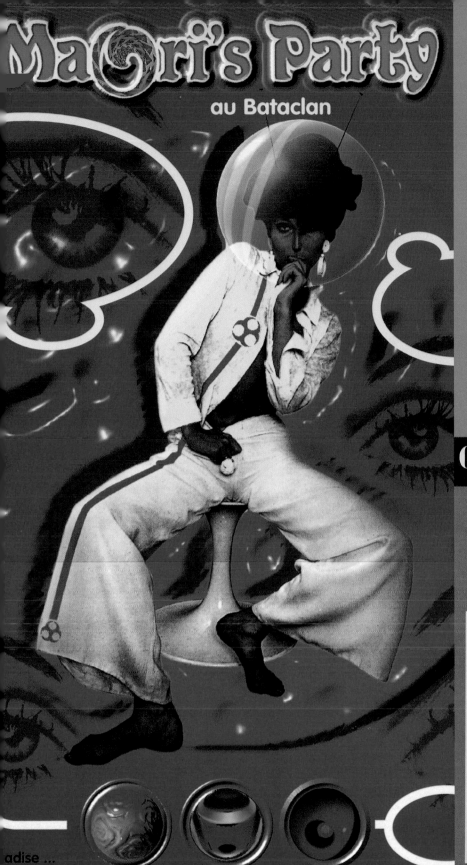

# Maori's Party
## au Bataclan

adise ...

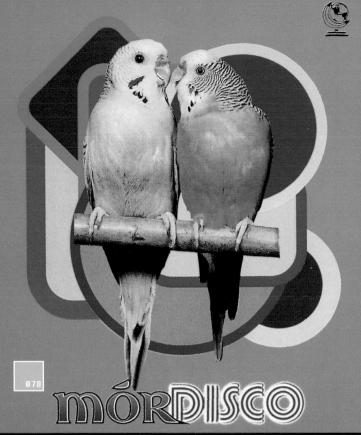

# mórDisco

## Go Where You Know You'll Have Fun

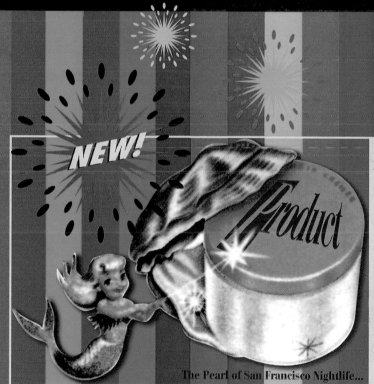

NEW!

Product

The Pearl of San Francisco Nightlife...

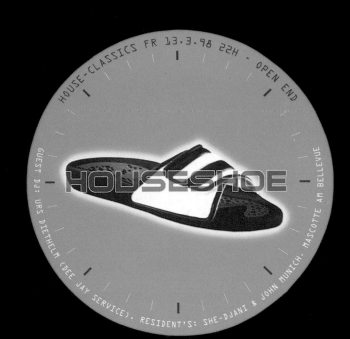

HOUSE-CLASSICS FR 13.3.98 22H - OPEN END
HOUSESHOE
GUEST DJ: URS DIETHELM (DEE JAY SERVICE). RESIDENT'S: SHE-DJANI & JOHN MUNICH. MASCOTTE AM BELLEVUE

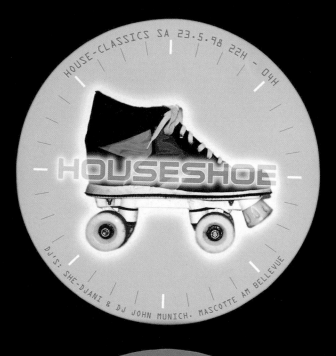

HOUSE-CLASSICS SA 23.5.98 22H - 04H
HOUSESHOE
DJ'S: SHE-DJANI & DJ JOHN MUNICH. MASCOTTE AM BELLEVUE

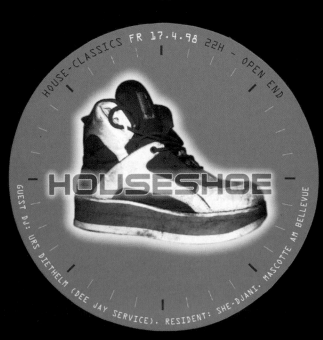

HOUSE-CLASSICS FR 17.4.98 22H - OPEN END
HOUSESHOE
GUEST DJ: URS DIETHELM (DEE JAY SERVICE). RESIDENT: SHE-DJANI. MASCOTTE AM BELLEVUE

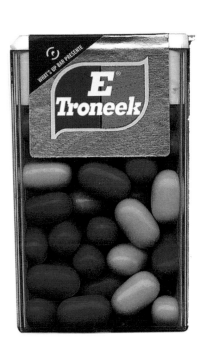

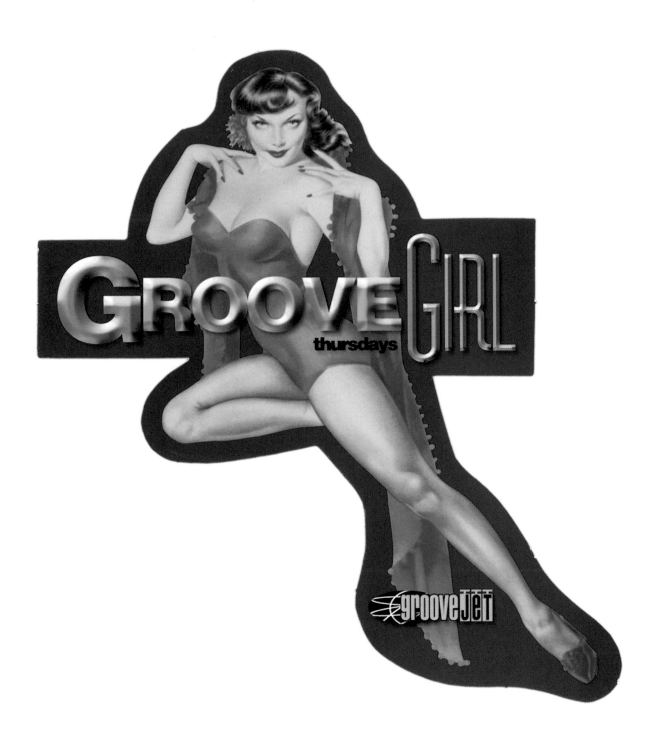

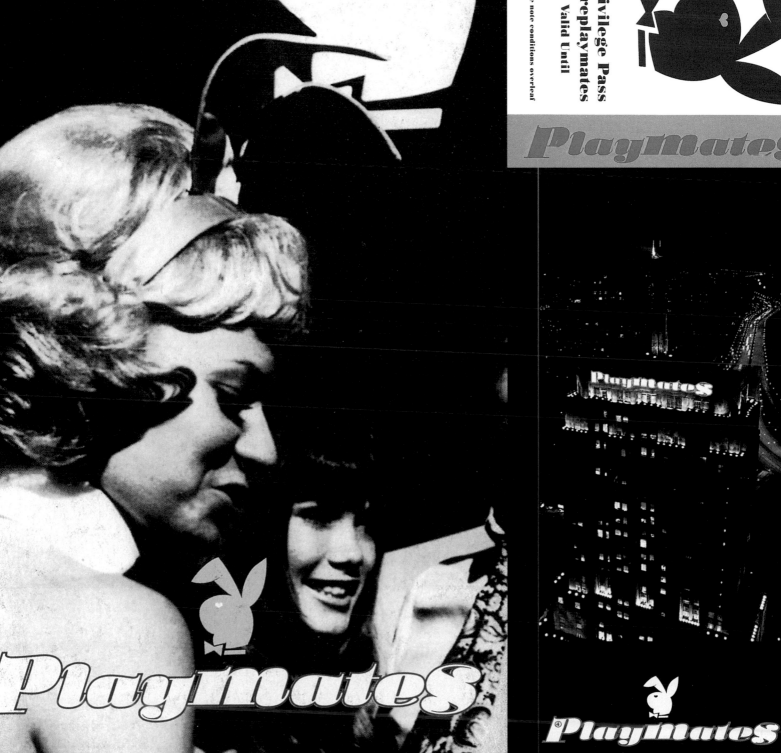

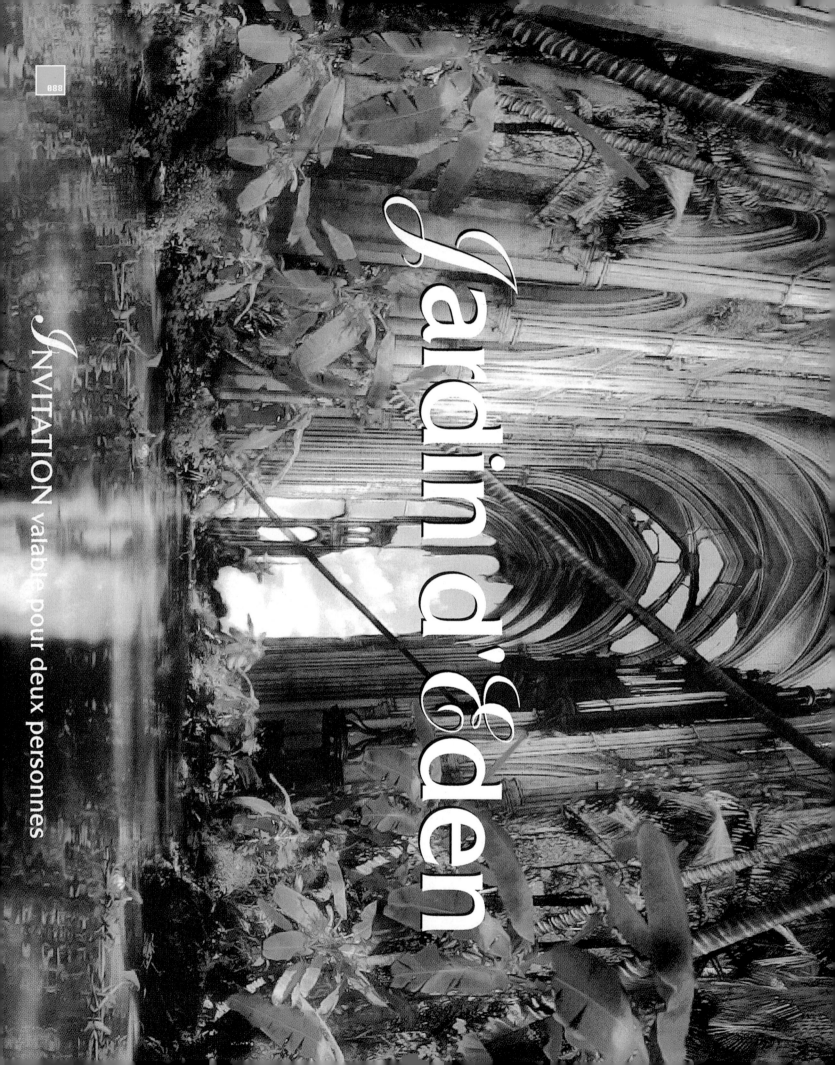

Jardin d'éden

Invitation valable pour deux personnes

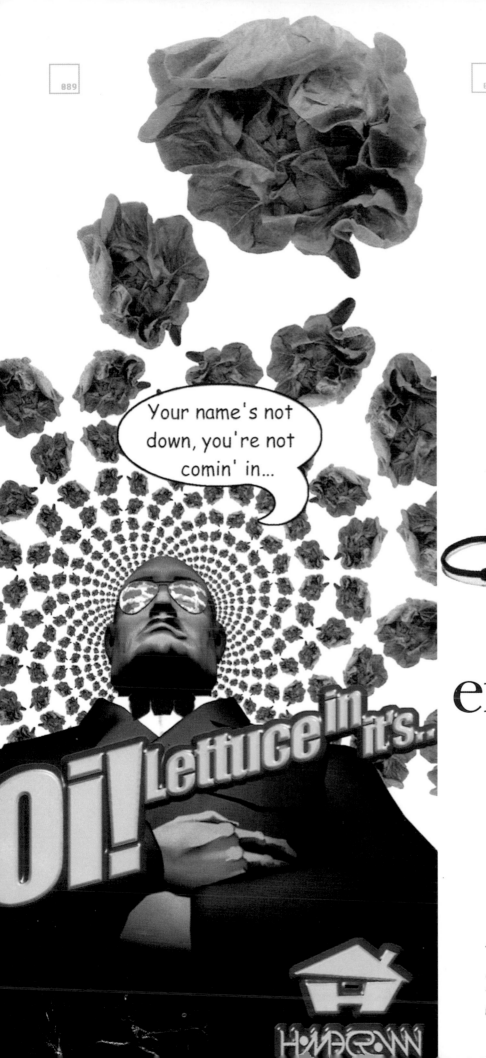

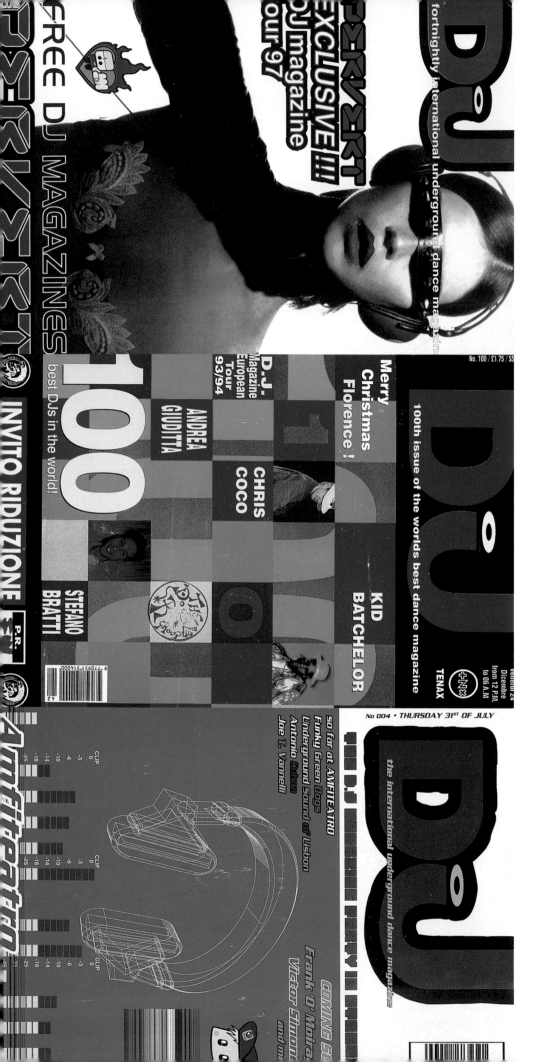

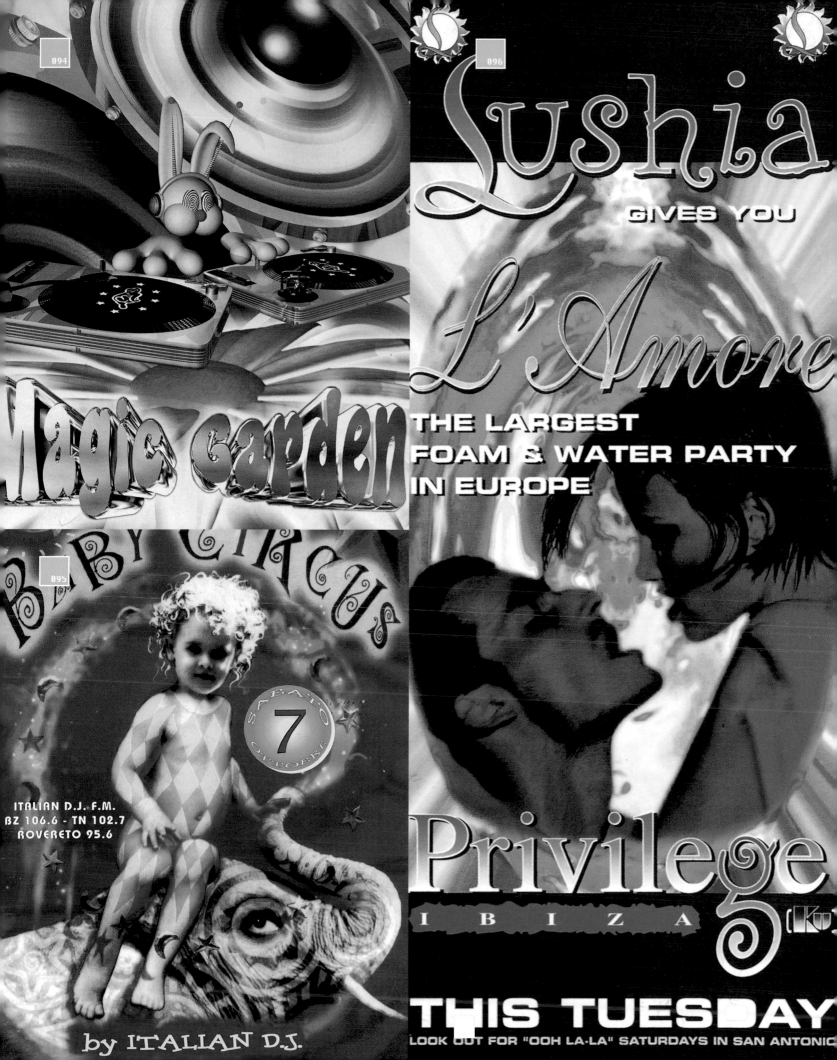

094

Magic Garden

095

BABY CIRCUS

SABATO 7 OTTOBRE

ITALIAN D.J. F.M.
BZ 106.6 - TN 102.7
ROVERETO 95.6

by ITALIAN D.J.

096

Lushia
GIVES YOU

L'Amore

THE LARGEST
FOAM & WATER PARTY
IN EUROPE

Privilege
IBIZA
5

THIS TUESDAY

LOOK OUT FOR "OOH LA-LA" SATURDAYS IN SAN ANTONIO

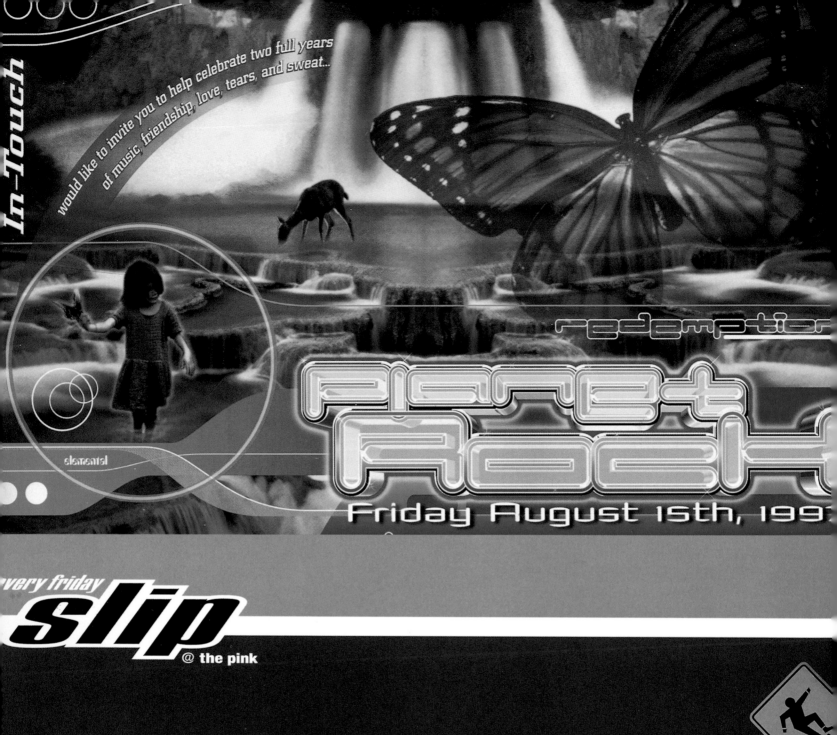

In-Touch

would like to invite you to help celebrate two full years
of music, friendship, love, tears, and sweat...

elemental

redemption

Planet Rock

Friday August 15th, 1997

every friday

slip

@ the pink

SEPTEMBER

12

OD

FRIDAY

1997

SAN FRANCISCO

BAY AREA

buzz

SUBJECT: THX 1138 VIOLATION

31 24 JANUARY

2000

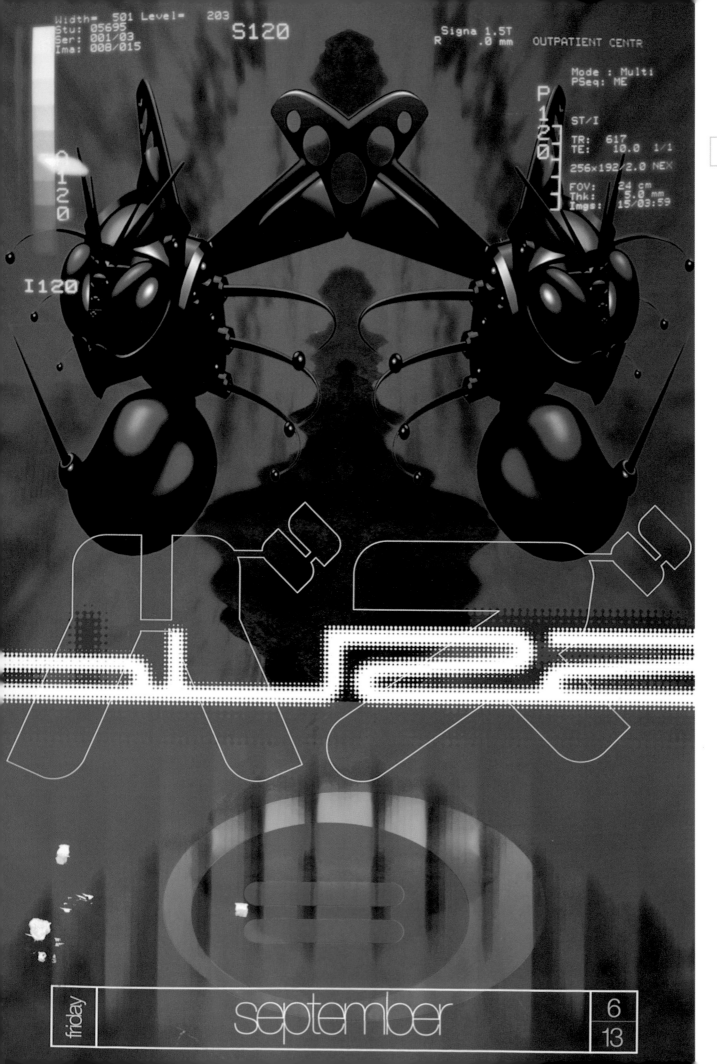

buzz

バズ

FEBRUARY

2.7.97
2.14.97
2.21.97
2.28.97

2062
2064

08.23.96
08.30.96

buzz

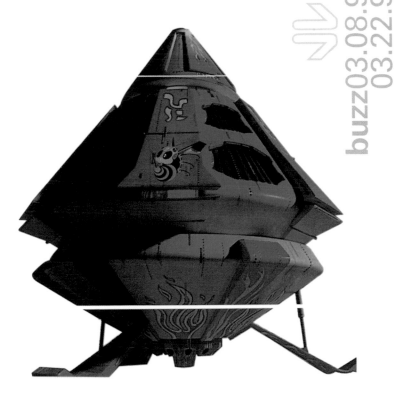

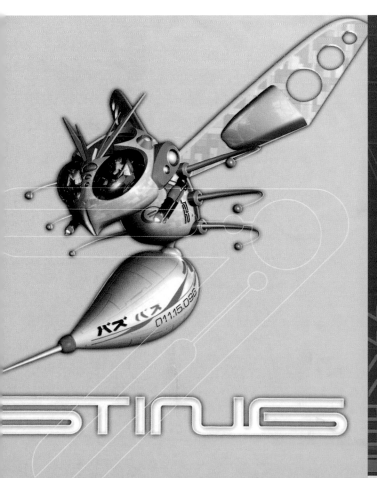

STING

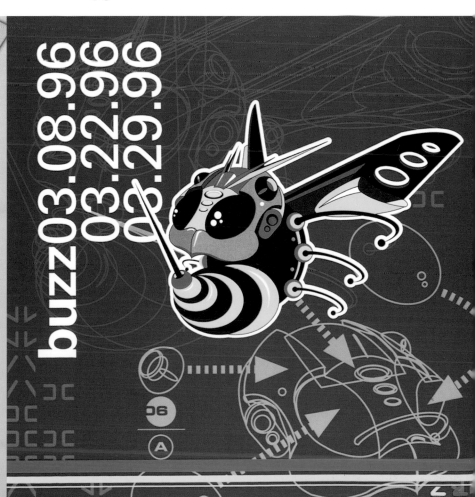

buzz03.08.96
03.22.96
03.29.96

06

A

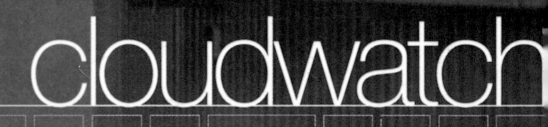

**CW 10.4.97**

CW 118

the great human sun touch . Rhombus . Infinity . 322 . Berlin . Swingset . Wally . We

LoveGrove . Fluid . Double Helix

DJ Swingset . DJ Wally .

cloudwatch

saturday.
**oct**ober_4.1997

sonic sc

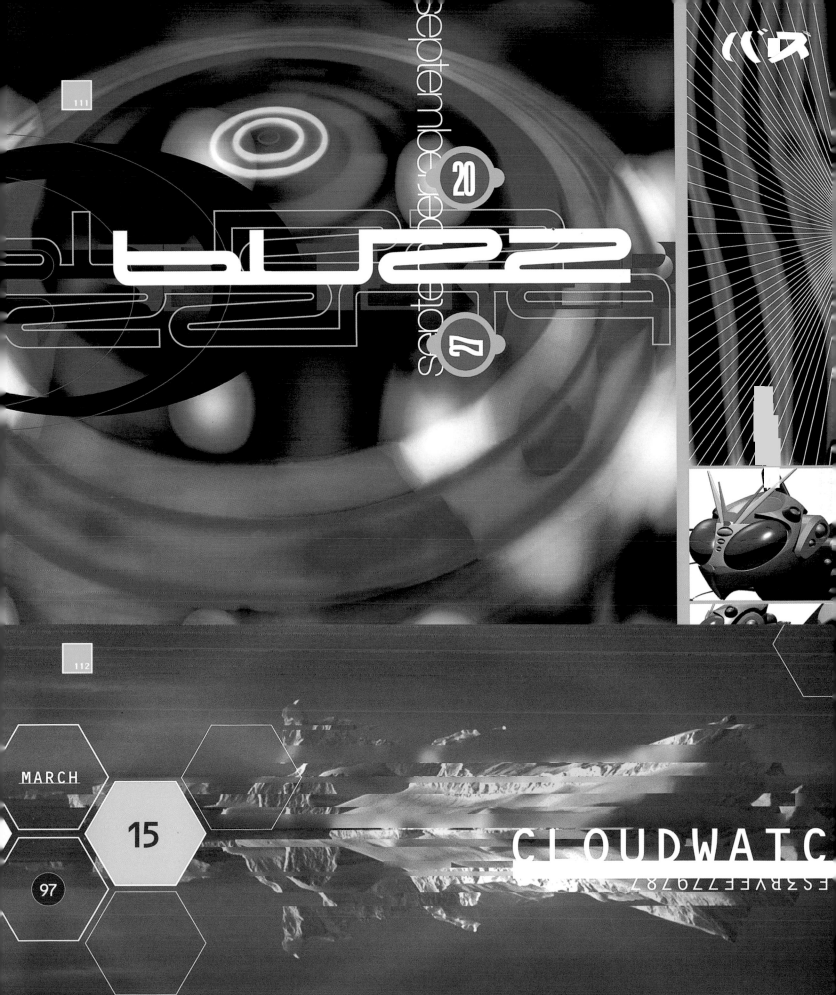

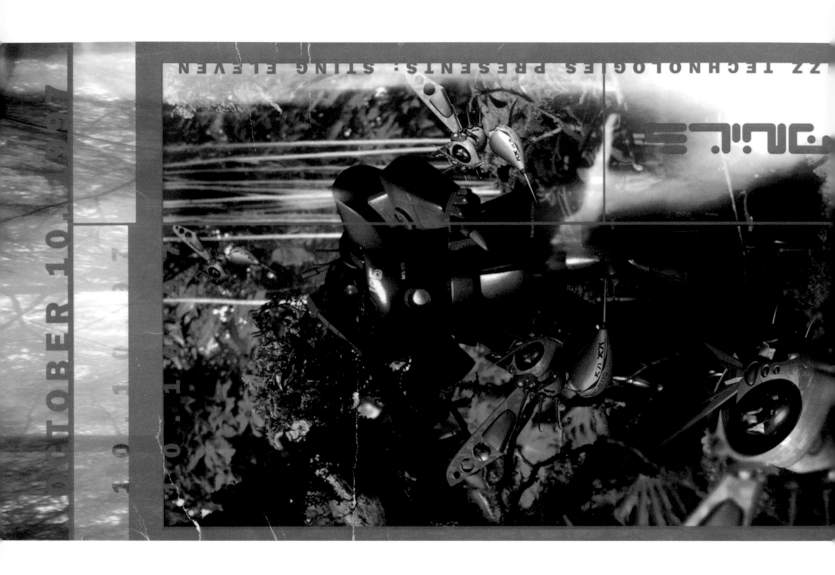

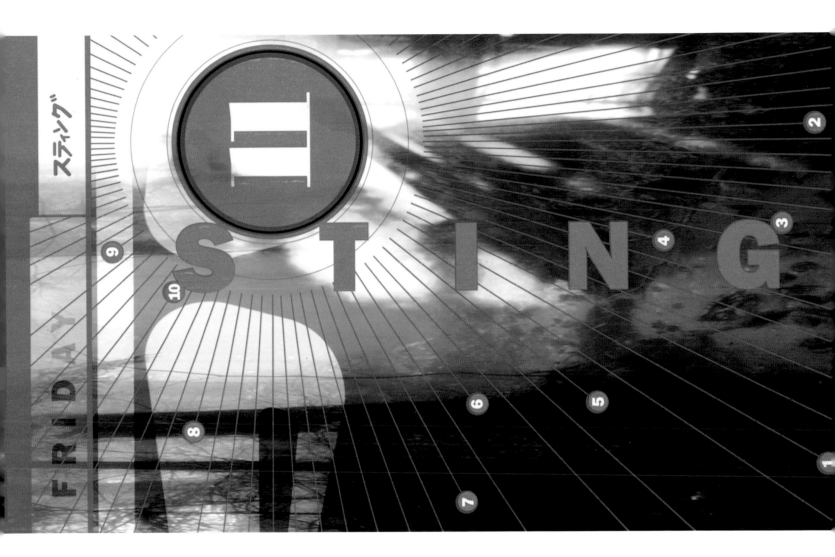

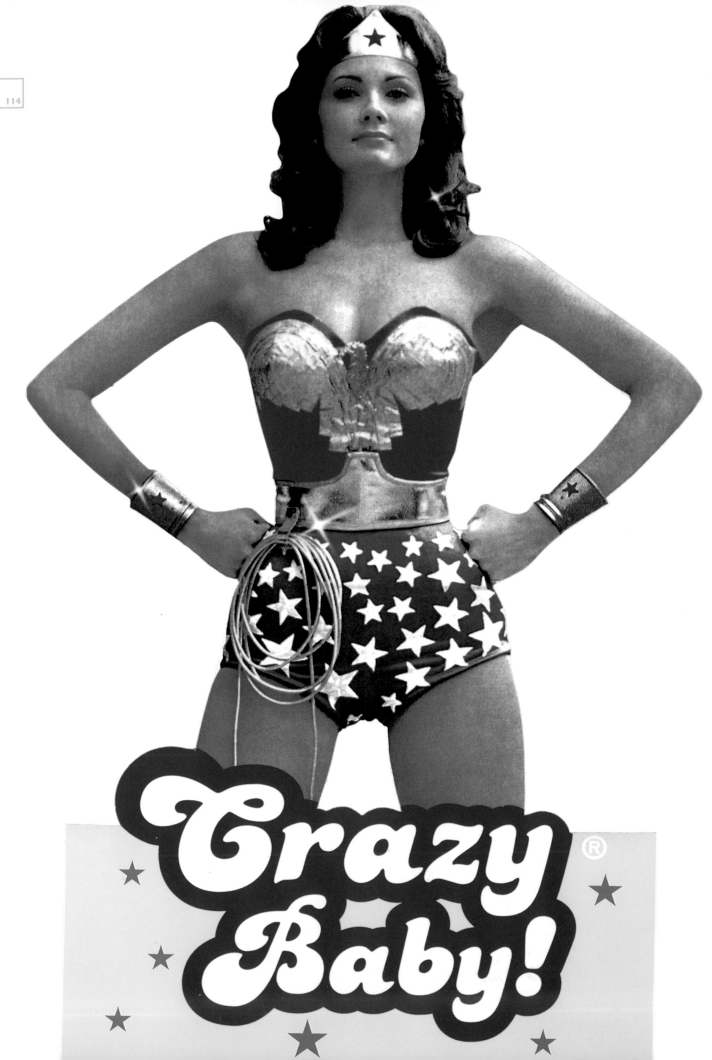

*Crazy Baby!® et le magazine 20ANS vous convient à la*

# JUNK-FOOD! PARTY

**VENDREDI 16 JUIN**
À PARTIR DE 1H

HOW TO EAT LIKE A REAL JAPANESE KID...

SEXY GIRLS LIVE ON STAGE!
SUPER HOSTESS BABY DIAMOND!

ONE NIGHT IN TOKYO WITH DJS KIMO, ALLAN, T. SCORDEL

FOLIES PIGALLE 11, PLACE PIGALLE PARIS 9È

わたし

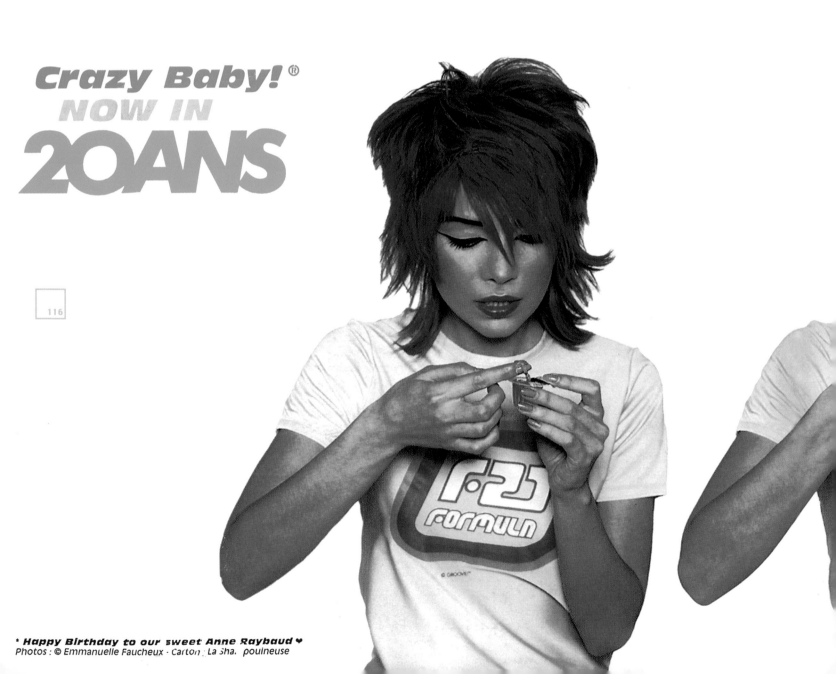

*Crazy Baby!*®
NOW IN
20ANS

116

FORMULA

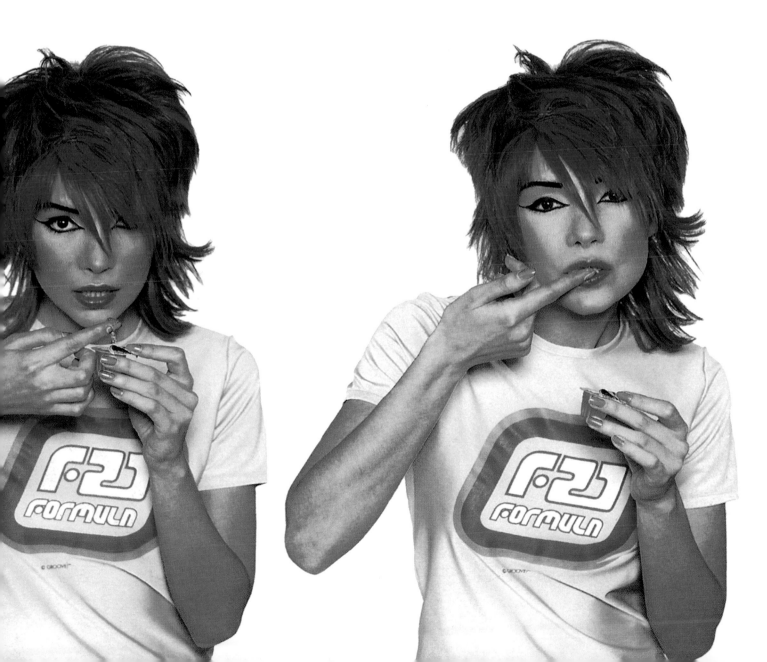

100 101 102 103 104 105 106 107
108 109 111
BUZZ @ THE CAPITOL BALLROOM
WASHINGTON DC. USA
DESIGN. AIRLINE INDUSTRIES

110 112
CLOUDWATCH @ THE UNDERGROUND PUB
WASHINGTON DC. USA
DESIGN. AIRLINE INDUSTRIES

113
STING II @ THE CAPITOL BALLROOM
WASHINGTON DC. USA
DESIGN. AIRLINE INDUSTRIES

114 115 116
CRAZY BABY @ THE FOLIES PIGALLE
PARIS. FRANCE
DESIGN. LA SHAMPOUINEUSE

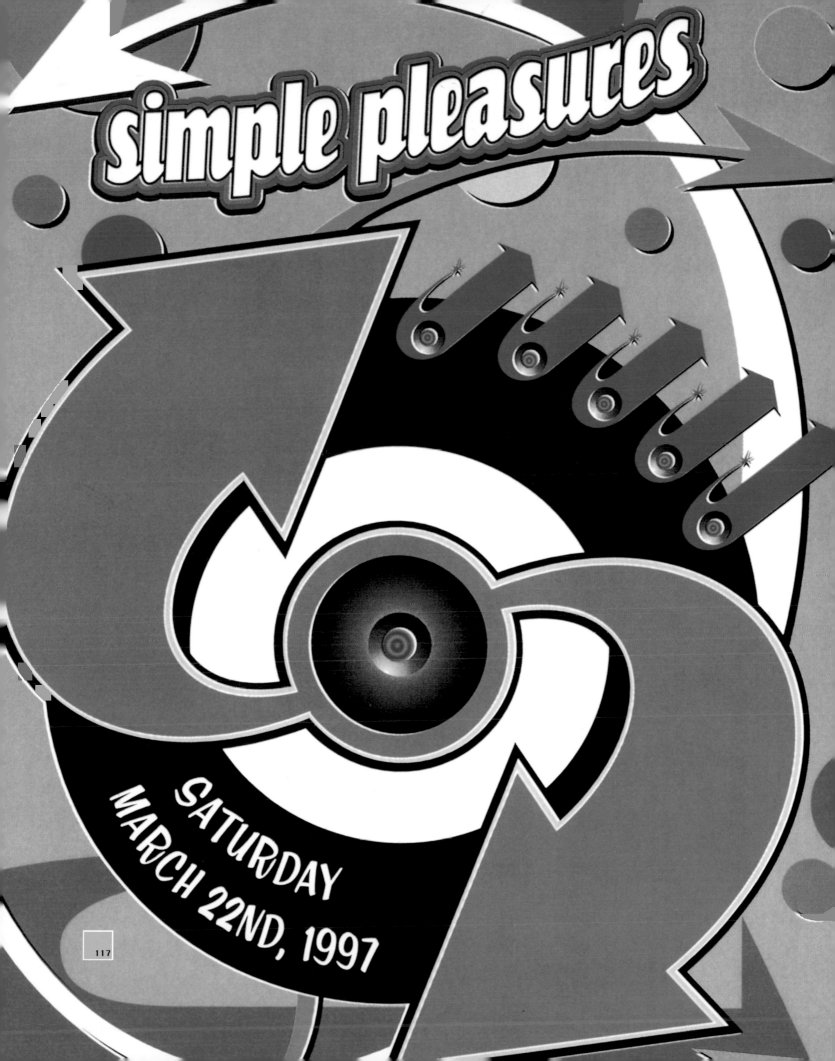

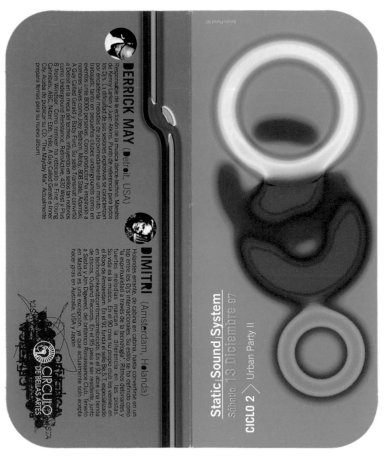

Static Sound System

Sábado 13 Diciembre 97

CICLO 2 > Urban Party II

**DERRICK MAY** (Detroit, USA)

Responsable de la eclosión de la música dance-techno. Maestro de Kenny Larkin y Juan Atkins. Punto de referencia para todos los DJ's. La dificultad de sus sesiones explosivas se caracterizan por encadenar melodías de aproximadamente un minuto. Ha trabajado tanto en pequeños clubes underground como en eventos ante 8000 personas. Como productor ha inspirado a nombres claves como Joey Beltram, Moby, 808 State, Atlantis, A Guy Called Gerald y Baby Ford. Su sello Transmat convirtió a Detroit en la meca del techno, influyendo en sellos tan notorios como Underground Ressistance, Retroactive, 430 West y Plus 8 from Windsor. Como remixer ha retocado a Fine Young Cannibals, ABC, Nitzer Ebb, Yello, A Guy Called Gerald e Inner City. Acaba de publicar su CD "The Mayday Mix". Actualmente prepara temas para su nuevo álbum.

**DIMITRI** (Amsterdam, Holanda)

Holandés errante, de cabina en cabina, hasta convertirse en un top entre los DJ's internacionales. Su estilo se ha definido como "la espiritualidad a través de la tecnología". Ritmos detonantes y fuertes melodías marcan la diferencia en las pistas. Su vida es la música. En el 90 crea su propio club los viernes en el Roxy de Amsterdam. En el 91 funda el sello Be.S.T. especializado en techno/minimal/contmncontreincto. En el 92 abre una tienda de discos, Outland Records. En el 95 pasa a ser residente, junto a Sasha y Jon Digweed, del británico Renaissance Club, teniendo en Madrid es una excepción, ya que actualmente solo acepta hacer giras en Australia, USA y Japón.

CIRCULO DE BELLAS ARTES

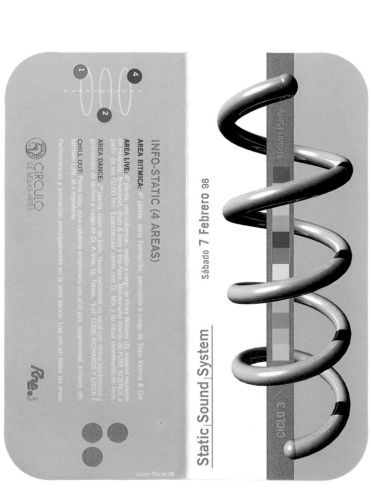

Static Sound System

Sábado 7 Febrero 98

CICLO 3 >

Urban Party

**INFO-STATIC (4 AREAS)**

**AREA RITMICA:** 4ª planta, zona fuentecilla, percusión a cargo de Sugu Varona & Cia.

**AREA LIVE:** 4ª planta, "sala columnas, sesión a cargo de Pinky Williams (DJ, español residente en Holanda) Breakbeat, drum & bass y trip-hop). Maratoniano directo de PURE SCIENCE a partir de las 02:00 hrs. Espectacular cierre con DJ. Mrk y su ritual movimiento Hi-Tech.

**AREA DANCE:** 2ª planta, salón de baile, house detonante no vocal con ritmos electrónicos principales de techno a cargo de DJ. A-Vela, DJ. Tolakes, "Evil" EDDIE RICHARDS Y ERICK E.

**CHILL OUT:** Planta baja, zona cafetería ambientada con acid jazz experimental, ambient, etc. Buffet libre. Te y repostería.

Performances y animación principalmente en la area dance. Live art en todas las áreas.

CIRCULO DE BELLAS ARTES

Rae.3

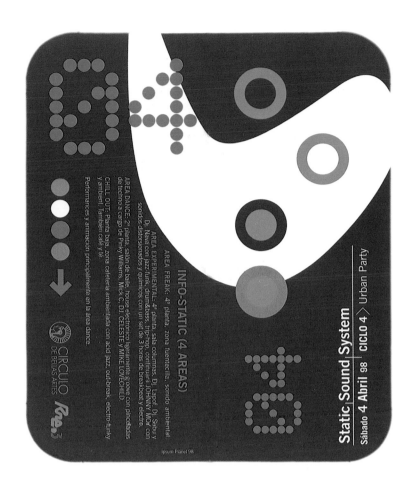

Ipsum Planet 98

Static Sound System
Sábado 4 Abril 98 | CICLO 4 ≫ Urban Party

INFO-STATIC (4 AREAS)

AREA FREAK: 4ª planta. zona fuentecilla, sonido ambiental.

AREA EXPERIMENTAL: 4ª planta, sala columnas. DJ Sabu y DJ Nava con jazz-funk, drum&bass, trip-hop, continuara JOHNNY MOï con sonidos distorsionados y químicos con un set de 3 horas de breakbeaty electro.

AREA DANCE: 2ª planta, salon de baile, house electronico ligeramente groove con pinceladas de techno a cargo de Pinky Williams. DJ Lapof, DJ Sabu y DJ Nava con jazz-funk, drum&bass, trip-hop, continuara JOHNNY MOï con

CHILL OUT: Planta baja, zona cafeteria ambientada con acid jazz, outbreak, electro-funky y ambient. También café y té.

Performances y animación principalmente en la area dance.

CIRCULO DE BELLAS ARTES Re.3

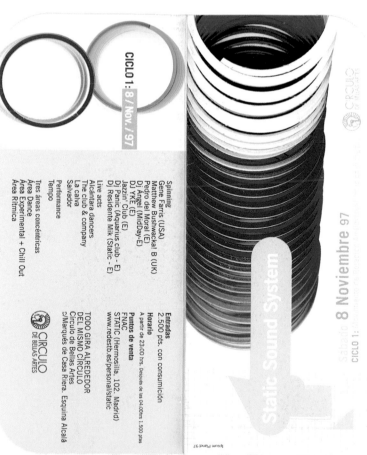

CICLO 1: 8 / Nov. / 97

Spinning
Gene Farris (USA)
Matthew Bushwacka! B (UK)
Pedro del Moral (E)
DJ Ángel (MidDay-E)
DJ YKÉ (E)
Jazzin' Club (E)
DJ Panic (Aquarius club - E)
DJ Residente Mik (Static - E)

Live acts
Alcántara dancers
The club & company
La caxa
Salvador
Performance
Tempo

Tres áreas concéntricas
Área Dance
Área Experimental + Chill Out
Área Rítmica

Entradas
2.500 pts, con consumición

Horario
A partir de 23:00 hrs. Después de las 04:00hrs 1.500 pts

Puntos de venta
FNAC
STATIC (Hermosilla, 102, Madrid)
www.redestb.es/personal/static

TODO GIRA ALREDEDOR
DEL MISMO CIRCULO
Círculo de Bellas Artes
c/Marqués de Casa Riera. Esquina Alcalá

CIRCULO DE BELLAS ARTES

Static Sound System
Sábado 8 Noviembre 97
CICLO 1:

Ipsum Planet 97

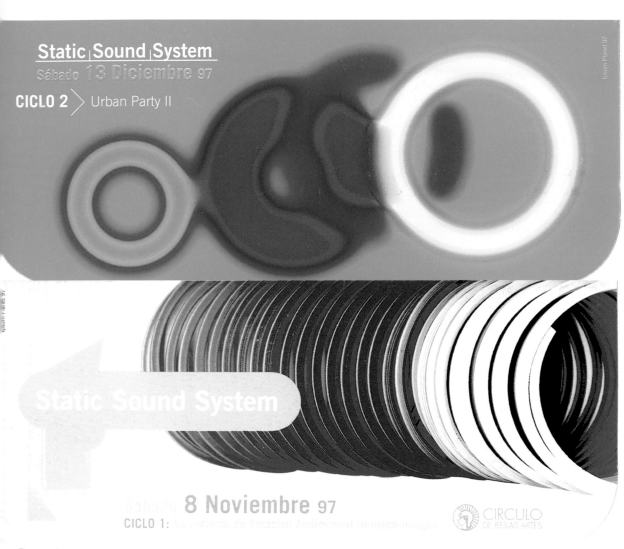

Static | Sound | System
Sábado 13 Diciembre 97

CICLO 2 > Urban Party II

Ixsum Planet 97

Static Sound System

Sábado 8 Noviembre 97
CICLO 1: Movimiento de Rotación Audiovisual (música-imagen)

CÍRCULO
DE BELLAS ARTES

Static | Sound | System      Sábado 7 Febrero 98

CICLO 3 >      Urban Party

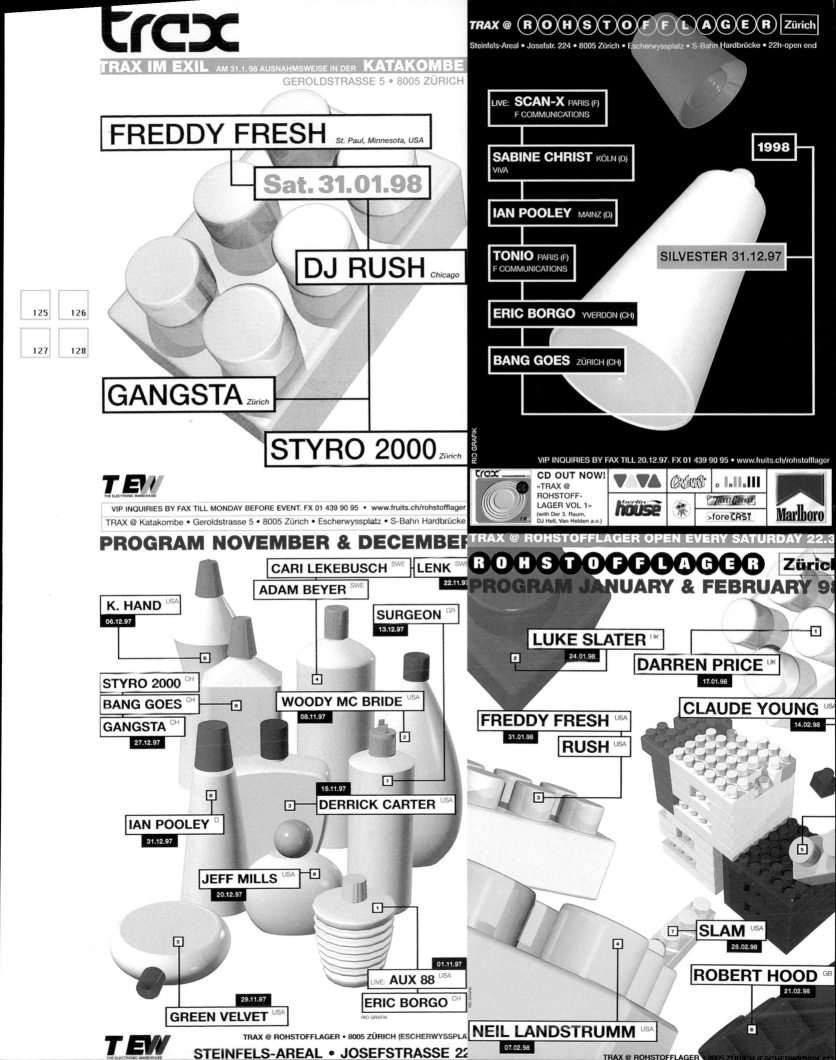

**trax**

TRAX IM EXIL AM 31.1.98 AUSNAHMSWEISE IN DER **KATAKOMBE**
GEROLDSTRASSE 5 • 8005 ZÜRICH

**FREDDY FRESH** St. Paul, Minnesota, USA

Sat. 31.01.98

**DJ RUSH** Chicago

**GANGSTA** Zürich

**STYRO 2000** Zürich

125    126

127    128

**T EW** THE ELECTRONIC WAREHOUSE

VIP INQUIRIES BY FAX TILL MONDAY BEFORE EVENT. FX 01 439 90 95 • www.fruits.ch/rohstofflager
TRAX @ Katakombe • Geroldstrasse 5 • 8005 Zürich • Escherwyssplatz • S-Bahn Hardbrücke

---

**TRAX @ ROHSTOFFLAGER** Zürich
Steinfels-Areal • Josefstr. 224 • 8005 Zürich • Escherwyssplatz • S-Bahn Hardbrücke • 22h-open end

LIVE: **SCAN-X** PARIS (F)
F COMMUNICATIONS

**SABINE CHRIST** KÖLN (D)
VIVA

**IAN POOLEY** MAINZ (D)

**TONIO** PARIS (F)
F COMMUNICATIONS

**ERIC BORGO** YVERDON (CH)

**BANG GOES** ZÜRICH (CH)

**1998**

SILVESTER 31.12.97

RID GRAFIK

VIP INQUIRIES BY FAX TILL 20.12.97. FX 01 439 90 95 • www.fruits.ch/rohstofflager

**trax** CD OUT NOW!
«TRAX @ ROHSTOFF-LAGER VOL 1»
(with Der 3. Raum, DJ Hell, Van Helden a.o.)

CaveUrs  D lr∥s∥I
berlin house  TICKET CORNER
>foreCAST  **Marlboro**

---

## PROGRAM NOVEMBER & DECEMBER

**CARI LEKEBUSCH** SWE    **LENK** SWE
22.11.97

**ADAM BEYER** SWE

**K. HAND** USA
06.12.97

**SURGEON** GR
13.12.97

6

**STYRO 2000** CH

**BANG GOES** CH    9

**GANGSTA** CH
27.12.97

**WOODY MC BRIDE** USA
08.11.97

4

2

0

**IAN POOLEY** D
31.12.97

7

15.11.97

3  **DERRICK CARTER** USA

**JEFF MILLS** USA    8
20.12.97

1

5

01.11.97

LIVE: **AUX 88** USA

29.11.97

**GREEN VELVET** USA    **ERIC BORGO** CH
RIO GRAFIK

**T EW** THE ELECTRONIC WAREHOUSE    TRAX @ ROHSTOFFLAGER • 8005 ZÜRICH (ESCHERWYSSPLA
**STEINFELS-AREAL • JOSEFSTRASSE 22**

---

TRAX @ ROHSTOFFLAGER OPEN EVERY SATURDAY 22.3

**ROHSTOFFLAGER** Zürich

## PROGRAM JANUARY & FEBRUARY 98

**LUKE SLATER** UK
2    24.01.98

1

**DARREN PRICE** UK
17.01.98

**FREDDY FRESH** USA
31.01.98

**RUSH** USA

**CLAUDE YOUNG** USA
14.02.98

3

5

7    **SLAM** USA
28.02.98

4

**ROBERT HOOD** GB
21.02.98

**NEIL LANDSTRUMM** USA
07.02.98

6

RIO GRAFIK

TRAX @ ROHSTOFFLAGER • 8005 ZÜRICH (ESCHERWYSSPL

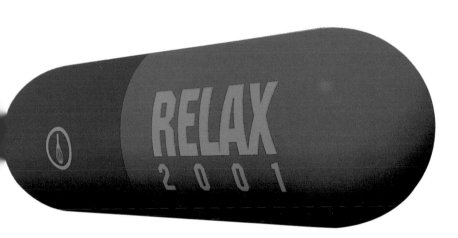

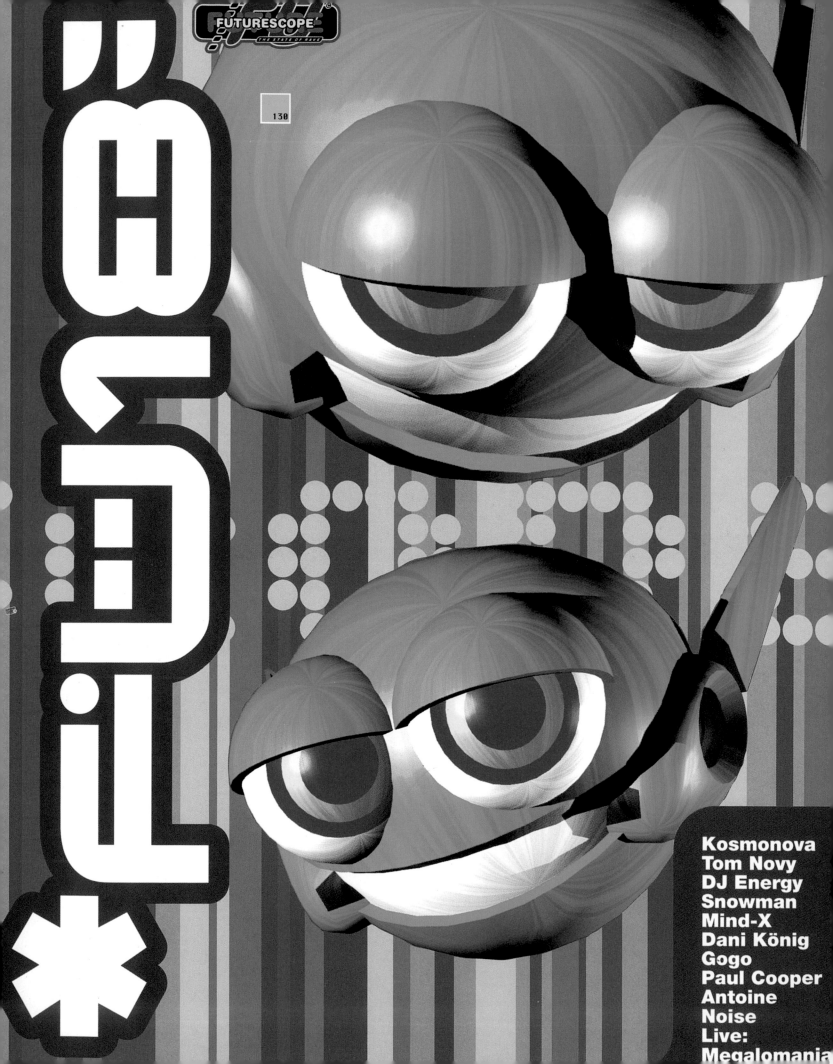

Kosmonova
Tom Novy
DJ Energy
Snowman
Mind-X
Dani König
Gogo
Paul Cooper
Antoine
Noise
Live:
Megalomania

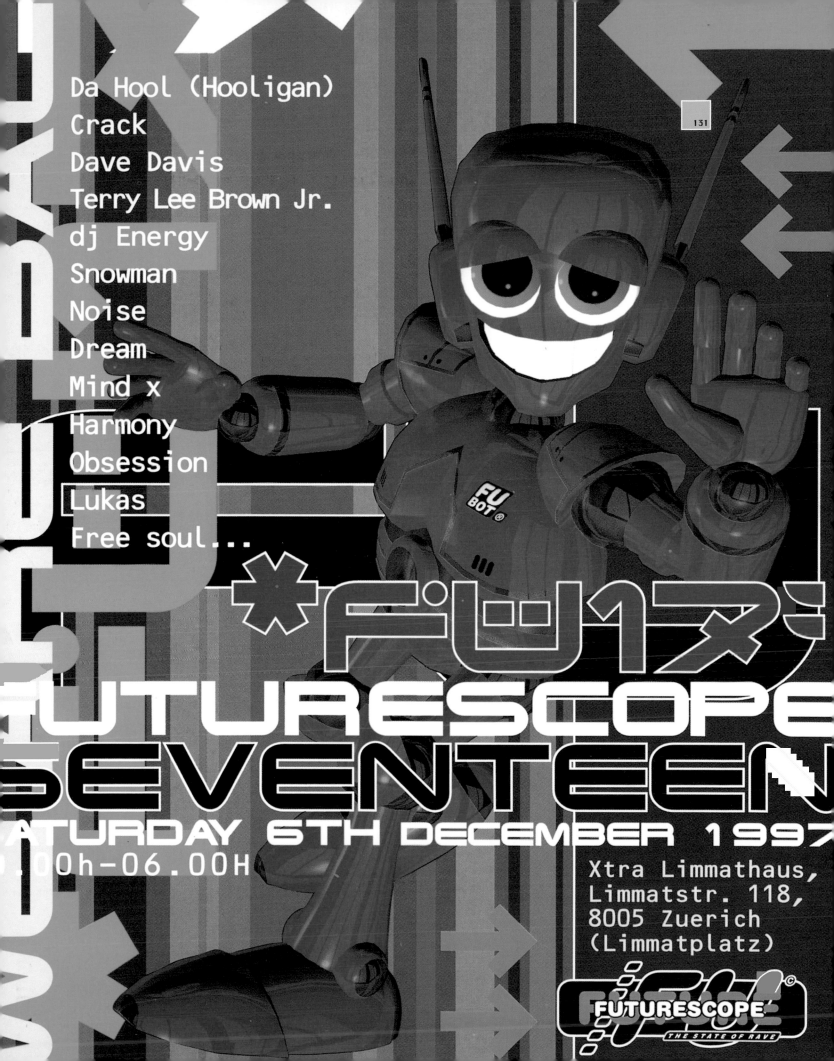

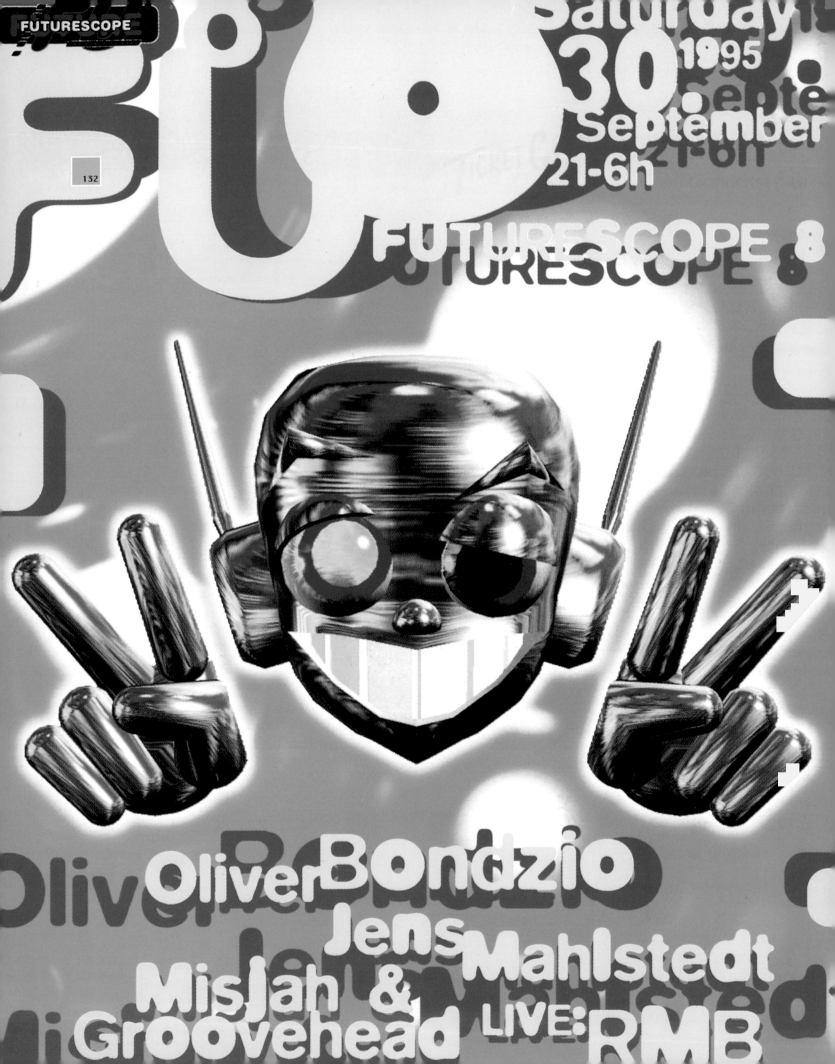

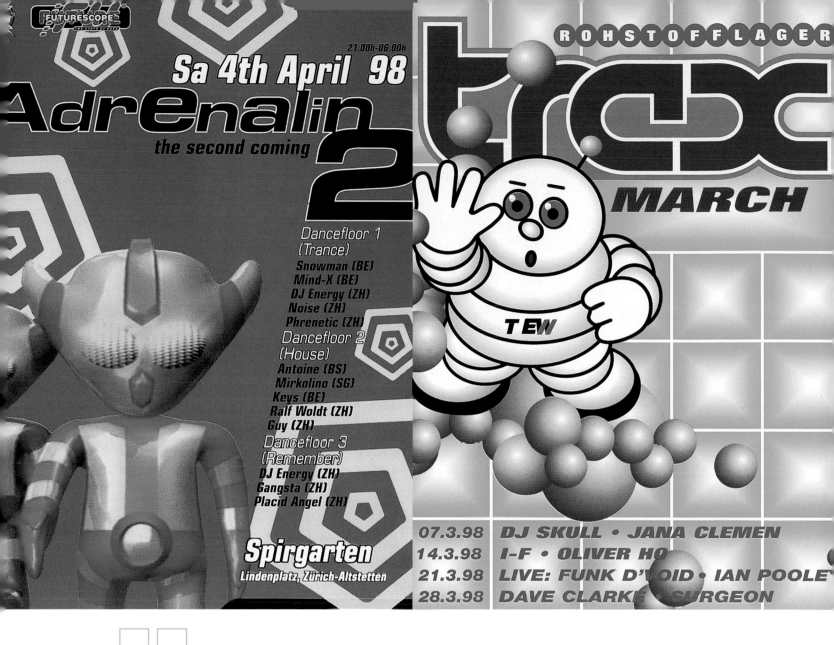

FUTURESCOPE

**21.00h-06.00h**

## Sa 4th April 98
# Adrenalin
### the second coming
# 2

ROHSTOFFLAGER

# trax
## MARCH

**Dancefloor 1
(Trance)**
Snowman (BE)
Mind-X (BE)
DJ Energy (ZH)
Noise (ZH)
Phrenetic (ZH)

**Dancefloor 2
(House)**
Antoine (BS)
Mirkolino (SG)
Keys (BE)
Ralf Woldt (ZH)
Guy (ZH)

**Dancefloor 3
(Remember)**
DJ Energy (ZH)
Gangsta (ZH)
Placid Angel (ZH)

# Spirgarten
**Lindenplatz, Zürich-Altstetten**

| | |
|---|---|
| 07.3.98 | DJ SKULL • JANA CLEMEN |
| 14.3.98 | I-F • OLIVER HO |
| 21.3.98 | LIVE: FUNK D'VOID • IAN POOLE |
| 28.3.98 | DAVE CLARKE • SURGEON |

133  134

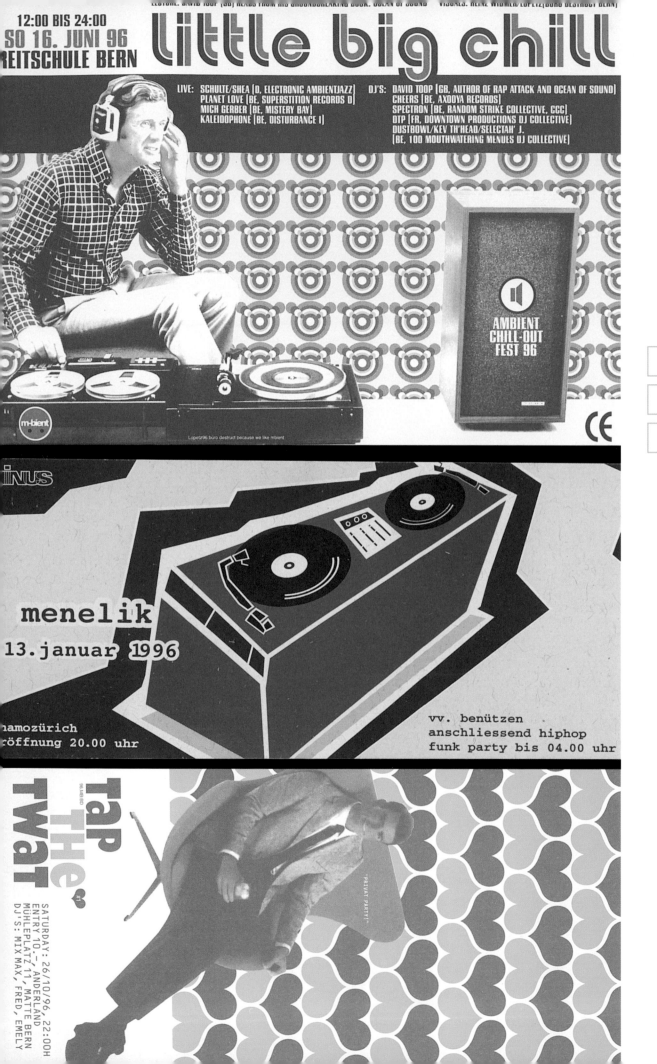

**12:00 BIS 24:00**
**SO 16. JUNI 96**
**REITSCHULE BERN**

# little big chill

LIVE: SCHULTE/SHEA [D, ELECTRONIC AMBIENTJAZZ]
PLANET LOVE [BE, SUPERSTITION RECORDS D]
MICH GERBER [BE, MISTERY BAY]
KALEIDOPHONE [BE, DISTURBANCE I]

DJ'S: DAVID TOOP [GB, AUTHOR OF RAP ATTACK AND OCEAN OF SOUND]
CHEERS [BE, AXODYA RECORDS]
SPECTRON [BE, RANDOM STRIKE COLLECTIVE, CCC]
DTP [FR, DOWNTOWN PRODUCTIONS DJ COLLECTIVE]
DUSTBOWL/KEV TH'HEAD/SELECTAH' J.
[BE, 100 MOUTHWATERING MENUES DJ COLLECTIVE]

AMBIENT CHILL-OUT FEST 96

Lopetz96 büro destruct because we like mbient

m-bient

CE

135

136

137

menelik

13. januar 1996

hamozürich
eröffnung 20.00 uhr

vv. benützen
anschliessend hiphop
funk party bis 04.00 uhr

TaP THe TWaT

SATURDAY: 26/10/96, 22:00H
ENTRY 10.– ,ANDERLAND
MÜHLEPLATZ 11, MATTE BERN
DJ'S: MIX MAX, FRED, EMELY

"PRIVAT PARTY!"

NO GUEST

NO GUEST

| 138 | 140 |
| 139 | 141 |

NO GUEST

NO GUEST

DANCE SE DESPIDE HASTA SEPTIEMBRE

VOL.2

dance

1 J. L. MAGOYA · 2 ANGEL DJ.

BD972

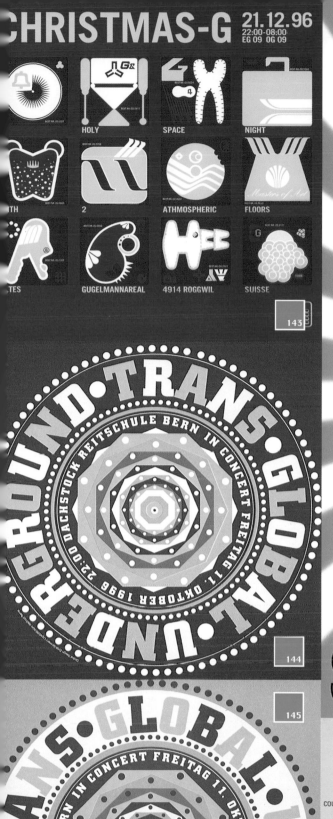

21.12.96
22:00-08:00
EG 09  OG 09

HOLY

SPACE

NIGHT

TH

2

ATHMOSPHERIC

FLOORS

TES

GUGELMANNAREAL

4914 ROGGWIL

SUISSE

143

TRANS · GLOBAL · UNDERGROUND
DACHSTOCK REITSCHULE BERN IN CONCERT FREITAG 11. OKTOBER 1996 22:00

144

145

TRANS · GLOBAL · UNDERGROUND
DACHSTOCK REITSCHULE BERN IN CONCERT FREITAG 11. OKTOBER 1996 22:00

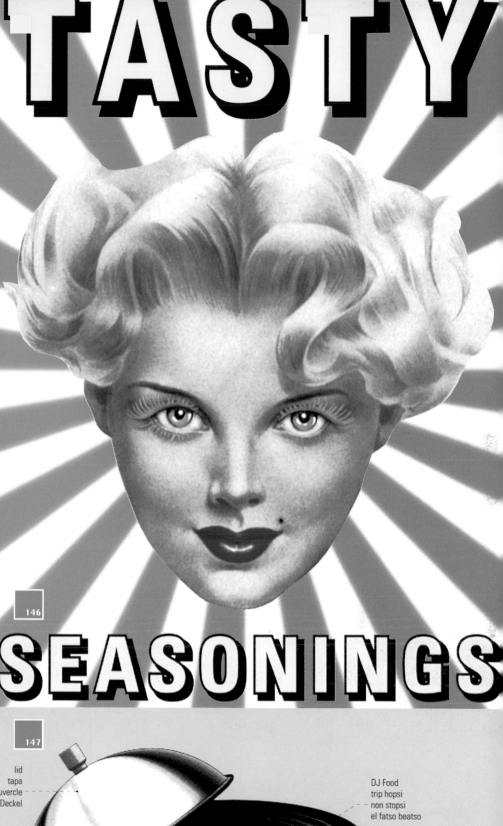

# TASTY

146

# SEASONINGS

147

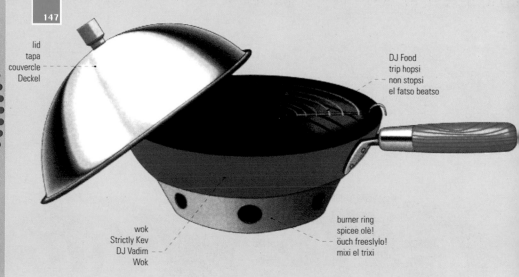

lid
tapa
couvercle
Deckel

DJ Food
trip hopsi
non stopsi
el fatso beatso

wok
Strictly Kev
DJ Vadim
Wok

burner ring
spicee olè!
öuch freeslylo!
mixi el trixi

# fuse

## has a new face for you
## SATURDAY 19TH OCTOBER

148

**PHI-PHI**

**DIMITRI**

**BENJAMIN**

**YOU**

## TOP *FLOOR* Hosted by Jan Bizar

**DENIS**

**KOENIE**

**PIERRE**

**JAN B..**

SPI 22 MARCH

Rue Blaesstraat 208 — 1000 BRUSSELS
Info : 02/511 97 89     D.A. : Benjamin

Entrance     300 bef*
*free entrance between 22h and 23h

208 rue Blaesstraat 1000 Brussels
info: 02/ 511.97.89

Sourire
DE LOT:96B29
EP DATE:02/99
Smile
Sourire

be fuse be safe

149

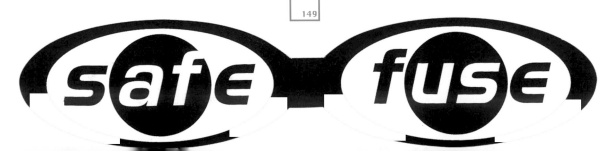

## safe fuse

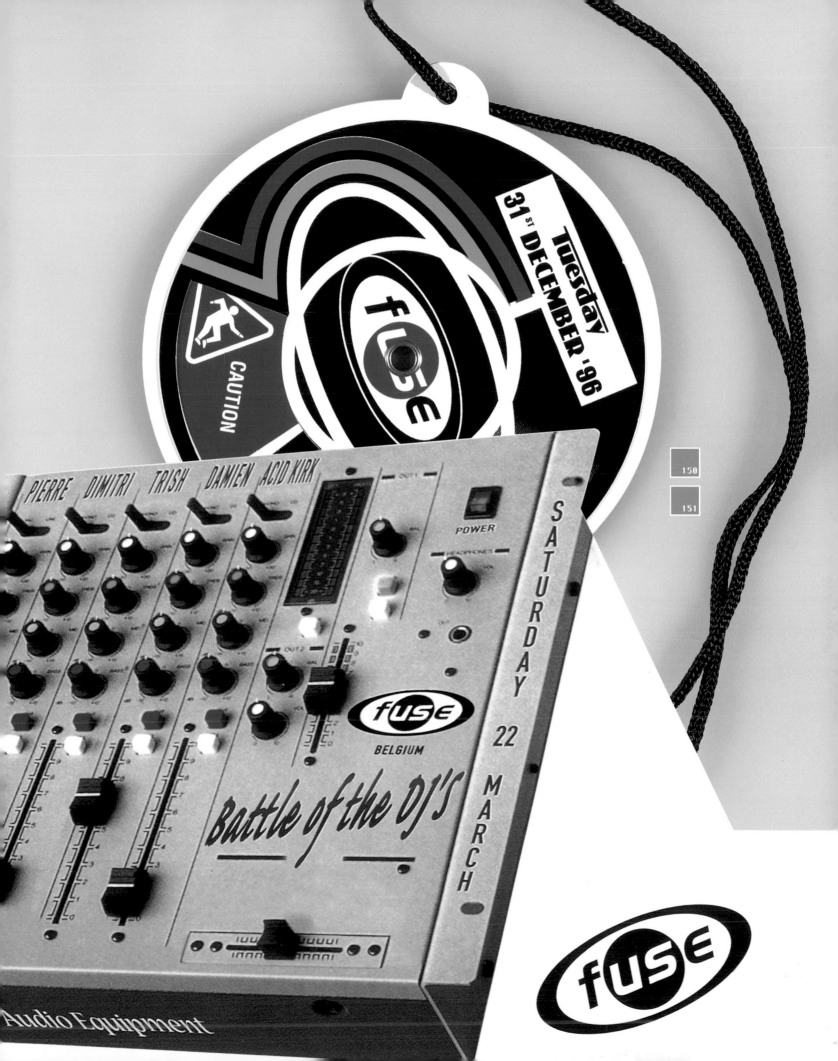

## 5 star clubbing

97
(intro)

F U    (Fuse'20.04.77;)

152

TAKE OFF FOIL
PUT TATTOO ON ARM
MAKE WET
KEEP DURING I MIN ON ARM

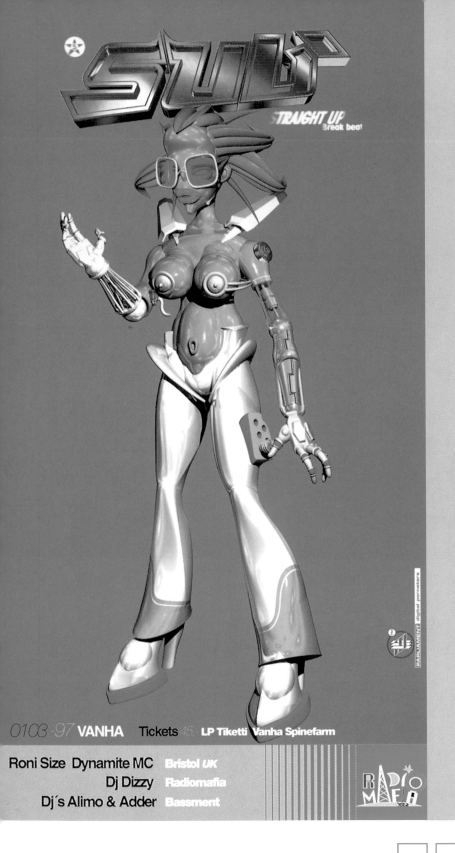

STRAIGHT UP
Break beat

0103-97 **VANHA**    Tickets *45,*    **LP Tiketti Vanha Spinefarm**

**Roni Size  Dynamite MC**   **Bristol** *UK*
**Dj Dizzy**   **Radiomafia**
**Dj´s Alimo & Adder**   **Bassment**

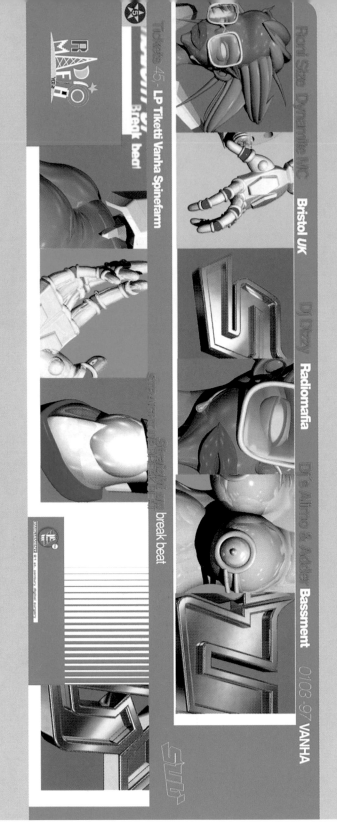

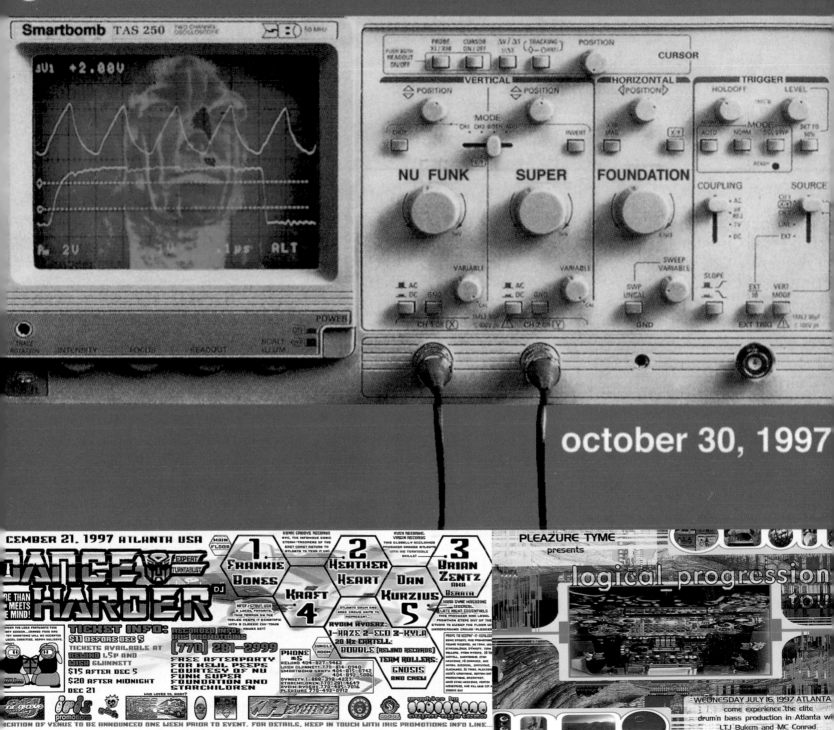

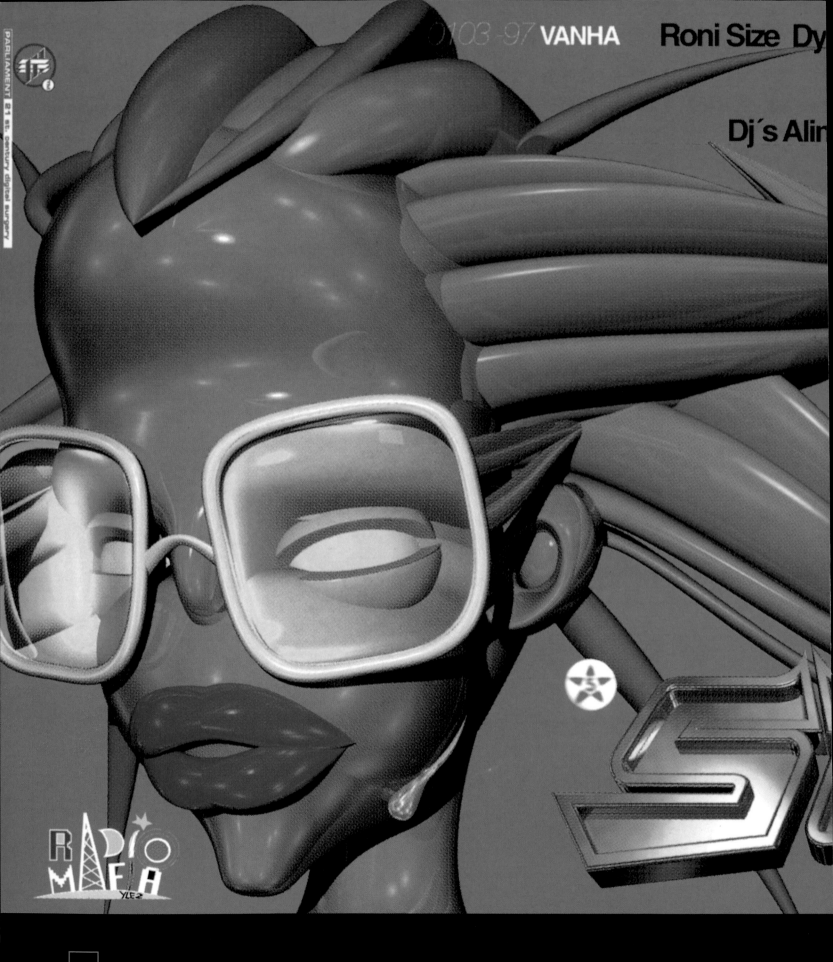

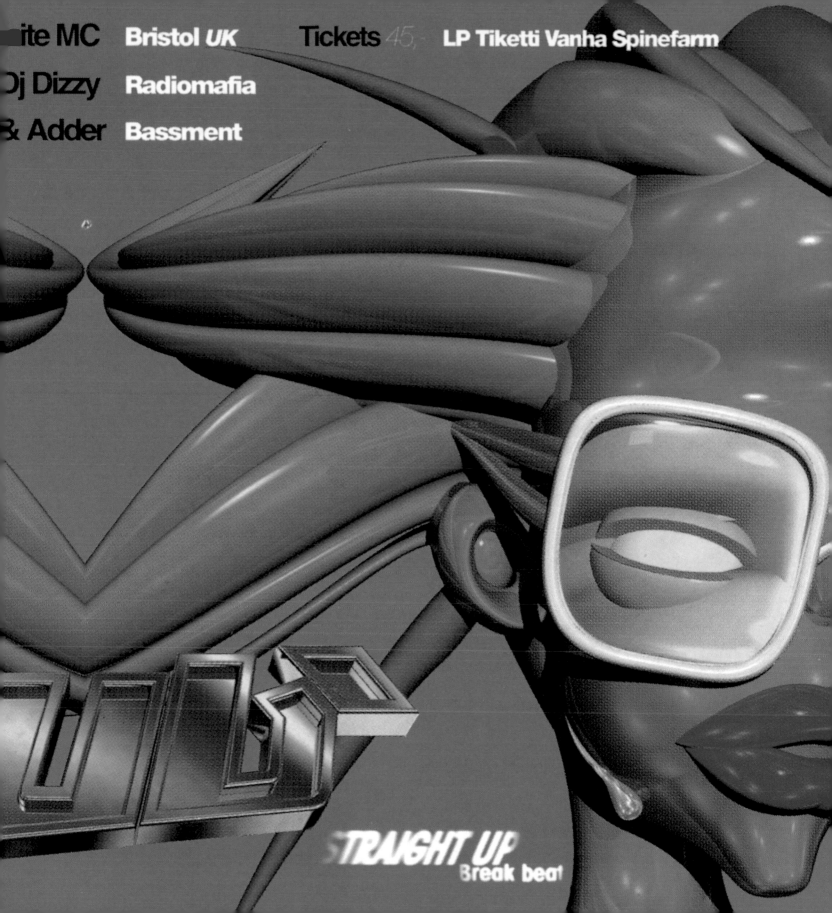

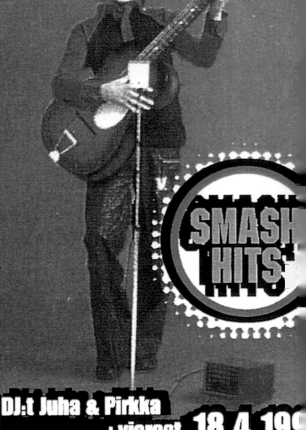
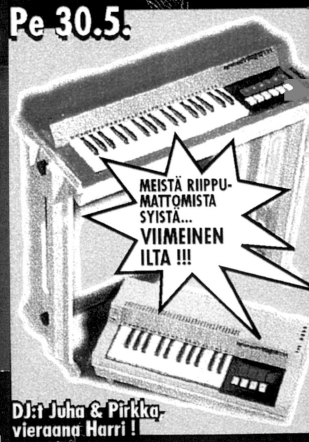

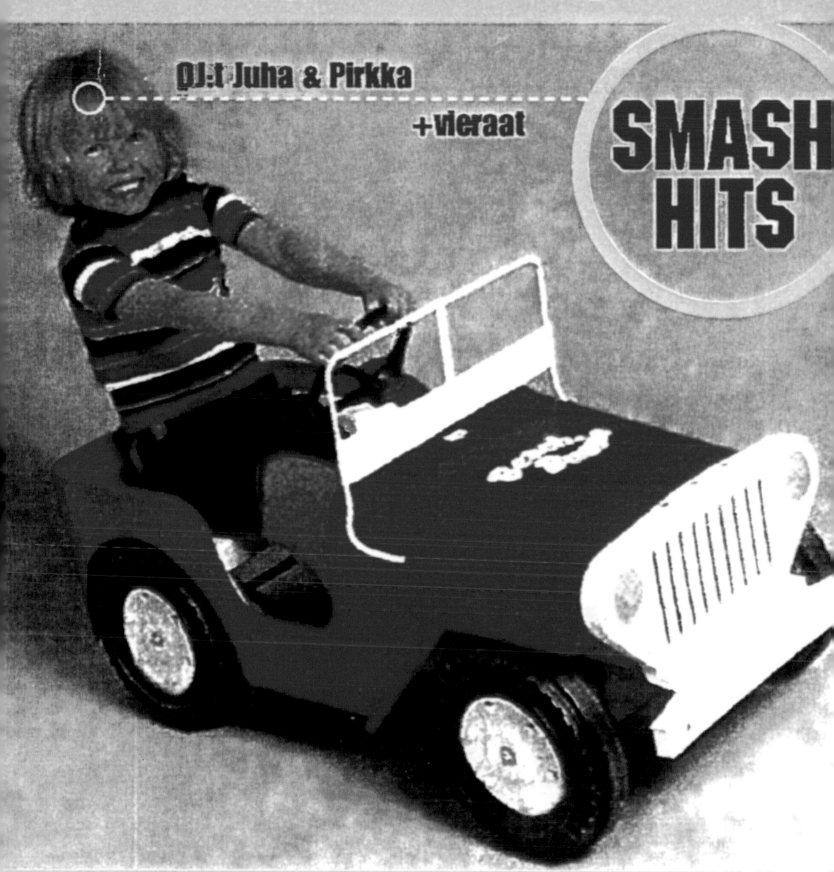

.YT SE ALKAA!!! Räjähtävä uusi klubi pe 4.4. alkaen.

DJ:t Juha & Pirkka

+vieraat

# SMASH HITS

Liput 20mk • 50:lle Ensimmäiselle ilmaiseksi SMASH HITS -kasett

Naurettavan halpa olut ja salmari klo 22-23

Stonewall Eerikinkatu 3 joka toinen perjantai klo 22-04

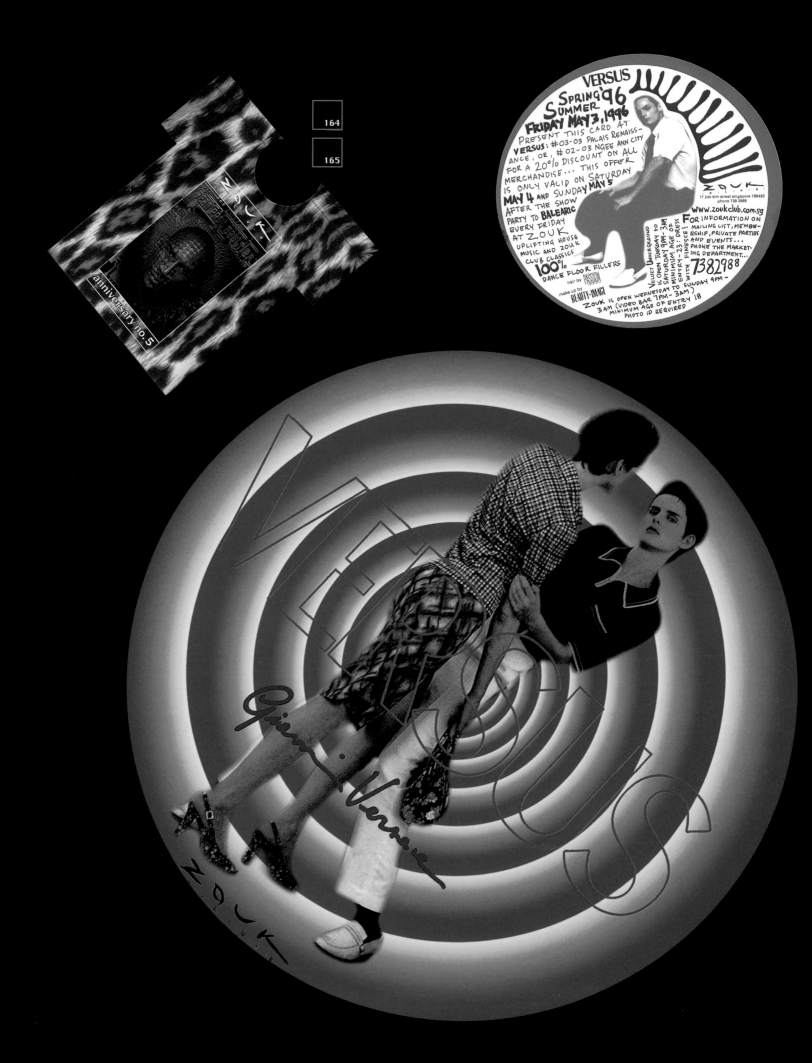

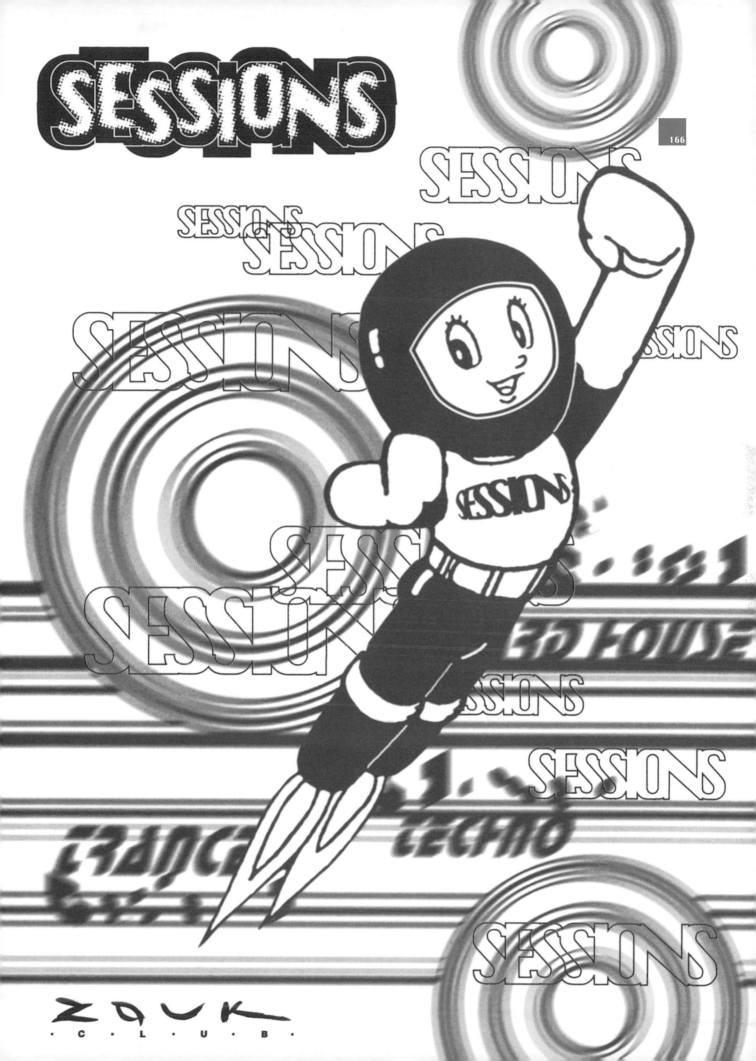

**Steroid abuse**

presents with *"no appointment necessary"* a night called

# Top Barnet

on **Saturday 6th December**
at **The Betsey Trotwood**
**56 Farringdon Rd London EC1**
(Opposite The Guardian)

**7pm till late**
**Admission £4**
*Farringdon Tube*
Buses: 63, 45, 19

### FEATURING TOP UNI-SEX STYLING FROM

**Chris Madden & Moose**
*Soundclash razor repairs & spares, Leeds*

**John Sweeney "Todd"**
*Doing damage in the barbers chair*

**Phil Mison**
*Feather cuts and ambient fringes*

**Ben Herr**
aka *"The scizzors from Stockwell"*

Features include:
- Perms, flat tops and french cuts
- An array of well thumbed, out of date, car and gardening magazines
- The first ever performance of *The Steroid Abuse Barbershop Trio* performing the classic *"and would you like something on it sir?"*
- Amateur cut-throat shaving display and "Denim" aftershave promotion*

*Reduced rates for Senior Citizens & Taxi Drivers*
*Subject to availability*

**Steroid abuse**

and **One Deck & Popular** *as the Saturday boys*

Present their **1st Birthday Party with**

# A NIGHT IN THE RING

**Saturday 22nd February 1997**
**7.30pm – 1am**
at **The Little Litten**
**Bowling Green Lane**
**London EC1**
**Tickets/Door: £3**

an evening featuring top tag action from

**The Rhythm Doctor**
*(Mama Records, London)*
*versus*
**Chris Madden & Moose**
*(Soundclash, Leeds)*
*versus*
**'One Deck & Popular'**
Pete     Steve K.
*(Ex-Camberwell Bus Garage)*
*versus*
**Sticky Steve**
*(Ministry of Vodka)*

*Featuring attractions like*
◆ **Full wedding reception catering***
◆ **Professional size wrestling ring***
◆ **Top DJ's and friendly barstaff**
◆ **Toilets and Dancefloor**
◆ **Security by *Cauliflower Ears***
*Subject to availability

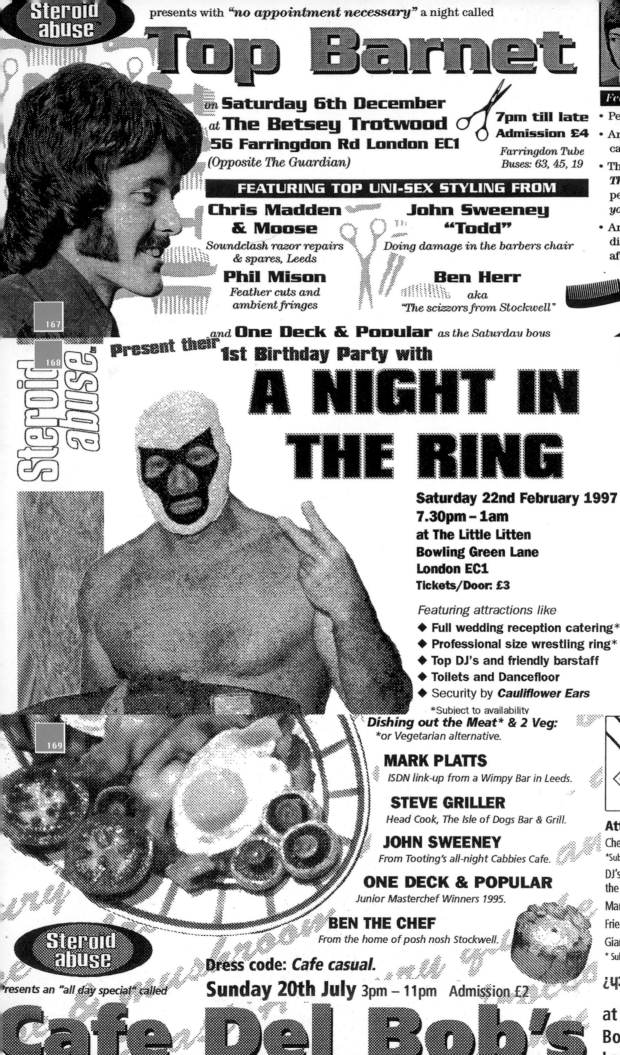

**Dishing out the Meat* & 2 Veg:**
**or Vegetarian alternative.*

**MARK PLATTS**
*ISDN link-up from a Wimpy Bar in Leeds.*

**STEVE GRILLER**
*Head Cook, The Isle of Dogs Bar & Grill.*

**JOHN SWEENEY**
*From Tooting's all-night Cabbies Cafe.*

**ONE DECK & POPULAR**
*Junior Masterchef Winners 1995.*

**BEN THE CHEF**
*From the home of posh nosh Stockwell.*

Nearest Tube:
**Farringdon**
Buses: **63, 45, 19**

**Attractions:**
Cheap Bevvy and Top Buffet (including Pork Pies*)
*Subject to availability in Sainsbury's
DJ's playing top ambient rock tunes to accompany the legendary EC1 sunset
Marathon acoustic guitar and bongo jam session
Friendly barstaff, top glass collector and clean toilets
Giant sized paddling pool and foam filled dancefloor
* Subject to availability

**Steroid abuse**

presents an "all day special" called

# Cafe Del Bob's

Dress code: *Cafe casual.*

**Sunday 20th July** 3pm – 11pm   Admission £2

Why not have a sausage sandwich?

at **The Little Litten**
**Bowling Green Lane**
**London EC1**

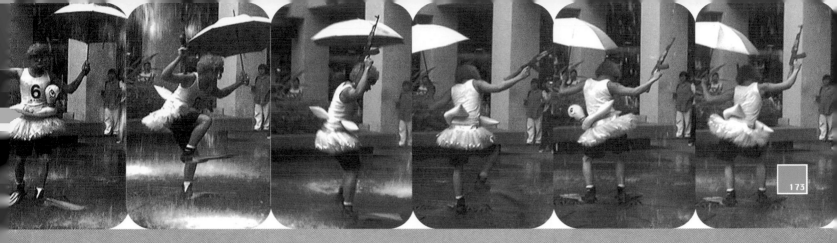

# Better Eccentric Etiquette

*the essential guide*

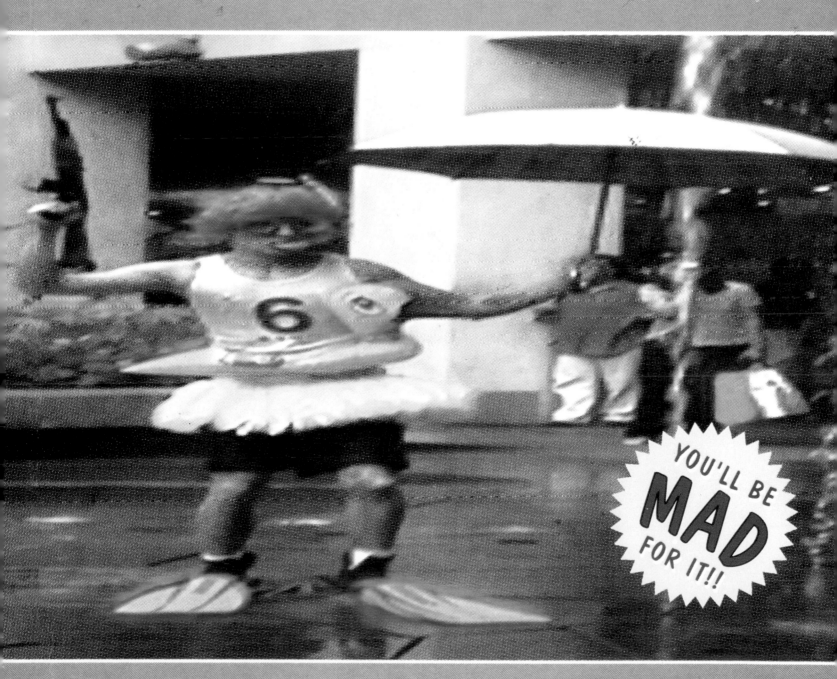

YOU'LL BE MAD FOR IT!!

ZOUK

markus weisbeck

samstag 15. oktober · 23.00 uhr · kaiserstraße 74 · frankfurt am meer

100% acid sex

dj anthony - delicious doughnuts berlin

lissania
essay

Einlaß nur mit dieser Karte · gültig für zwei Personen

174  175

176

markus weisbeck

graphic: markus weisbeck

lissania samst

einlaß nur mit dieser einladung · gültig für zwei pers

shantel «club guerilla» the bri

lissania
essay

Lissania e
Kaiserstraße 74
Frankfurt am Main

DJ's · Dan & Shantel · Elixier vitae · Obstsalat · Kuchen · Chadiya · Oliven · Purde

Einlaß nur mit dieser Einladung · gültig für zwei Personen   Samstag · 12. März · 2

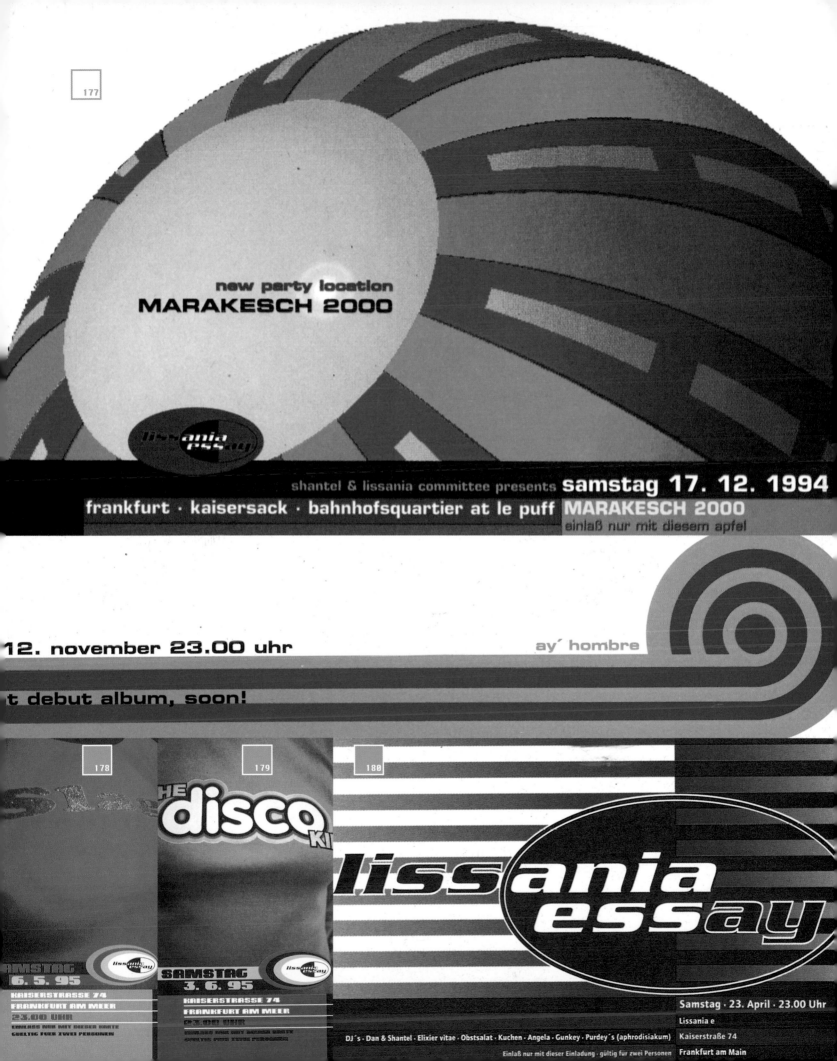

new party location
MARAKESCH 2000

lissania essay

shantel & lissania committee presents **samstag 17. 12. 1994**
frankfurt · kaisersack · bahnhofsquartier at le puff **MARAKESCH 2000**
einlaß nur mit diesem apfel

12. november 23.00 uhr          ay´hombre

t debut album, soon!

THE disco KI

lissania essay

**lissania essay**

AMSTAG
6. 5. 95
KAISERSTRASSE 74
FRANKFURT AM MEER
23.00 UHR
EINLASS NUR MIT DIESER KARTE
GUELTIG FUER ZWEI PERSONEN

SAMSTAG
3. 6. 95
KAISERSTRASSE 74
FRANKFURT AM MEER
23.00 UHR
EINLASS NUR MIT DIESER KARTE
GUELTIG FUER ZWEI PERSONEN

DJ´s · Dan & Shantel · Elixier vitae · Obstsalat · Kuchen · Angela · Gunkey · Purdey´s (aphrodisiakum)

Einlaß nur mit dieser Einladung · gültig für zwei Personen

Samstag · 23. April · 23.00 Uhr

Lissania e

Kaiserstraße 74

Frankfurt am Main

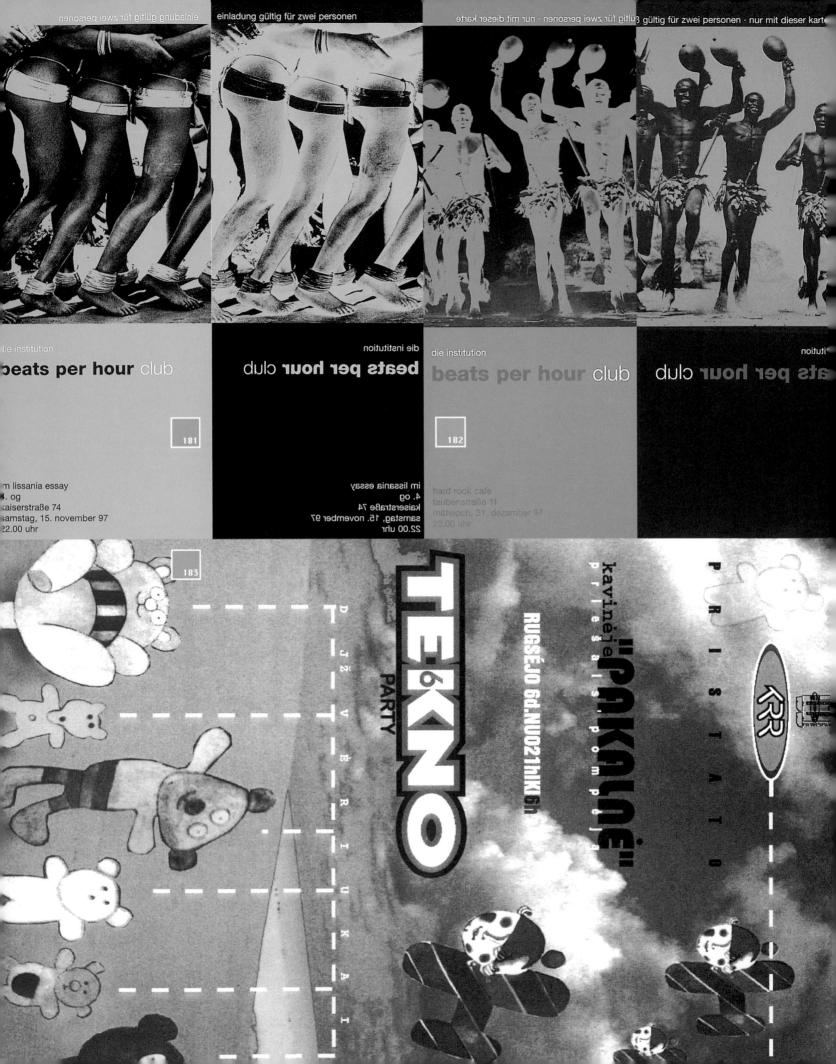

beats per hour club

die institution

beats per hour club

die institution

beats per hour club

club

**181**

**182**

im lissania essay

4. og

kaiserstraße 74

samstag, 15. november 97

22.00 uhr

im lissania essay

4. og

kaiserstraße 74

samstag, 15. november 97

22.00 uhr

hard rock cafe

taubenstraße 11

mittwoch, 31. dezember 97

22.00 uhr

**183**

TEKNO PARTY

kavinéje priešais pompėja

RUGSĖJO 6d.NU021h1Ki6h

"PAKUNĖ"

PRISTATO

RRR

kavinė 'PAKALNĖ'
PRIEŠAIS POMPĖJĄ
Įėjimas iš Putvinsklo g-vės

ry ralio

gegužės 10d.

nuo disko iki disko

+huosėteknoacid ect.

aikas : 21h=6h

su džiu

vietimu=7lt

e jo=20lt

riky=5lt

184

---

185

kavinė 'PAKALNĖ'
(priešais Pompėją)
PRAMPROJEKTAS
Įėjimas iš putvinsklo g-vės

balandžio 19d.

pradžia 21.00h

tekkno naktis su

su šiuo kvietimu

7lt

be jo

20lt

where the story ends, life begin´s

27. dezember · 22.00 uhr
lissania essay · kaiserstraße 74
frankfurt am main

here comes one and one makes one

7. februar · 22.00 uhr
lissania essay · kaiserstraße 74
frankfurt am main

essay

l'amour looks something like you

21. februar · 22.00 uhr
lissania essay · kaiserstraße 74
frankfurt am main

188
189
190
191

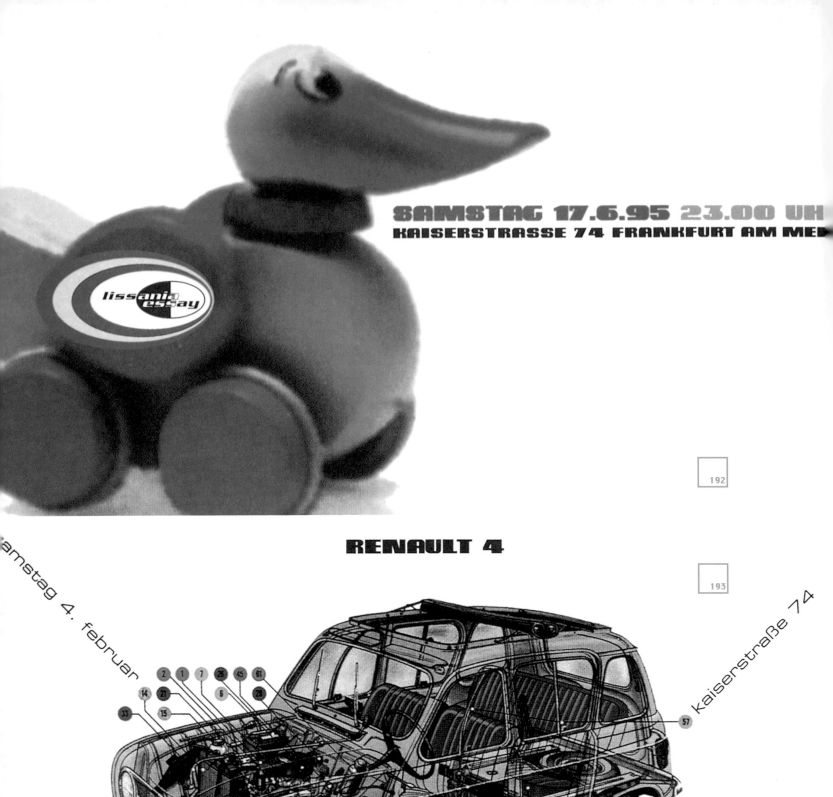

**SAMSTAG 17.6.95 23.00 UH**
**KAISERSTRASSE 74 FRANKFURT AM MED**

192

# RENAULT 4

193

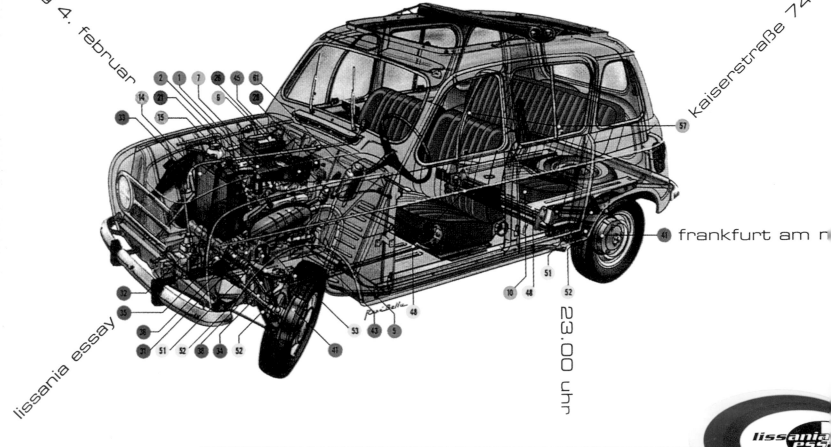

**einlaß nur mit dieser karte · gültig für zwei personen**

lissania essay

194

SAMSTAG 1.7.95 23.00 UHR

KAISERSTRASSE 74

FRANKFURT AM MEER

LISSANIA ESSAY

EINLASS NUR MIT DIESER KARTE GUELTIG FUER ZWEI PERSONEN

lissania essay

R:evolution (Presents) f Party 1
# LIGHTER THAN AIR
Richard Farmer > Downstairs
D.J. T.I.M. > Upstairs

Sat, 7th December @ Ponsonby Racket Club

## LIGHTER THAN AIR

"Everything that flies is lighter than air," remarked Monsieur Mouche.

"I hate to contradict you," said a scientist, "but that is not true. Birds are heavier than air."

"How do you know?" asked Monsieur Mouche.

"I weighed one," answered the scientist.

"But was it flying when you weighed it?" asked Monsieur Mouche.

$5.00 @

Jervois Rd
Blake St
Sheehan St

The Year of the Ra

ZOUK
17 JIAK KIM STREET SINGAPORE 169420 TELEPHONE 738 2988

guest dj nicky holloway
(london) feb 16-20

chinese new year 199

195

196

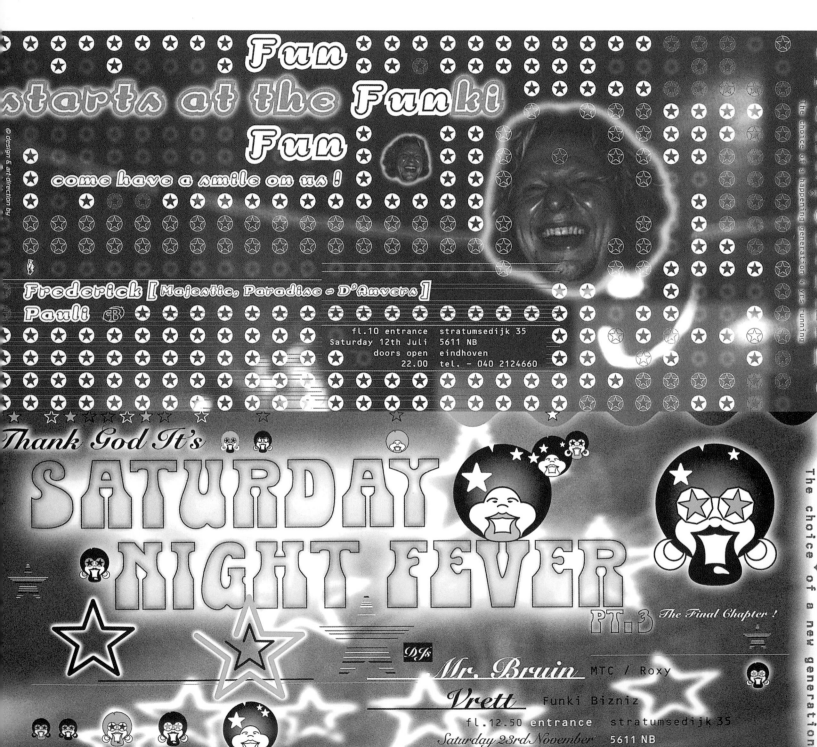

Fun
starts at the Funki
Fun

come have a smile on us !

Frederick [ Majestic, Paradise - D'Anvers ]
Pauli

fl.10 entrance    stratumsedijk 35
Saturday 12th Juli    5611 NB
doors open    eindhoven
22.00    tel. - 040 2124660

© design & art-direction by

FUNKIBIZNIZ BY
The choice of a happening generation 4 yrs running

Thank God It's
SATURDAY
NIGHT FEVER
PT.3    The Final Chapter !

DJs
Mr. Bruin    MTC / Roxy
Vrett    Funki Bizniz

fl.12.50 entrance    stratumsedijk 35
Saturday 23rd November    5611 NB
doors open    eindhoven
22.00    t 040 2124660

dress code - show you feel da' Funk !

FUNKIBIZNIZ BY
The choice of a new generation

23 11 5    05

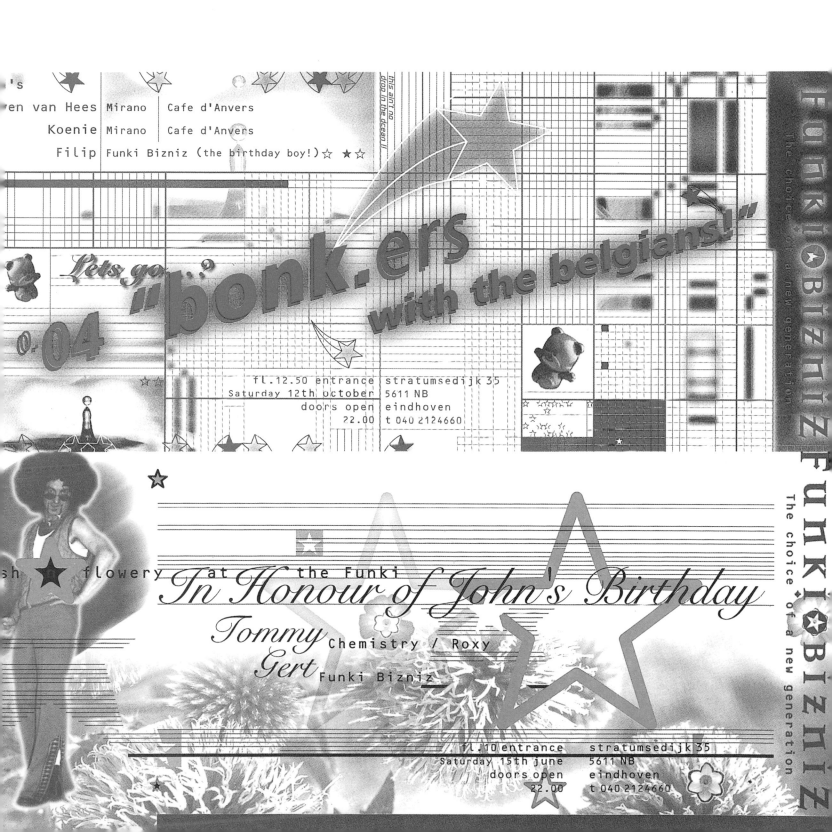

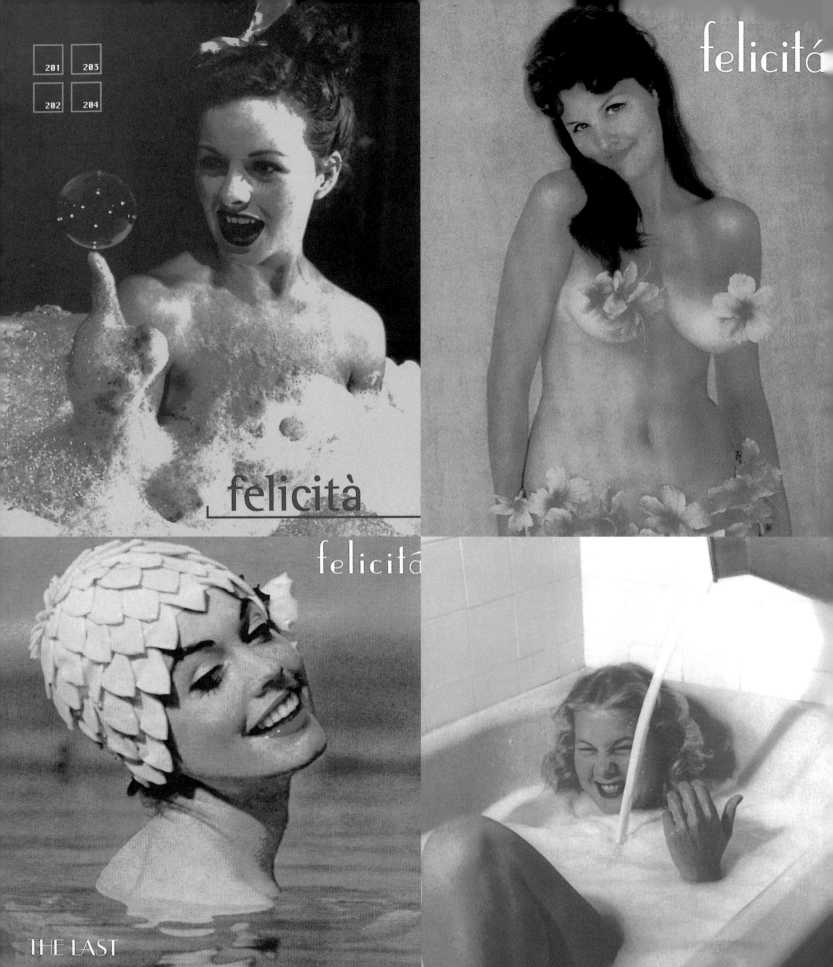

201  203
202  204

felicitá

felicità

felicità

THE LAST

SPLASH

OF

felicitá

felicità

atomic

Leisure.

# JIMI TENOR
## FUTUREPOP, ELECTRONICA AND SOUND ARCHITECTURE

**SUPPORT: CURD DUCA
MILLE PLATEAUX**

**FRIDAY 26. 09.97** 21:00
**ROTE FABRIK ZH-AKTIONSHALLE**

MUSIKBÜRO ROTE FABRIK, SEESTRASSE 395, 8038 ZÜRICH
INFOLINE: 01 481 91 21. URL: WWW.HUGO.CH
VVK: ZURICH: BIZZ 01 2212283, CRAZY BEAT, JAMARICO, JELMOLI CITY,
HAND ATTACK, MIGROS CITY, RECREC. WINTERTHUR: MUSICBOX.
BADEN: ZERO ZERO. BERN: LOLLYPOP. ST.GALLEN: BRO RECORDS.

WARP

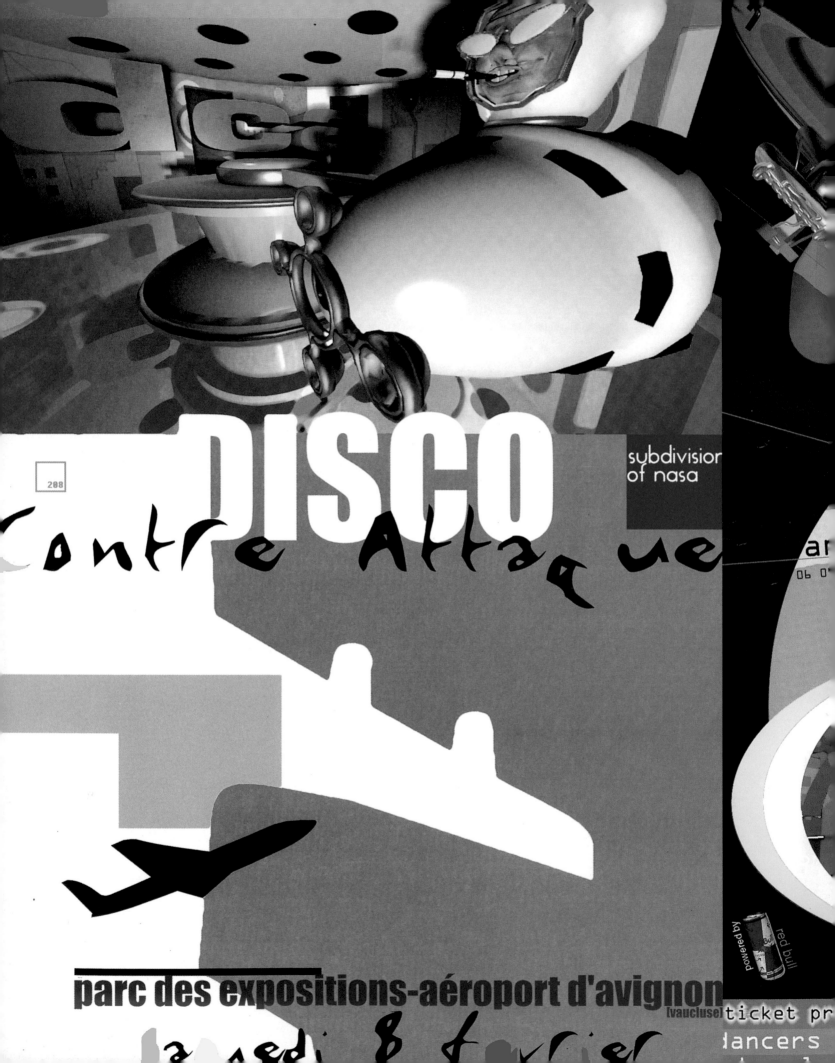

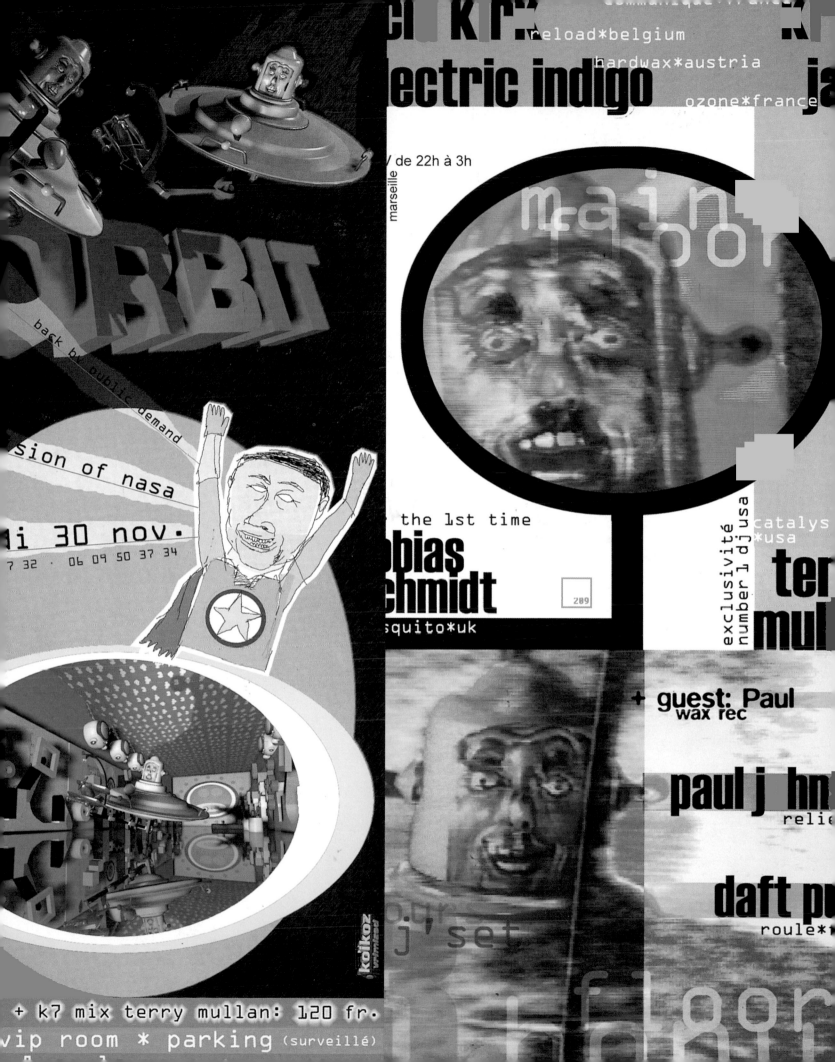

210

# Three Coin Finger Twister

## for two players

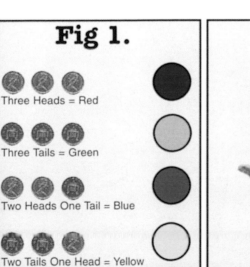

### Fig 1.

Three Heads = Red

Three Tails = Green

Two Heads One Tail = Blue

Two Tails One Head = Yellow

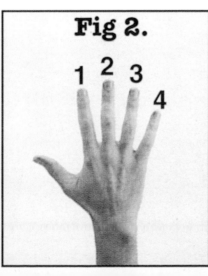

### Fig 2.

1 2 3 4

**Rules of play**

1. Toss a coin to decide who goes first.
2. The player going first throws three coins to determine which colour the playing finger will be placed on (fig 1)
3. The players fingers must be played in sequence. The fingers are numbered as shown (fig 2)
4. Player two then throws and repeats the sequence above.
5. The play continues alternately until all the fingers are on the board and then the finger sequence is repeated until a player is unable to move
6. No finger can leave the playing area once it has been placed, unless it is involved in the current turn.
7. The winner is the person who has all his or her fingers placed on the board after an opponent is unable to move, or their fingers have left the board.

ssy

teckno

fra

*artiste sous reserve de modification

212

n dale
ce'londres

par penelope de lyon.
watts sur 3 dancefloors, multi lights fx, scans,
e smoke, infolines: 06 09 50 37 32 - 06 09 50 37 34
c Chanot/marseille: 22h-3h / navettes gratuites assurées

a plage 97.)

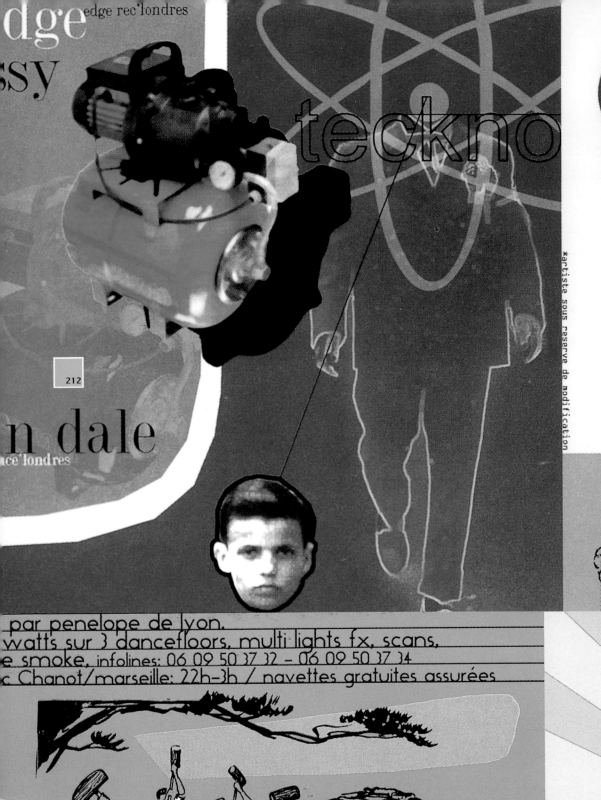

coquille poumon
anus estomac
intestin
R.B

co farfa*
se

max le sale gosse
montpellier

[[+ progressive]

transe

HARDCOR

liza'n eliaz
belgique

laurent ho
epiteth.paris

the box

15 février

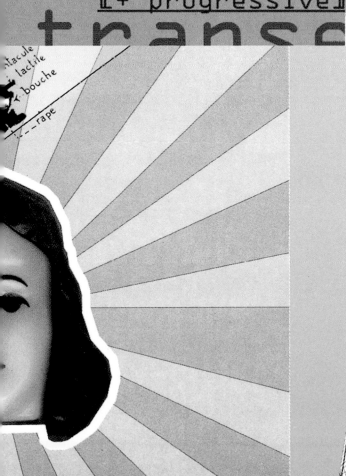
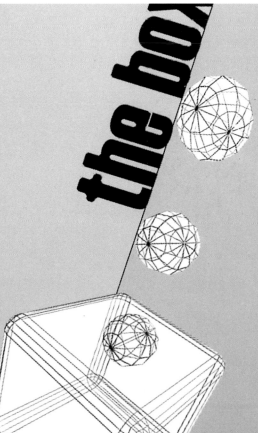

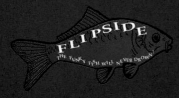

214

FLIPSIDE
THE FUNKY FISH WILL NEVER DROWN!

213

215

# HEY H

216

# HUNGRY FO

## HOMO·ACTION·MOVIES

# HOMO!

# RHAM.?

## FOR BUTCHER QUEERS

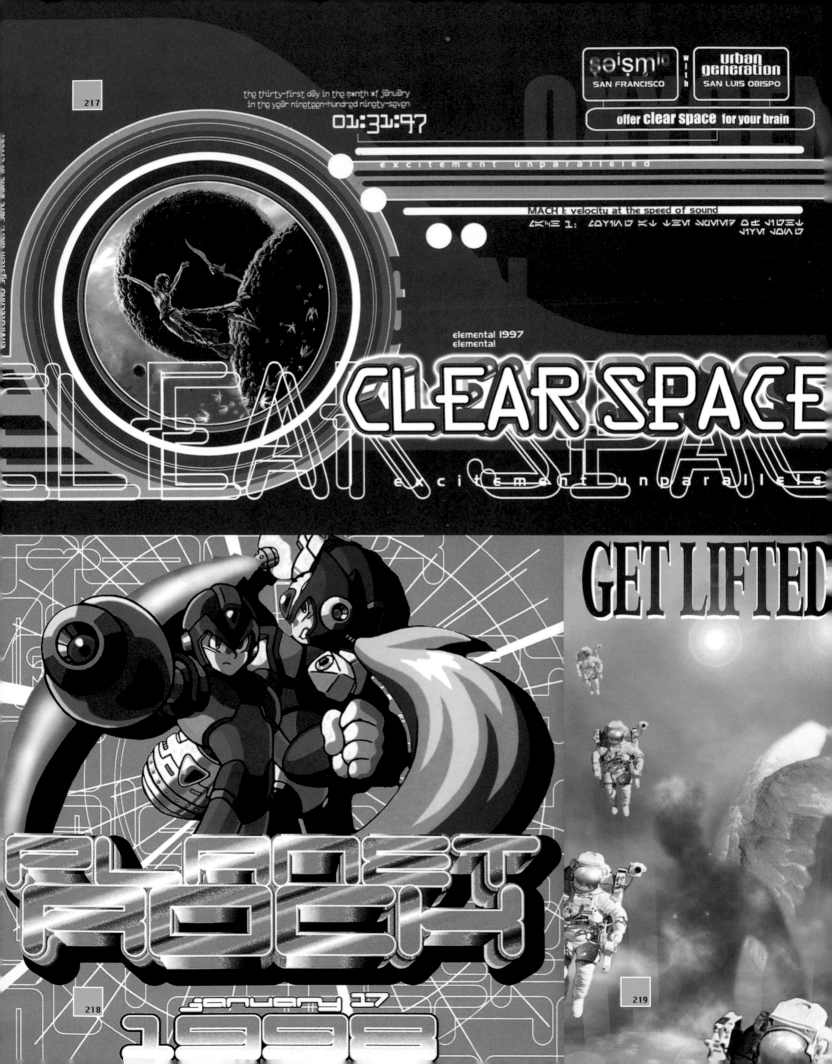

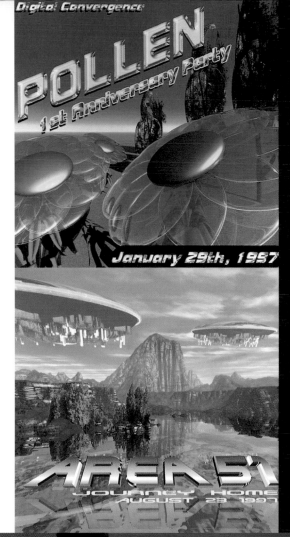

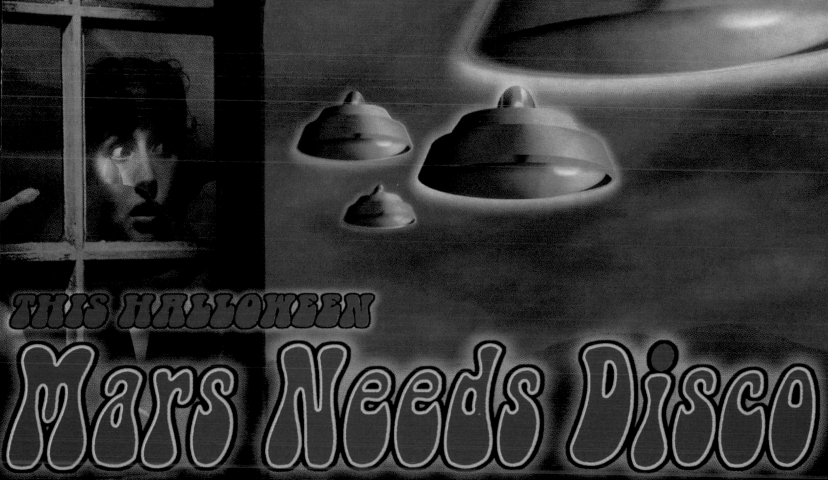

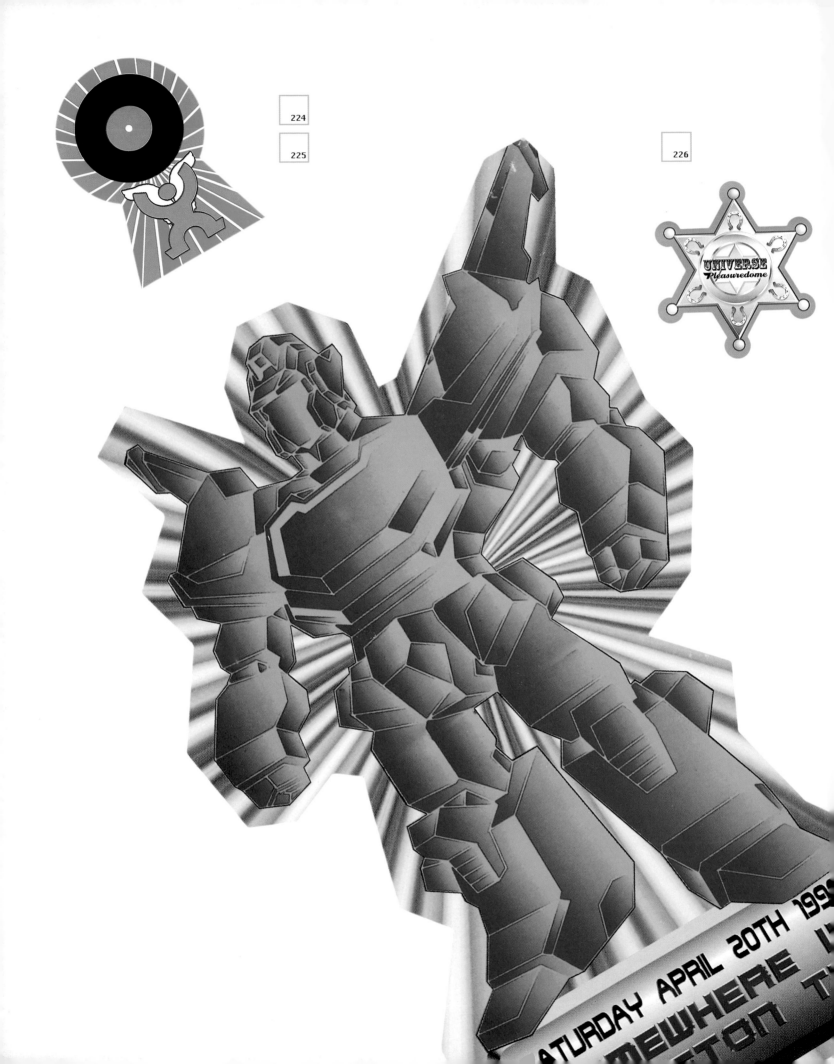

224

225

226

# the most underground techno party in town

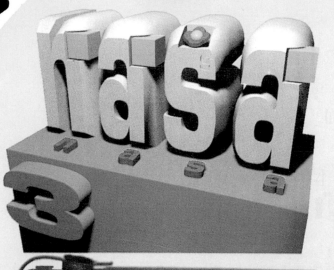

nasa 3

SAMEDI 18 MAI

sm:)e
sam pocket
mosquito
l'art-scène
plink plonk
3d kolkoz
TEKMICS
TAKTIK
CODa

## LIVE ACTS:
**SILICIUM** [READY MADE/PARIS]
**STEVE STOLL** [PROPER/212 NYC]

## DJ's:
**MIKE DEARBORN** [DJAX/CHICAGO]
**STEPHANOVITCH** [HEXAGONAL REC/PARIS]
**CHRISTIAN VOGEL** [MOSQUITO-TRESOR/LONDRES]
**FABRICE G.** [DISTRIX/MARSEILLE]
**STRAT** [TECKMICS/LYON]
**JEROME** [ALLIANCE PROD/MARSEILLE]

fly kolko.z 09 54 18 07

## bonus dj's
**CEDRI'X** [TECKMICS] **NICO** [READY MADE]
**KIKO** [OZONE REC] **WILLY** [PINGUIN'S REC]

**warm up** DJ'OIL [TRIP HOP JAZZ FUSION]
+ AUX PERCUS: **JEAN**

228

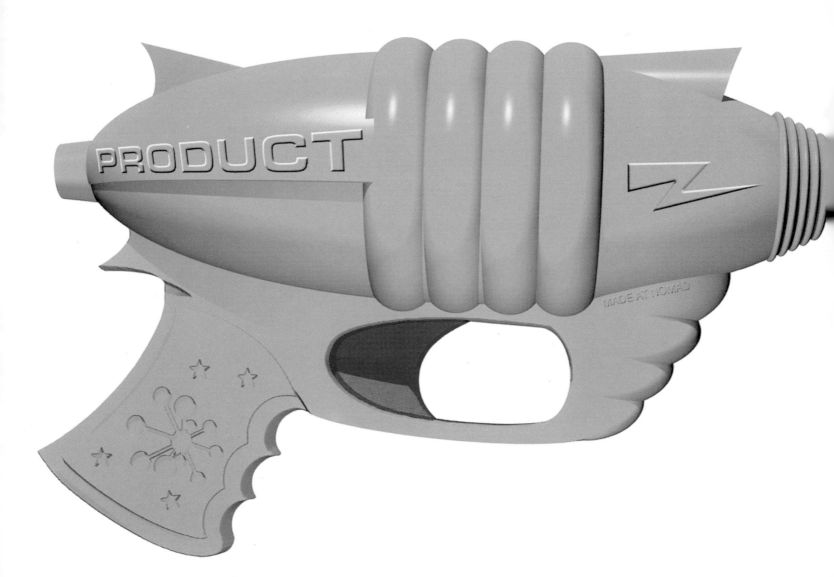

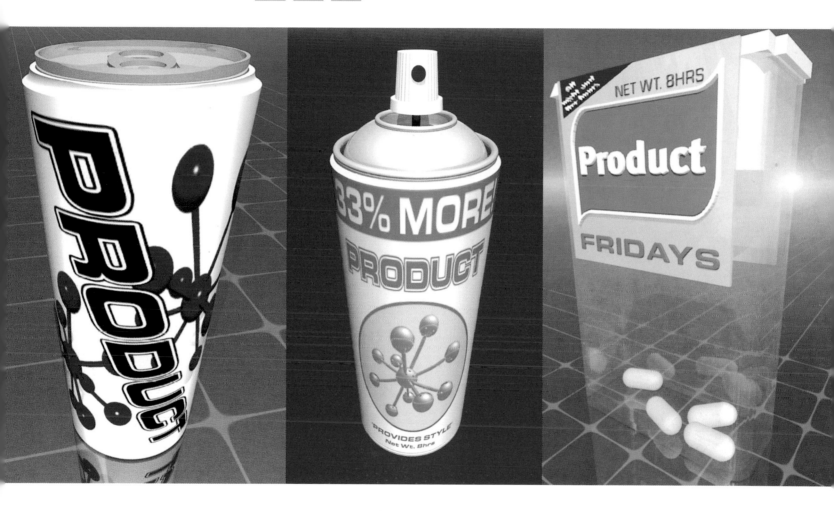

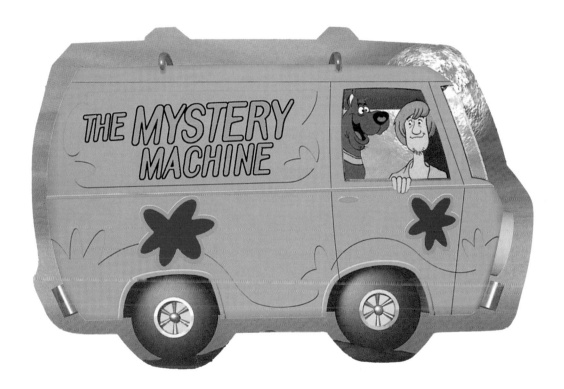

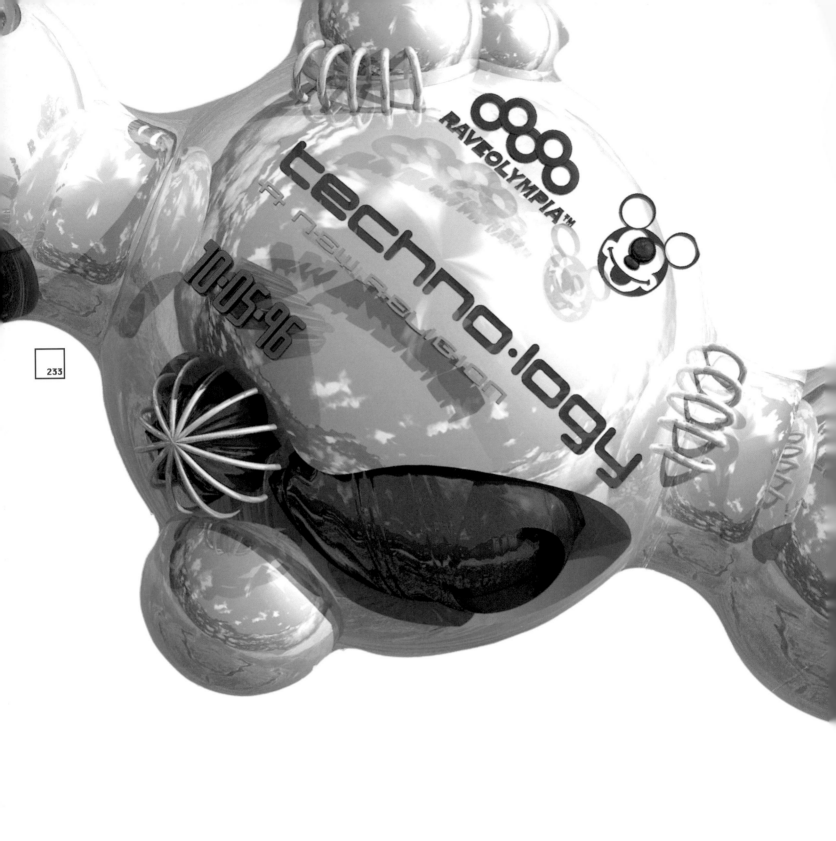

techno.logy

a new religion

RAVE OLYMPIA™

888

10.05.96

233

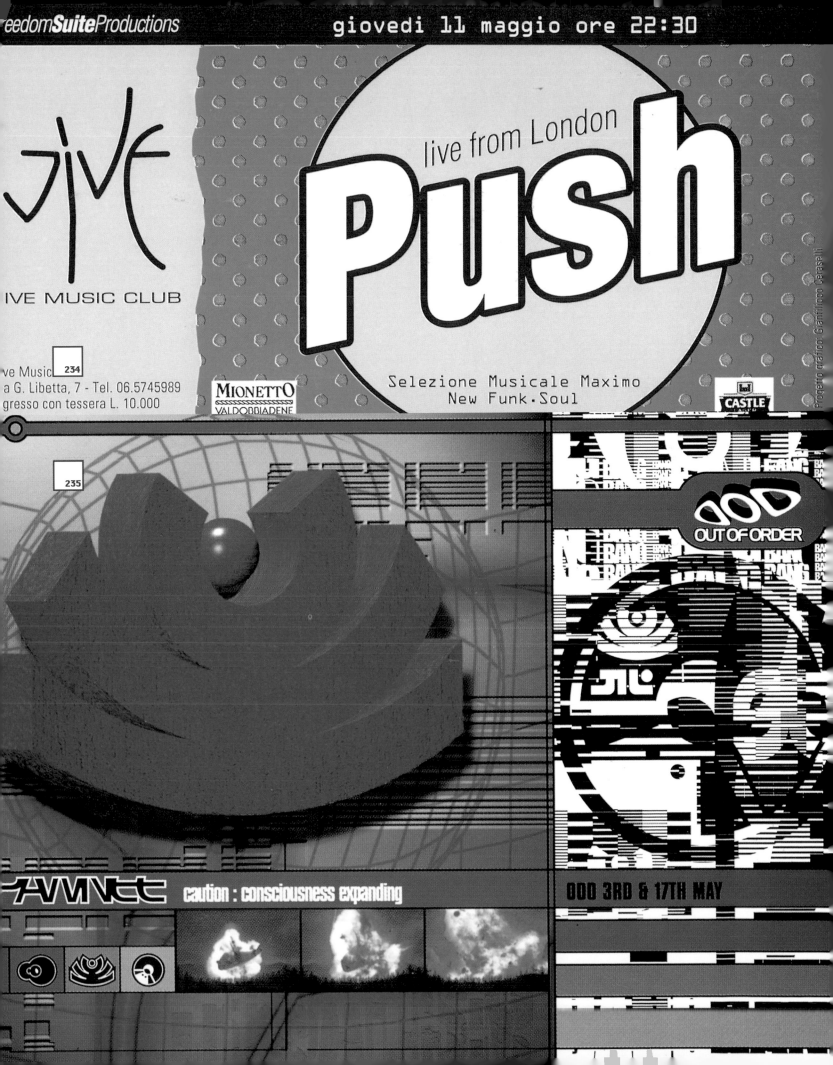

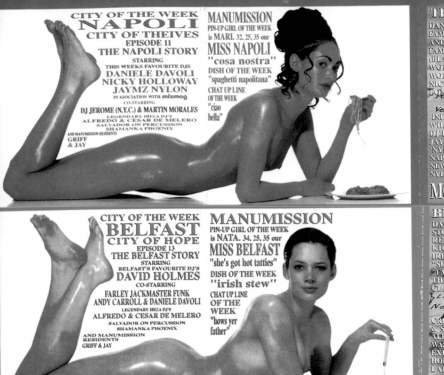

CITY OF THE WEEK
NAPOLI
CITY OF THIEVES
EPISODE 11
THE NAPOLI STORY
STARRING
THIS WEEKS FAVOURITE DJS
DANIELE DAVOLI
NICKY HOLLOWAY
JAYMZ NYLON
IN ASSOCIATION WITH *mixmag*
CO-STARRING
DJ JEROME (N.Y.C.) & MARTIN MORALES
LEGENDARY IBIZA DJS
ALFREDO & CESAR DE MELERO
SALVADOR ON PERCUSSION
SHAMANKA PHOENIX
GRIFF & JAY

MANUMISSION
PIN-UP GIRL OF THE WEEK
is MARI. 32, 25, 35 our
MISS NAPOLI
"cosa nostra"
DISH OF THE WEEK
"spaghetti napolitana"
CHAT UP LINE
OF THE WEEK
"ciao bella"

THIS WEEKS FAVOURITE DJ'S
DANIELE DAVOLI: THE ITALIAN EXPORT ROSE TO
FAME IN ITALY SPINNING ON THREE DECKS, SAMPLER
AND KEY BOARD IN THE MID 80'S. INTERNATIONAL
FAME CAME WITH THE SUCCESS OF HIS 'RIDE ON TIME'
(BLACK BOX) WHICH SOLD OVER 5,000,000 COPIES
WORLD WIDE, DAVOLI HAS DJ'D ALL OVER THE
WORLD, ESPECIALLY IN ITALY, SPAIN AND THE UK.
NICKY HOLLOWAY: RESIDENT AND FOUNDER OF
LONDON'S VELVED UNDERGROUND, ONE OF THE
INITIATORS OF THE BRITISH HOUSE SCENE, NICKY
WILL BE CELEBRATING HIS 16th PLACE IN IBIZA BY
DJ'ING NAKED THIS WEEK IN MANUMISSION.
JAYMZ NYLON: FOUNDER OF NEW YORK LABLE
'NYLON' RECORDS WHICH IS A SUBSIDUARY OF
NAPOLI'S FLYING RECORDS, WILL BE FLYING IN FROM
NEW YORK TO GIVE YOU A TASTE THE UNDERGROUND
NYLON SOUND IN THE BACK ROOM.
MONDAY 26th AUGUST  Privilege

MANUMISSIO

THE WORLD SERI

---

CITY OF THE WEEK
BELFAST
CITY OF HOPE
EPISODE 13
THE BELFAST STORY
STARRING
BELFAST'S FAVOURITE DJ'S
DAVID HOLMES
CO-STARRING
FARLEY JACKMASTER FUNK
ANDY CARROLL & DANIELE DAVOLI
LEGENDARY IBIZA DJ'S
ALFREDO & CESAR DE MELERO
SALVADOR ON PERCUSSION
SHAMANKA PHOENIX
AND MANUMISSION RESIDENTS
GRIFF & JAY

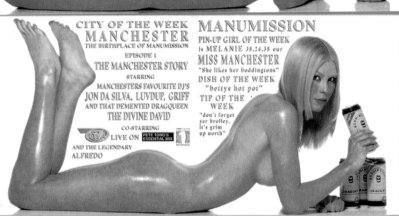

MANUMISSION
PIN-UP GIRL OF THE WEEK
is NATA. 34, 25, 35 our
MISS BELFAST
"she's got hot tatties"
DISH OF THE WEEK
"irish stew"
CHAT UP LINE
OF THE WEEK
"hows yer father"

BELFAST'S FAVOURITE DJ'S
DAVID HOLMES: THE BELFAST LEGEND WILL BE
STORMING IN THE BACK ROOM. A WORLDWIDE DJ,
REMIXER & PRODUCER, DAVID HOLMES
KICKSTARTED THE DANCE REVOLUTION IN
IRELAND WITH HIS INCREDIBLE CLUB NIGHT
"SUGAR SWEET" & "SHAKE YA BRAIN" HERALDED
"FAST, FUNKY & FURIOUS" BY THE FACE. AS PART OF
THE DISCO EVANGELISTS HE CREATED THE CLUB
CLASSIC "DE NIRO", A RENOWNED REMIX FOR HIS
CREDITS INCLUDE ST. ETIENNE, SABRES OF PARADISE
& SVEN VATH. SIGNED TO "GO DISCS" HIS DEBUT
ALBUM "THIS FILMS CRAP, LETS SLASH THE SEATS"
WAS RELEASED TO MASSIVE CRITICAL ACCLAIM. TO
EXPAND THE HOUSE SCENE IN IRELAND, DAVID
HOLMES HAS RECENTLY SET UP HIS OWN BELFAST
LABEL "EXPLODING PLASTIC INEVITABLE".
MONDAY 9th SEPTEMBER  Privilege

MANUMISSIO

THE WORLD SERI

---

CITY OF THE WEEK
MANCHESTER
THE BIRTHPLACE OF MANUMISSION
EPISODE 1
THE MANCHESTER STORY
STARRING
MANCHESTERS FAVOURITE DJ'S
JON DA SILVA, LUVDUP, GRIFF
AND THAT DEMENTED DRAGQUEEN
THE DIVINE DAVID
CO-STARRING
LIVE ON PETE TONG'S ESSENTIAL MIX
AND THE LEGENDARY
ALFREDO

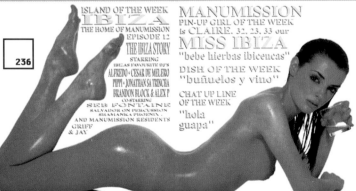

MANUMISSION
PIN-UP GIRL OF THE WEEK
is MELANIE 35,24,35 our
MISS MANCHESTER
"She likes her boddingtons"
DISH OF THE WEEK
"bettys hot pot"
TIP OF THE WEEK
"don't forget yer brolley, it's grim up north"

NEW YORK'S FAVOURITE
TODD TERRY: "THE INOVATOR" NO OTHER DJ
DESERVES TO GRACE MANUMISSIONS NEW YORK
NIGHT IN IBIZA. PERHAPS THE WORLDS BIGGEST DJ,
A LEGEND WHO CONTINUES TO KEEP THE PARTY
GOING STRONG. TODD TERRY HAS MOVED FROM
STREET JAMS IN BROOKLYN, TO PLAYING THE
WORLDS MOST INFLUENCIAL CLUBS. AS A PRODUCER
TODD TERRY IS RESPONSIBLE FOR LAST YEARS IBIZA
ANTHEM "MISSING" (EVERYTHING BUT THE GIRL),
ALSO "BOUNCE TO THE BEAT" & "WRONG", NOW
HERE TO CELEBRATE THE EUROPEAN LAUNCH OF
HIS CURRENT MASSIVE HIT "JUMPIN" ON MANIFESTO
RECORDS.
WITH SPECIAL THANKS TO SERIOUS ARTIST MANAGEMENT.
MONDAY 22ND JULY  Privilege

MANUMISSIO

THE WORLD SERI

---

ISLAND OF THE WEEK
IBIZA
THE HOME OF MANUMISSION
EPISODE 12
THE IBIZA STORY
STARRING
IBIZAS FAVOURITE DJ'S
ALFREDO • CESAR DE MELERO
PIPPI • JONATHAN SA TRINCHA
BRANDON BLOCK & ALEX P
CO-STARRING
SEB FONTAINE
SALVADOR ON PERCUSSION
SHAMANKA PHOENIX
AND MANUMISSION RESIDENTS
GRIFF & JAY

MANUMISSION
PIN-UP GIRL OF THE WEEK
is CLAIRE. 32, 23, 33 our
MISS IBIZA
"bebe hierbas ibicencas"
DISH OF THE WEEK
"buñuelos y vino"
CHAT UP LINE
OF THE WEEK
"hola guapa"

IBIZA FAVOURITE DJ'S
ALFREDO: THE ARGENTINE DJ, BECAME AN IBIZA ICON FOR MANY UK CLUBBERS IN
THE LATE 80'S AND EARLY 90'S. HE HELPED FORGE THE ORIGINAL "BALEARIC BEATS"
VIBE THAT SO INSPIRED THAT INITIAL BRITISH ACID REVOLUTION. AS WELL AS PLAYING ALL AROUND THE WORLD ALFREDO HAS BEEN DJ'ING IN
IBIZA FOR OVER 20 YEARS. AMNESIA BACK IN THE DAY, THE TERRACE AT SPACE
AND NOW A MANUMISSION RESIDENT. ALFREDO IS... "NOT JUST THE MAN BEHIND
THE LEGEND. HE IS THE LEGEND"
CESAR DE MELERO: BORN IN BARCELONA, CESAR HAS PLAYED IN IBIZA SINCE
'82. PREVIOUSLY DJ'ING IN AMNESIA, SPACE & PACHA HE HAS BEEN THE RESIDENT
AT KU SINCE '83. IN '91 CESAR RELEASED HIS FIRST RECORD "NICK" MOVES" WHICH
HIT THE TOP 20 IN SPAIN & EUROPE. PART OF THE NEW IBIZA/PARIS LABEL
FROZAL TRAX, WITH A NEW RELEASE "TV SCENE" UP ON THIS LABEL &
CURRENTLY WORKING WITH DE/CONSTRUCTION IN THE UK.
PIPPI: ANOTHER IBIZA LEGEND. A RESIDENT DJ IN IBIZA FOR OVER 15 YEARS.
ORIGINALLY FROM ITALY, PIPPI HAS PLAYED FOR MOST OF THE MAJOR CLUBS
ALL OVER THE WORLD THOUGH PRIMARILY AT PACHA WHERE HE CURRENTLY
REIGNS. AS A PRODUCER HE IS RESPONSIBLE FOR THE IBIZA ANTHEM "LUV U
BABY". HIS CURRENT TRACK "TO YOUR NIGHT" (VIRTUAL DISCO) HAS BEEN
BUILDING ON THE ISLAND THIS SUMMER.
MONDAY 2nd SEPTEMBER  Privilege

MANUMISSIO

THE WORLD SERIE

---

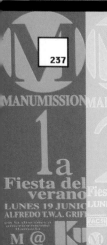

MANUMISSION

1
1a
Fiesta del verano
LUNES 19 JUNIO
ALFREDO T.W.A. GRIFF

MANUMISSION
2
2a
Fiesta del Verano
LUNES 26 DE JUNIO

MANUMISSION
3
4
Fiesta del Verano
LUNES 3 DE JULIO
JEREMY HEALEY
ALFREDO
ROBIN
GRIFF

MANUMISSION
5
4a
Fiesta del verano
LUNES 10 DE JULIO
DANIELLE DAVOLI
SEB FONTAINE
GRIFF
JASON BYE

MANUMISSION
6
Fiesta del verano
LUNES 17 DE JULIO
TONY DE VIT • RACHEL AUBURN
PETE WARDMAN • ALFREDO • GRIFF

MANUMISSION
7
Fiesta del verano
LUNES 24 DE JULIO
Colours
DANIELE DAVOLI • SEB FONTAINE
ALFREDO • JON MANCINI
BONEY • GRIFF • JASON BYE

MANUMISSION
8
7a
Fiesta del verano
LUNES 31 DE JULIO
renaissance
JOHN DIGWEED
IAN OSSIA
CHRIS & JAMES
GRIFF

MANUMISSION
8a
Fiesta del verano
LUNES 7 DE AGOSTO
LIVE FOR ESSENTIAL SELECTION
PETE TONG
TALL PAUL, NICK RAPHAEL
ALFREDO, GRIFF & TV LIVE

MANUMISSION
9
Fiesta del verano
LUNES 14 DE AGOSTO
MALIBU STACEY

MANUMISSION
10
Fiesta del ver
LUNES 21 DE AGO
DJ JEROM

M @ Ku

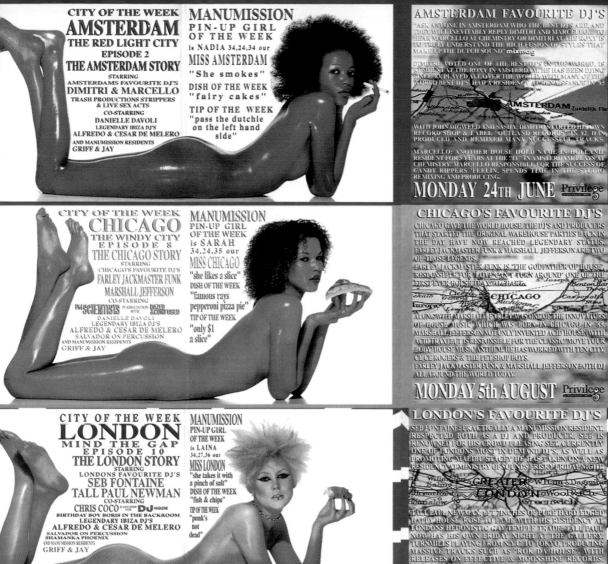

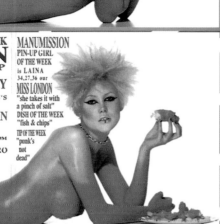

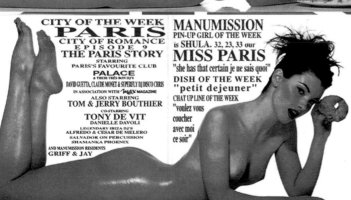

LEAF / WIRE

**NOV/96**

7–12pm  The Spitz, 109 Commercial Street, Spitalfields Market, London E1  Liverpool Street/Aldgate East Tubes
£6 (£4 concs)  booking: 0171 247 9747  info: 0171 439 6422  Cheap Bar & Food  Gallery  Projections  ISDN  Design:

*united*mutations

some of the artists featured on this cd will be showing up so small job

LEAF / WIRE

*united*mutations

**NOV/96**

7–12pm  The Spitz, 109 Commercial Street, Spitalfields Market, London E1  Liverp
£6 (£4 concs)  booking: 0171 247 9747  info: 0171 439 6422  Cheap Bar & Fo

DesignEdit:Simon(&Jon)@MayTheForss...

Moonshak

9:30

10:30 Mixmaste

SCRA

WIRE  LEAF

DesignedbySimon@MayTheForss...  ISDN  Light Surgeons  Visuals by  Gallery  Cheap Bar & Food  0171 439 6422  info:  0171 247 9747  booking:
ommercial Street, Spitalfields Market, London E1  Liverpool Street/Aldgate East Tubes
C/96

WIRE  LEAF

SCRAT

booking: 0171 247 9747 info: 0171 439 6422 Cheap Bar & Food Gallery Visuals by Light Surgeons ISDN  oooh.Eeee.AaahRemixbyJon@MayT

# sale

## MANUMISSION

### STILL ONLY FIVE POUNDS

this is a mixed night

Coach + Entry
LONDON £15
LEEDS £7
(FROM INDIE JOZE)

**Disc jockies and Showbiz Personalities**

Rob the Camera Man

Polly the Poof

Barbie Superstar

Patricia & Debbie

Griff

Roger More

Timm & Laurie

Des Marshall

Captain Stratford Governing

The Divine David

Fully Liberate Yourself

FULLY LIBERATE YOURSELF

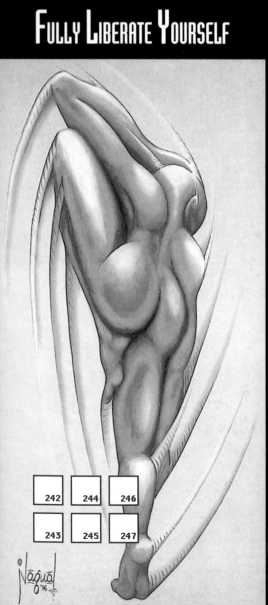

242 244 246

243 245 247

FULLY LIBERATE YOURSELF

# F.L.Y

## AGARIC

"YEAH THAT'S RIGHT CAPTAIN, IT'S REALLY PUMPIN' DOWN HERE"

*Wish You Were Here..?*

"I HEAR THERE'S A BIG ONE ON THE BOAT TODAY"

*Wish You Were Here..?*

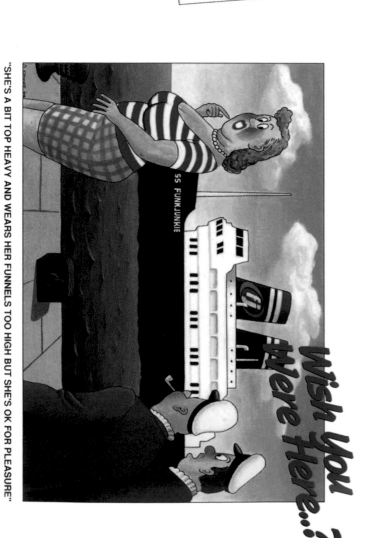

"SHE'S A BIT TOP HEAVY AND WEARS HER FUNNELS TOO HIGH BUT SHE'S OK FOR PLEASURE"

*Wish You Were Here..?*

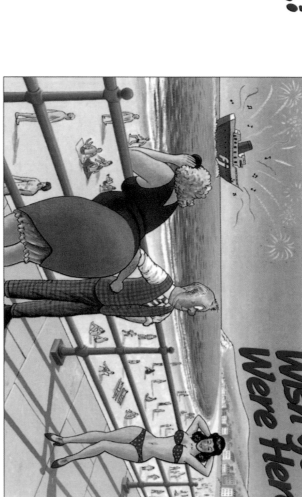

"ERE ERNIE, I BET THAT LIVELY ONE CUTS A WAKE UP THE CHANNEL"

*Wish You Were Here..?*

# renaissance ®
## SILK END OF SUMMER BALL

renaissance ®
biza 1997

pacca
ibiza

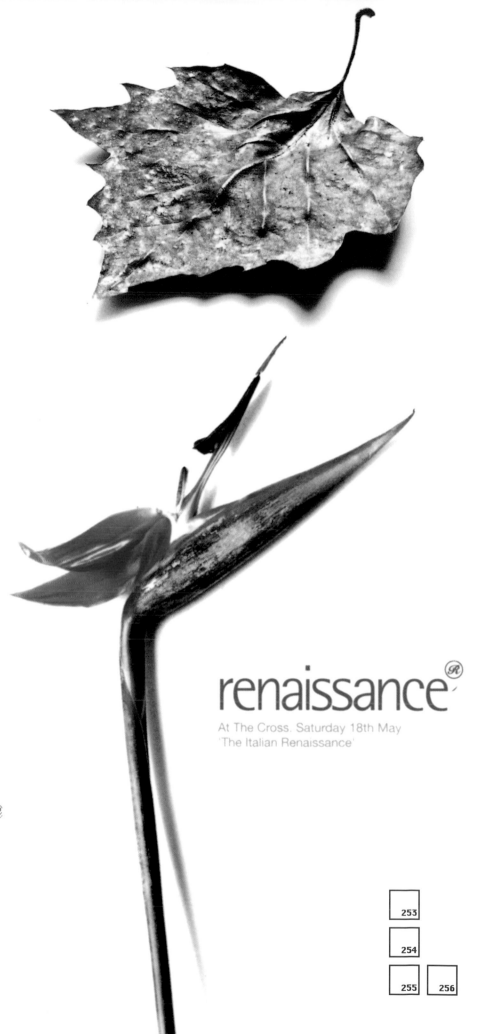

# renaissance ®
At The Cross. Saturday 18th May
'The Italian Renaissance'

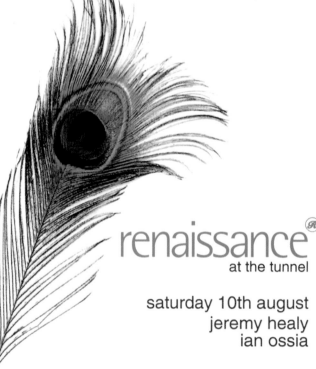

# renaissance ®
at the tunnel

saturday 10th august
jeremy healy
ian ossia

residents
colin tevendale
steven m<sup>c</sup>creery
room 2
kevin mcfarlane

| | |
|---|---|
| 253 | |
| 254 | |
| 255 | 256 |

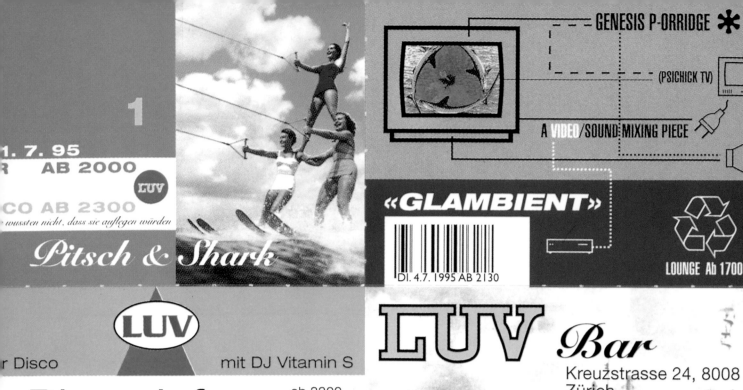

1. 7. 95
R AB 2000
CO AB 2300
wussten nicht, dass sie auflegen würden

*Pitsch & Shark*

GENESIS P-ORRIDGE ✳
(PSICHICK TV)
A VIDEO/SOUND·MIXING·PIECE
«GLAMBIENT»
DI. 4.7. 1995 AB 2130
LOUNGE Ab 1700

FR.

LUV
r Disco       mit DJ Vitamin S

Disco Inferno ab 2200

LUV *Bar*
Kreuzstrasse 24, 8008
Zürich
Tel 01 262 40 07

BREMEN

unge ab 1700       So 9. 7. 95

Öffnungszeiten: tägl. von 1700-0200
Fr 1700-0400, Sa 2000-0400

Glit
Jede

Sa 15.7.95

J's Röne & Michi

Disco ab 2200
Bar    ab 2000

Konnten genötigt werden wieder
einmal aufzulegen

*Incredible*
STRANGE
So 16. 7. 95
LUV Lounge 1700

MUSIC FOR INCREDIBLE STRANGE PEOPLE
*DJ Buzzawhile verwöhnt sensible Ohren mit Obskuritäten aus
seiner Plattensammlung ab 2200*

Fr
LUV
U
Hat

Nadala
INDIAN INCENSE
ulinarische, musikalische und
filmische Spezialitäten aus Indien

*Tragic India*
statt Magic America

Fr 28. 7. 95
Lounge ab 1700

LUV

Disco Inferno ab 2200
von DJ Vitamin S

SAMSTA
B

DISTA 3105   PROZAC 20mg

Präsentiert

257

ライブ
ブットビヨーキ
BOREDOM5 JAPAN
35 Bar ab 1900 DIE TOKYOTER CULT KOMBO Konzert ab 2130
anschl. DJ UJO

Konzert
**Este Rito le Sugerimos**
CH

**Sa 8.7.95 2130**
Bar ab 2000

Bündner
Crossover mit
Unterländer
Einschlag

Anschliessend
Disco
mit Nepper
**DJan**

LUV Bar

UV *Lounge*
Mo-Fr ab 1700

Excess
ab 2300

für tänzerisch andersbegabte. African
American Music played by
Caucasian Centraleuropean DJ's

**VENDETTA**
präsentieren ihre ersten beiden Singles

LOUNGE
ab 1700

*Luv*
Fr 14.7.95

ZUERICH

DJ's Patrick & Philip

geben Euch danach den Rest

KONZERT.....( 2130 )

7.95 *Lounge ab 1700*

DJ
100
chen wieder mal was anderes aufzulegen

Sa 22. 7. 95 **LUV** DISCO  SLIPPMAT & ME THINKS

stellen ab 2200 intelektuelle  Höchstansprüche BAR AB 2000

.95
2000

LUV
SCO

das grösste Team-Up seit
uperman & Spiderman

von Surf bis Hip alles,
nerheiden so mögen

*So 30.7.95*
*Lounge ab 1700*

Jamsession
Mit freundliche
Unterstützung des
Hausmeisters
Mark

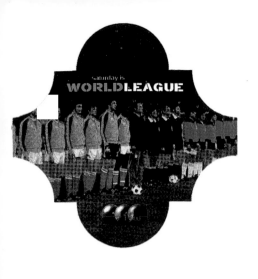

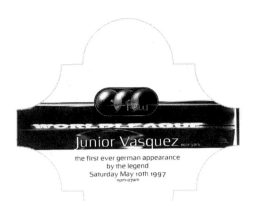

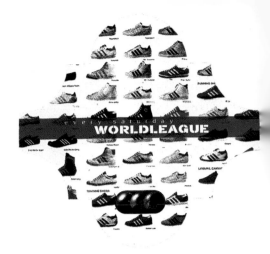

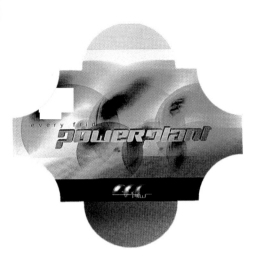

| 258 | 259 | 260 | 261 | 262 | 263 |
|---|---|---|---|---|---|
| 264 | 265 | 266 | 267 | 268 | 269 |

270

Sa. 13.09.
passion
4 Decks/2 Mixers
René Vaill & Linus (kw)
live percussions & vocals kraze
all members free entry!

WORLD LEAGUE

saturday is
WORLD LEAGUE

every friday
powerplant
Fr, 15.08.
TETSUO Talla 2XLC
presents the famous
TECHNO from Frankfurt

every friday
powerplant
Fr, 13.06.
TETSUO Talla 2XLC
presents the famous
TECHNO from Frankfurt
(Tomcrafts Birthday-Party)

powerplant
Freitag 06.12.96
DJ Cirillo
Cocorico/Rimini

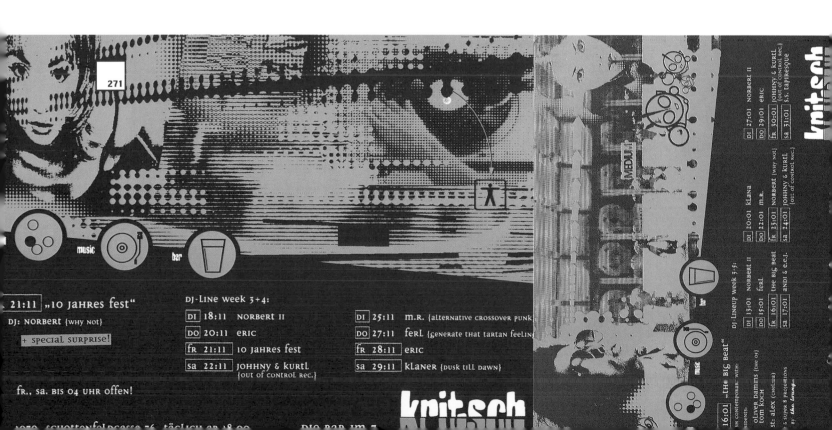

271

21:11 „10 jahres fest"

DJ: Norbert (why not)

+ special surprise!

fr., sa. bis 04 uhr offen!

DJ-Line week 3+4:

DI 18:11 Norbert II
DO 20:11 eric
fr 21:11 10 jahres fest
sa 22:11 johhny & kurtl
(out of control rec.)

DI 25:11 m.r. (alternative crossover punk)
DO 27:11 ferl (generate that tartan feeling)
fr 28:11 eric
sa 29:11 klaner (dusk till dawn)

knitsch

DJ-lineup week 1-5:

DI 13:01 Norbert II
DO 15:01 ferl
fr 16:01 the big beat
sa 17:01 andi & c.e.j.

DI 27:01 Norbert II
DO 29:01 eric
fr 30:01 johhny & kurtl
(out of control rec.)
sa 31:01 s.s. tapresque

DI 20:01 klana
DO 22:01 m.r.
fr 23:01 Norbert (why not)
sa 24:01 johhny & kurtl
(out of control rec.)

16:01 „the big beat"
sa contemporal with:
Oliver Damms (nee oy)
tom koch
st. alex (cheetza)
6 super 8 projections
by the house

knitsch

232
THE MYSTERY MACHINE @ CLUB 181
SAN FRANCISCO. USA
DESIGN. KENNETH PAUL. NOMAD DESIGN

233
TECHNOLOGY
SAN FRANCISCO. USA
DESIGN. STIMULI

234
JIVE MUSIC CLUB
ROME. ITALY
DESIGN. GIANFILIPPO CERASELLI

235
SPAWNEE POSSE @ THE PHOENIX
MANCHESTER. UK
DESIGN. JASON TRUE. LIAM FARRELL

236
MANUMISSION @ PRIVILEDGE
IBIZA. SPAIN
DESIGN. MIKE.CLAIRE.ANDY.DAWN
@MANUMISSION

237
MANUMISSION @ KU
IBIZA. SPAIN
DESIGN. MIKE.CLAIRE.ANDY.DAWN
@MANUMISSION

238
SCRATCH @ THE SPITZ
LONDON. UK
DESIGN. SIMON @ THE FORSS

239
SCRATCH @ THE SPITZ
LONDON. UK
DESIGN. JON @ THE FORSS

240
MANUMISSION @ EQUINOX
MANCHESTER. UK
DESIGN. MIKE.CLAIRE.ANDY.DAWN
@MANUMISSION

241
ROMA @ ES PARADIS
IBIZA. SPAIN

242 244 246
F.L.Y. @ TRENZ
LONDON. UK
DESIGN. PHILLIP LONG.
NAGUAL CREATIONS

243 245
F.L.Y. @ BRIXTON ACADEMY
LONDON. UK
DESIGN. PHILLIP LONG.
NAGUAL CREATIONS

248
F.L.Y. @ TYSSEN STREET STUDIOS
LONDON. UK
DESIGN. PHILLIP LONG.
NAGUAL CREATIONS

249 250 251 252
WISH YOU WERE HERE (BOAT PARTIES)
LEAVING SOUTHAMPTON. UK
DESIGN. ANTHONY BEBBINGTON
ILLUSTRATION. DAVE STOOKE

253 254 255 256
RENAISSANCE @ THE TUNNEL
GLASGOW. SCOTLAND. UK
RENAISSANCE @ THE CROSS
LONDON. UK
RENAISSANCE @ ALLERTON CASTLE
NORTH YORKSHIRE. UK
RENAISSANCE @ PACHA
IBIZA. SPAIN
DESIGN. DOLPHIN

257
SERIES OF 16 EVENTS @ THE LUV LOUNGE
ZURICH. SWITZERLAND
DESIGN. HFSF HINDERFREISCHLATTERFEUZ
GRAFIK

258 TO 269
POWERPLANT @ KW-DAS HEIZKRAFTWERK
MUNICH. GERMANY
DESIGN. 3 DELUXE

270 271
KRITSCH BAR
VIENNA. AUSTRIA
DESIGN. THE LOUNGE

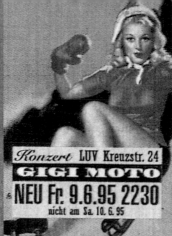
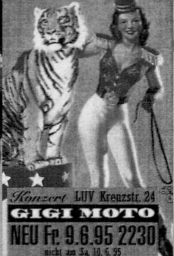

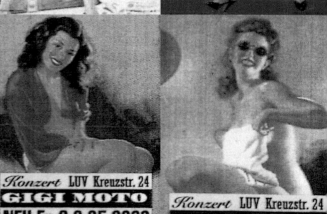

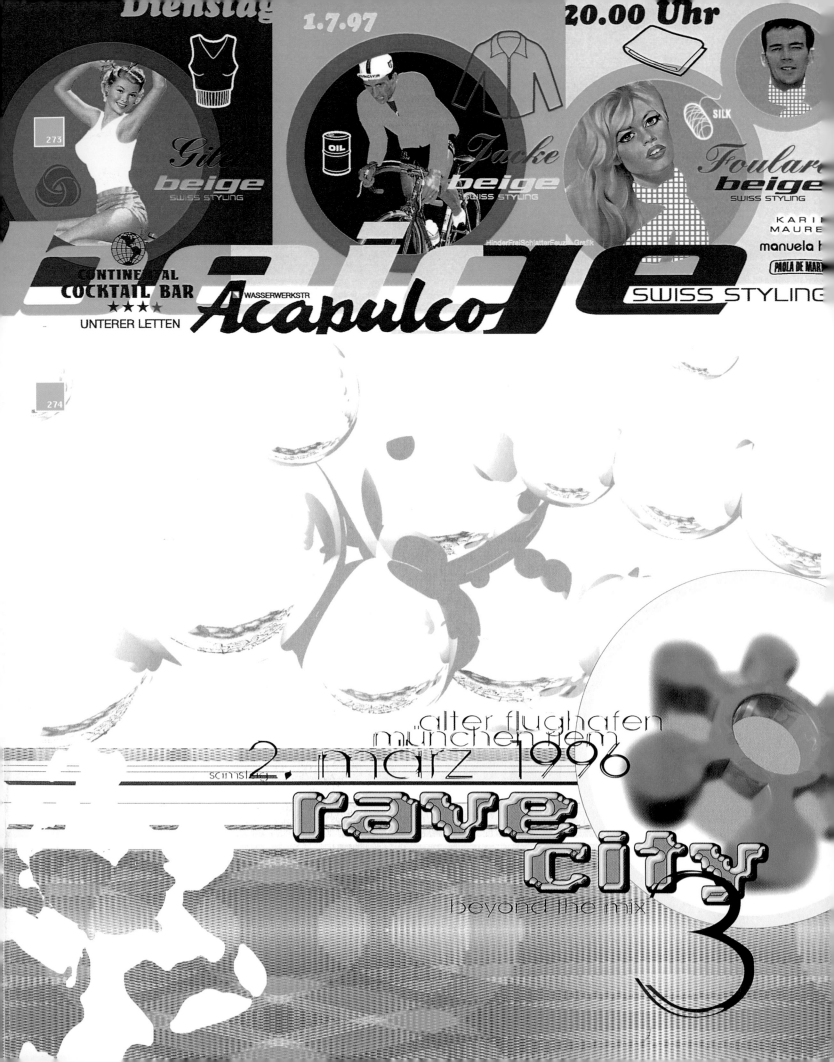

275

montag: vestibül-melancholie
dienstag: brachfeld-poesie
mittwoch: kniebrecher
donnerstag: formenlehre
freitag: melange-ton
samstag: synkretismus
sonntag: puderquaste

*Der Mensch verläßt die Erde*

umknicken und zukleben

Jawlenskystraße 1
65183 Wiesbaden
0611.590108

ein Tag im Alltag ist kein Alltag

276

rave city 4

München
28.sept96
Kunstpark Ost
The new capital
(opening the doors of perception)

Rave City III - beyond the mix, 02.03.1996

**The Past**

**The Present**

**Rave City III - beyond the mix, 02.03.1996**

**The Past**

**The Present**

**The Pictures**

**The Future**

breakbeat
jungle hop

chill out

Lottgroover (London)
Basssforce Sascha (Mannheim)
Nicky Blackmarket (London)
Coldcut (London)
DJ Food (London)
Herbaliser (London)
Funki Porcini (London)
Xero (Kapstadt)

Jose Padilla (Ibiza)
Michael Reinboth (M

Rave City geht in die vierte Runde. Mit einer glanzvollen Abschiedsvorstellung, mit knapp an 20.000 begeisterten Besuchern ausverkauft, und tausenden Partypeople vor den Türen, die keine Tickets mehr erwerben konnten, hat man sich vom legendären alten Flughafen Riem verabschiedet. Mit euphorischen Stimmungsverläufen, war Rave City 3 das Partyhighlight des 1. Halbjahres '96. Zu den Höhepunkten zählte neben Carl Cox, Marc Spoon oder Jeff Mills sicherlich Weltstar Boy George, der mit einem kickenden Set den House Ballroom zum Kochen brachte. Die nervende "Techno ist tot"- Debatte war somit beendet und jetzt war klar, daß Großraves wie Rave City, die durch innovatives Line-up, coole Locations, Deko und Organisation bestechen, nach wie vor die Richtung weisen. Rave City hat wie kein anderer Großrave den Festivalgedanken in den Vordergrund gestellt und bietet neben Spitzen Line ups und High Quality Technik, Specials und Entertainment, wie man es sonst selten findet. Nach dem Abriß des alten Flughafens Riem dachten viele, daß Rave City wohl nicht

**Open your doors of perception!**
Rave City wird mit einem hochklassigen Line-up und unzähligen Highlights an der Spitze eines heißen Partyjahres stehen. Mit 808 State aus Manchester steht einer der Kult Acts seit langer Zeit wieder in Deutschland auf der Bühne. Klassiker wie "Pacific State" sprechen für sich und man darf sich auf einen heißen Auftritt gespannt sein. Mit Klaus Schulze (Tangerine Dream),

the new capital (opening the door of perception)

**Open your doors of perception!**

Rave City wird auf dem neuen Gelände einen vulminanten Start hinlegen. Technik, PA und Licht werden bei gleichem Eintrittspreis abermals aufgestockt.

Get ready for the future and open your doors of perception!

Rave City-already for the fourth time! Let's look back to Rave City 3; It was a fabulous farewell party that was thrown at the old airport-nearly 20.000 visitors filled the legendary halls which are already torn down today. Rave City 3 was completely sold out with thousands of party people who didn't get a ticket cheering outside. The ecstatic and euphoric atmosphere enabled everybody: Rave City 3 was THE party highlight in the fist half of 1996. Superstars like Carl Cox, Mark Spoon or Jeff Mills-and even Boy George who turned the house ballroom upsidedown with his striking set-were part of the senationell line up.

**Open your doors of perception!**
Rave City is going to be the peak event of a hot party summer with it's first class line ups und numberless highlights. For those who know! Partyanimal Marc "You are the Love Parade", Spoon, the producer of the last Rave City hymn is going up the headquarter. Frankie Knuckles and David Morales, two living "House, legends from New York, can also be found on turntables.

So get ready for the future and open your doors of perception!

House
Ballroom

Hard
core Hell

David Morales (New York)
Frankie Knuckles (New York)
Erick E. (Amsterdam)
Farley & Heller Project feat.
Pete Heller (London)
Terry Farley (London)

Lenny Dee (New York)
DJ Seduction (Bristol)
Stunned Guys aka Maxx
Manopoli & DJ Giansy (Masland)
Charly Lownoise (Amsterdam)
Mental Theo (Amsterdam)
Darrien Kelly (Rotterdam)
Cpt. E-Glow (München)
MC Magika (London)

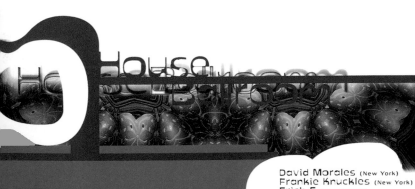

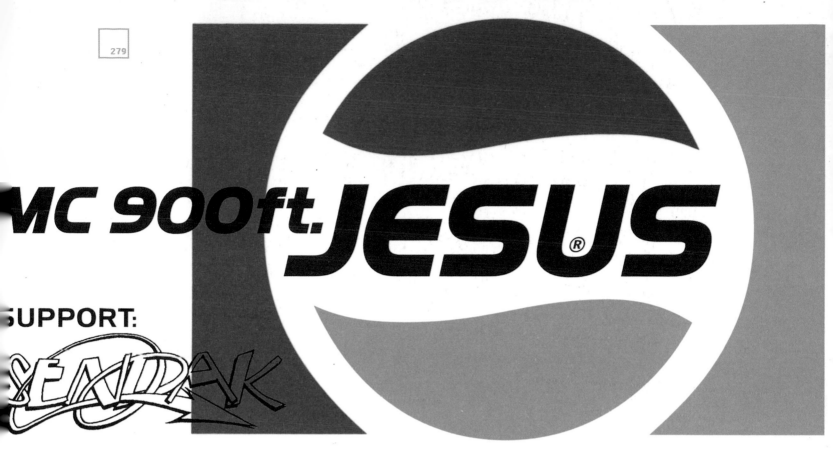
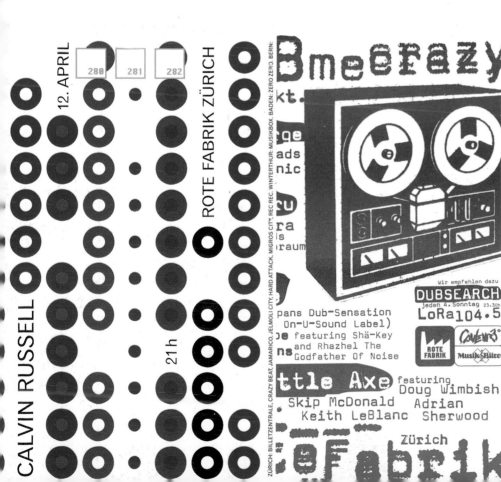
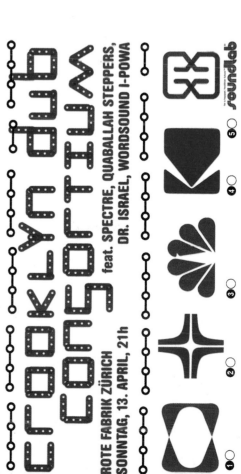

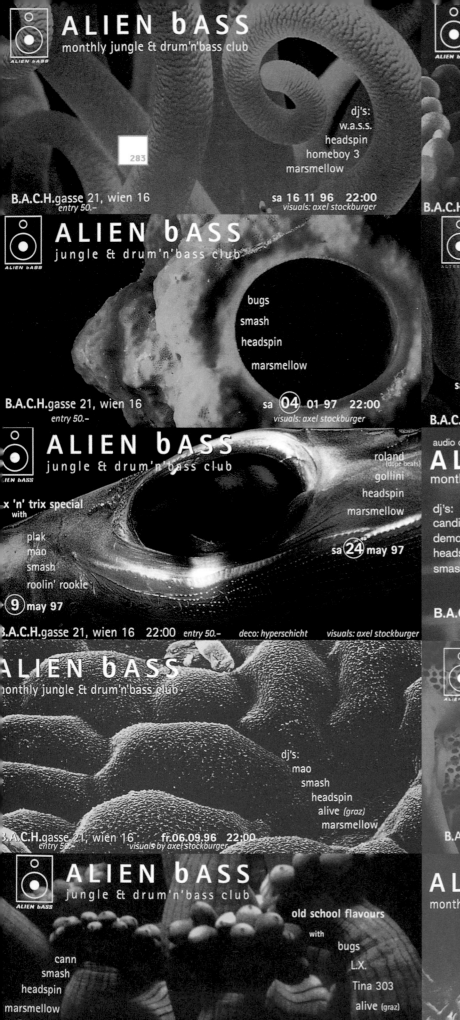
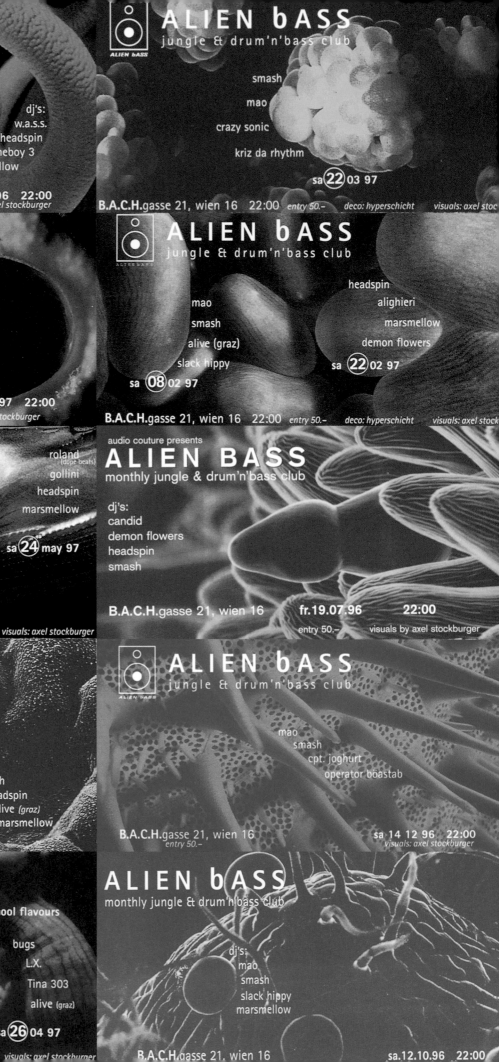

**ALIEN bASS**
monthly jungle & drum'n'bass club

283

dj's:
w.a.s.s.
headspin
homeboy 3
marsmellow

B.A.C.H.gasse 21, wien 16
entry 50.–
sa 16 11 96  22:00
visuals: axel stockburger

---

**ALIEN bASS**
jungle & drum'n'bass club

smash
mao
crazy sonic
kriz da rhythm

sa 22 03 97

B.A.C.H.gasse 21, wien 16  22:00  entry 50.–  deco: hyperschicht  visuals: axel stoc

---

**ALIEN bASS**
jungle & drum'n'bass club

bugs
smash
headspin
marsmellow

B.A.C.H.gasse 21, wien 16
entry 50.–
sa 04 01 97  22:00
visuals: axel stockburger

---

**ALIEN bASS**
jungle & drum'n'bass club

mao
smash
alive (graz)
slack hippy

sa 08 02 97

headspin
alighieri
marsmellow
demon flowers

sa 22 02 97

B.A.C.H.gasse 21, wien 16  22:00  entry 50.–  deco: hyperschicht  visuals: axel stock

---

**ALIEN bASS**
jungle & drum'n'bass club

x 'n' trix special
with

plak
mao
smash
roolin' rookie

9 may 97

roland (dope beats)
gollini
headspin
marsmellow

sa 24 may 97

B.A.C.H.gasse 21, wien 16  22:00  entry 50.–  deco: hyperschicht  visuals: axel stockburger

---

audio couture presents

**ALIEN BASS**
monthly jungle & drum'n'bass club

dj's:
candid
demon flowers
headspin
smash

B.A.C.H.gasse 21, wien 16  fr.19.07.96  22:00
entry 50.–  visuals by axel stockburger

---

**ALIEN bASS**
monthly jungle & drum'n'bass club

dj's:
mao
smash
headspin
alive (graz)
marsmellow

B.A.C.H.gasse 21, wien 16  fr.06.09.96  22:00
entry 50.–  visuals by axel stockburger

---

**ALIEN bASS**
jungle & drum'n'bass club

mao
smash
cpt. joghurt
operator böastab

B.A.C.H.gasse 21, wien 16  sa 14 12 96  22:00
entry 50.–  visuals: axel stockburger

---

**ALIEN bASS**
jungle & drum'n'bass club

cann
smash
headspin
marsmellow

a 12 04 97

old school flavours
with
bugs
L.X.
Tina 303
alive (graz)

sa 26 04 97

B.A.C.H.gasse 21, wien 16  22:00  entry 50.–  deco: hyperschicht  visuals: axel stockburger

---

**ALIEN bASS**
monthly jungle & drum'n'bass club

dj's:
mao
smash
slack hippy
marsmellow

B.A.C.H.gasse 21, wien 16  sa.12.10.96  22:00

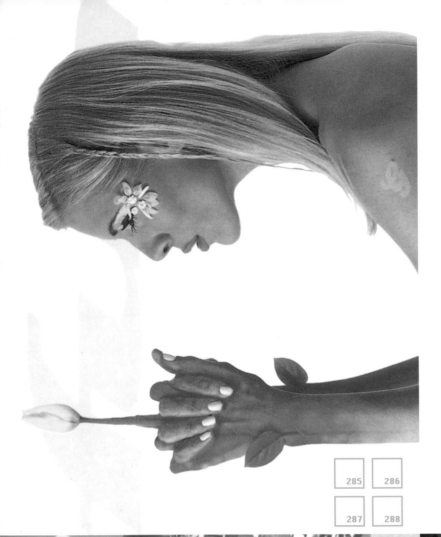

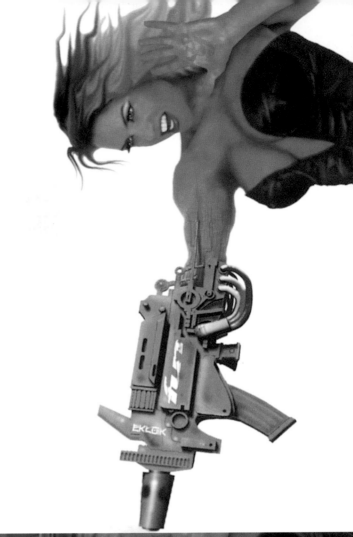

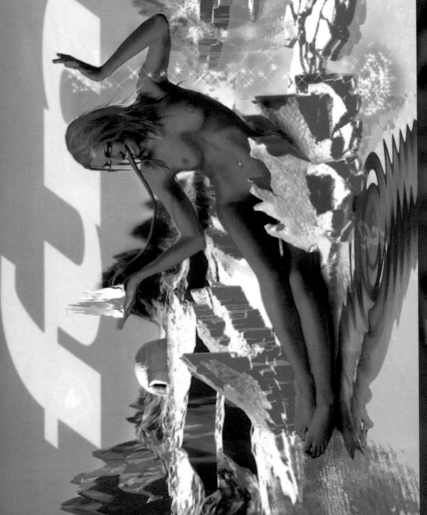

285 286

287 288

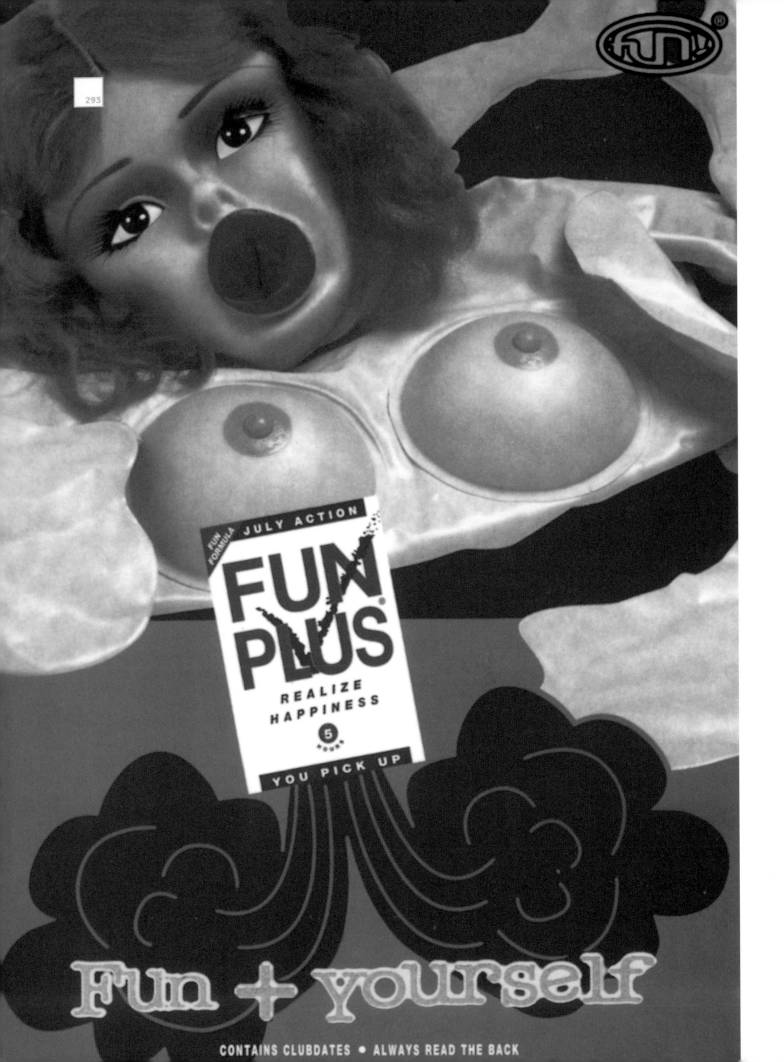

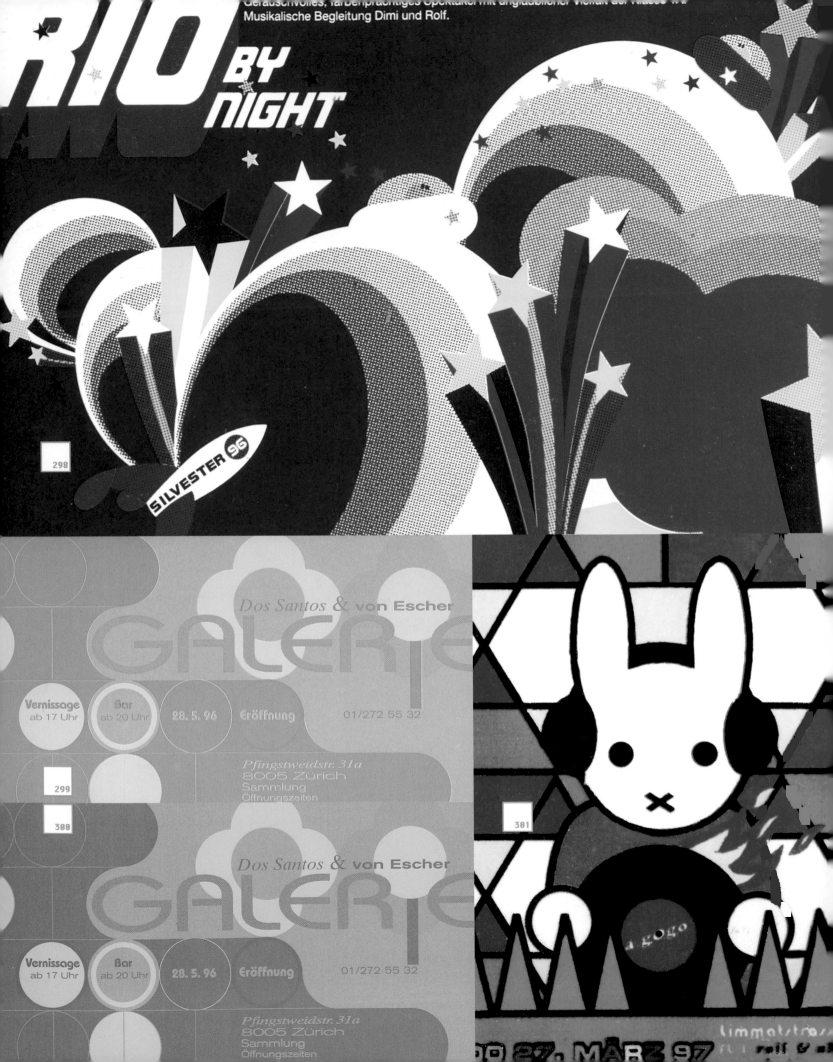

Geräuschvolles, farbenprächtiges Spektakel mit unglaublicher Vielfalt der Klasse w.a
Musikalische Begleitung Dimi und Rolf.

# RIO
## BY NIGHT

**SILVESTER 96**

298

---

Dos Santos & von Escher

GALERIE

Vernissage
ab 17 Uhr

Bar
ab 20 Uhr

28. 5. 96

Eröffnung

01/272 55 32

Pfingstweidstr. 31a
8005 Zürich
Sammlung
Öffnungszeiten

299

300

Dos Santos & von Escher

GALERIE

Vernissage
ab 17 Uhr

Bar
ab 20 Uhr

28. 5. 96

Eröffnung

01/272 55 32

Pfingstweidstr. 31a
8005 Zürich
Sammlung
Öffnungszeiten

301

a gogo

SO 27. MÄRZ 97

Limmatstrasse

rolf & a

## disko b *freaky*

dj blake baxter + robert görl (live pa)
dj prozac + dj patrick pulsinger
dj abe duque + acid scout (live pa)
area 2 the rancho relaxo allstars (live pa)
special guests: b. low (live pa)

samstag 10.05.1997
ultraschall-münchen

doors open: 23h. grafingerstr.6. kunstpark ost

disko b im vertrieb
efa medien gmbh
http://www.efamedien.com
http://www.diskob.com
EFA

Ultraschall

supported by
THE PULSE OF AMERICA Marlboro NETWORK

---

## disko b *funfarm*

dj hell + robert görl (live pa)
the rancho relaxo allstars (live pa)
dj patrick pulsinger + acid scout (live pa)
dj abe duque + dj barbara
dj prozac + suchtrupp (live pa)
dj blake baxter + dj upstart

(STRADA)

do.01.05.1997 hamburg-powerhouse
fr 02.05.1997 essen weststadt 5-7
sa 03.05.1997 mannheim-neckarau hd800
mi 07.05.1997 köln-apollo
fr 09.05.1997 frankfurt-box
sa 10.05.1997 münchen-ultraschall

disko b im vertrieb
der efa medien gmbh
http://www.efamedien.com
http://www.diskob.com

supported by
THE PULSE OF AMERICA Marlboro NETWORK

two areas - line up differs

---

## disko b *wiked*

dj abe duque + robert görl (live pa)
dj barbara + dj prozac + acid scout (live pa)
area 2 dj upstart + suchtrupp (live pa)
the rancho relaxo allstars (live pa)

freitag 09.05.1997
frankfurt-box

doors open: 22h. Willi-Brand-Platz 1-3

disko b im vertrieb
der efa medien gmbh
http://www.efamedien.com
http://www.diskob.com

EFA  BOX

supported by
THE PULSE OF AMERICA Marlboro NETWORK

---

## disko b *sleazy*

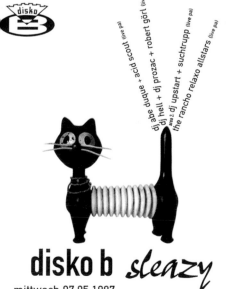

dj abe duque + acid scout (live pa)
dj hell + dj prozac + robert görl (live pa)
area 2 dj upstart + suchtrupp (live pa)
the rancho relaxo allstars

mittwoch 07.05.1997
köln-apollo

doors open: 22h. Hohenzollernring 79-83

disko b im vertrieb
efa medien gmbh
http://www.efamedien.com
http://www.diskob.com

supported by
THE PULSE OF AMERICA Marlboro NETWORK

EFA

---

## disko b *dandy*

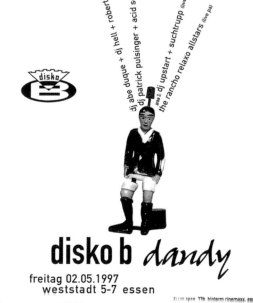

dj abe duque + dj hell + robert görl (live pa)
dj patrick pulsinger + acid scout (live pa)
area 2 dj upstart + suchtrupp (live pa)
the rancho relaxo allstars (live pa)

freitag 02.05.1997
weststadt 5-7 essen

doors open: 22h. hinterm cinemaxx. essen zentrum

disko b im vertrieb
der efa medien gmbh
http://www.efamedien.com
http://www.diskob.com

supported by
THE PULSE OF AMERICA Marlboro NETWORK

EFA

---

## disko b *modern*

(STRADA)

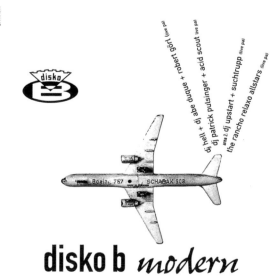

dj hell + dj abe duque + robert görl (live pa)
dj patrick pulsinger + acid scout (live pa)
area 2 dj upstart + suchtrupp (live pa)
the rancho relaxo allstars (live pa)

samstag 03.05.1997
hd800 mannheim-neckarau

doors open: 22h. Angstr. 5-10

disko b im vertrieb
der efa medien gmbh
http://www.efamedien.com
http://www.diskob.com

supported by
THE PULSE OF AMERICA Marlboro NETWORK

EFA

(STRADA)

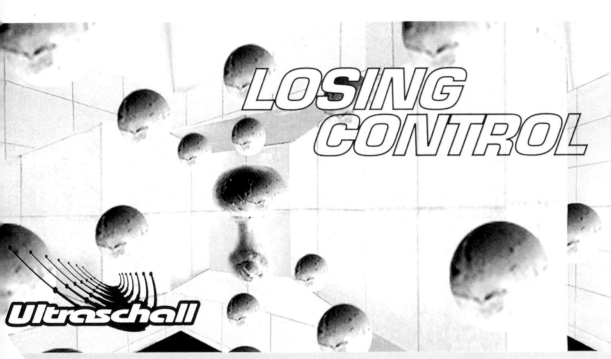

**LOSING CONTROL**

Ultraschall

Freitag 03:03:95

**DJ LAURENT GARNIER**
f-com (paris)

**Dj Monika**
ultraschall (münchen)

**Dj Ker**
ultraschall (münchen)

Samstag 04:03:95

**DJ DANIEL BELL**
peacefroc, accelerate
(detroit)

live pa **Dj Kirlian**
tension (new york)

**Dj Hell**
disko-b (münchen)

der club  am flughafen riem münchen  jeden fr/sa ab 23.00h

**FUTURe HOUSe**

Ultraschall

Freitag 15:07:94

**Dj Dave Clarke**
bush / magnetic north records london

**Dj Olaf**
**Dj Ker**

Samstag 16:07:94

**Dj Hell**
disko b münchen

**Dj Upstart**
**Dj CPT. Reality**

+ guest Dj´s at cafe abstract

der club - am flughafen riem münchen - jeden fr/sa ab 23.00h

# CECI N'EST PAS
# UNE REALITE
# VIRTUELLE

sweetreat

a free member's party, halloween thursday october 31

312

Opens Saturday 31 May

OFF-CENTRE

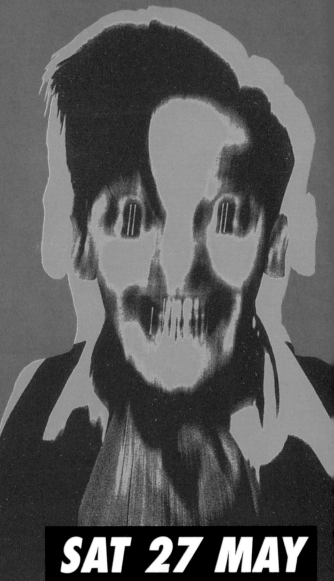

CECI C'EST
*SOMA*

# david alvarado
viernes 30 mayo en Dance

**SAT 27 MAY**

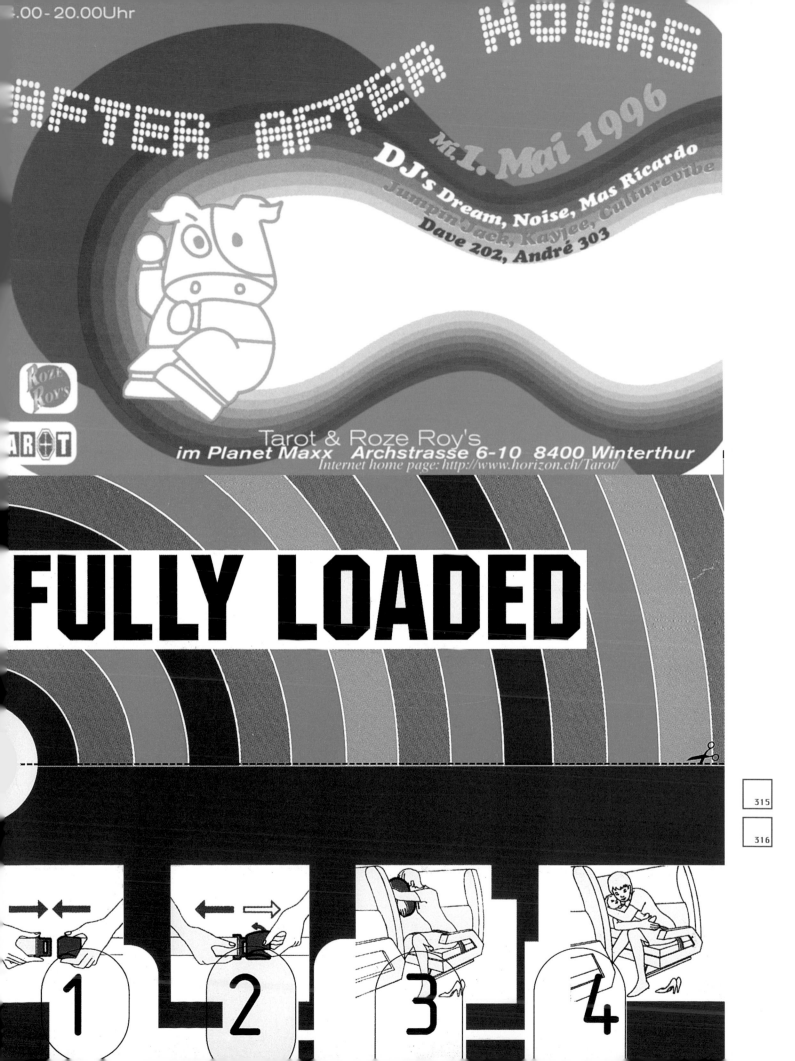

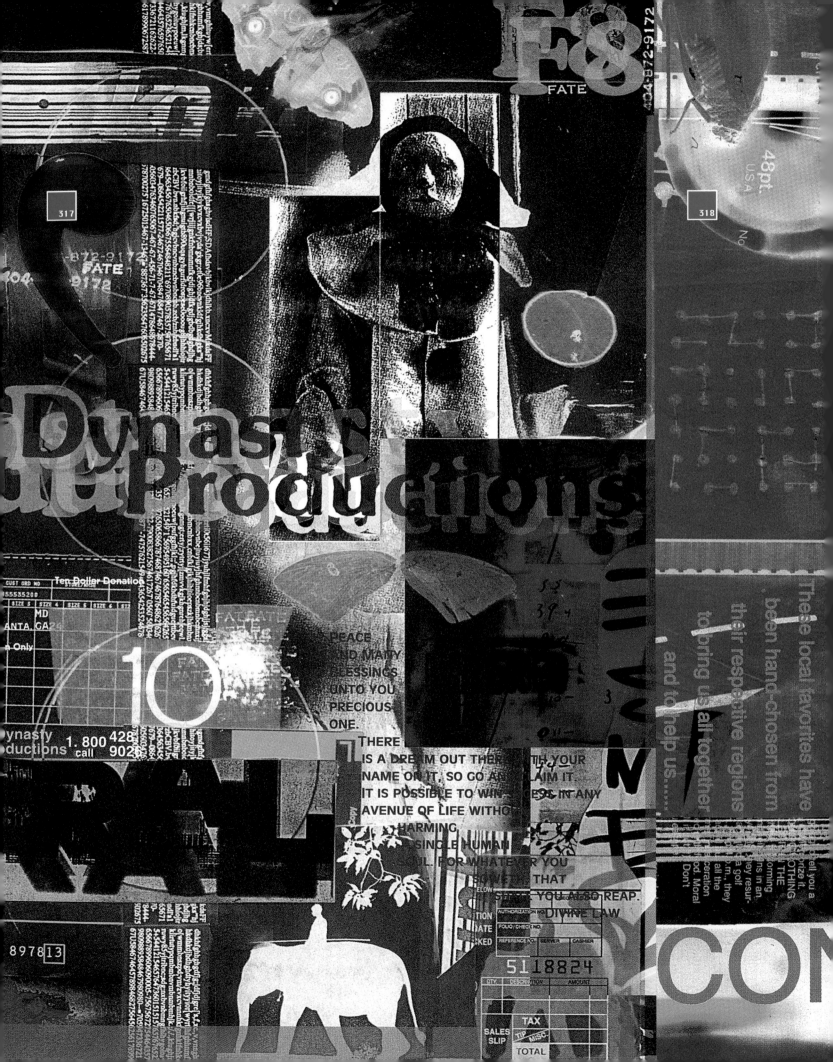

Dynasty Productions

FATE

F8

404-872-9172
FATE
9172

317

318

48pt.
USA
No

Ten Dollar Donation

CUST ORD NO
55535200
SIZE 5 | SIZE 4 | SIZE 5 | SIZE 6 | SIZE
MD
ANTA. CA24
A Only

10

Dynasty
Productions     1.800 428
call     902

8978 13

PEACE
AND MANY
BLESSINGS
UNTO YOU
PRECIOUS
ONE.

THERE
IS A DREAM OUT THERE WITH YOUR
NAME ON IT, SO GO AND CLAIM IT.
IT IS POSSIBLE TO WIN SUCCESS IN ANY
AVENUE OF LIFE WITHOUT
HARMING
A SINGLE HUMAN
SOUL. FOR WHATEVER YOU
SOW IT IS THAT
YOU ALSO REAP.
DIVINE LAW

These local favorites have
been hand-chosen from
their respective regions
to bring us all together
and to help us...

AUTHORIZATION NO
FOLIO/CHECK NO.
REFERENCE NO     SERVER     CASHIER

51 18824

QTY     DESCRIPTION          AMOUNT

SALES     TAX
SLIP     TIP
MISC
TOTAL

CON

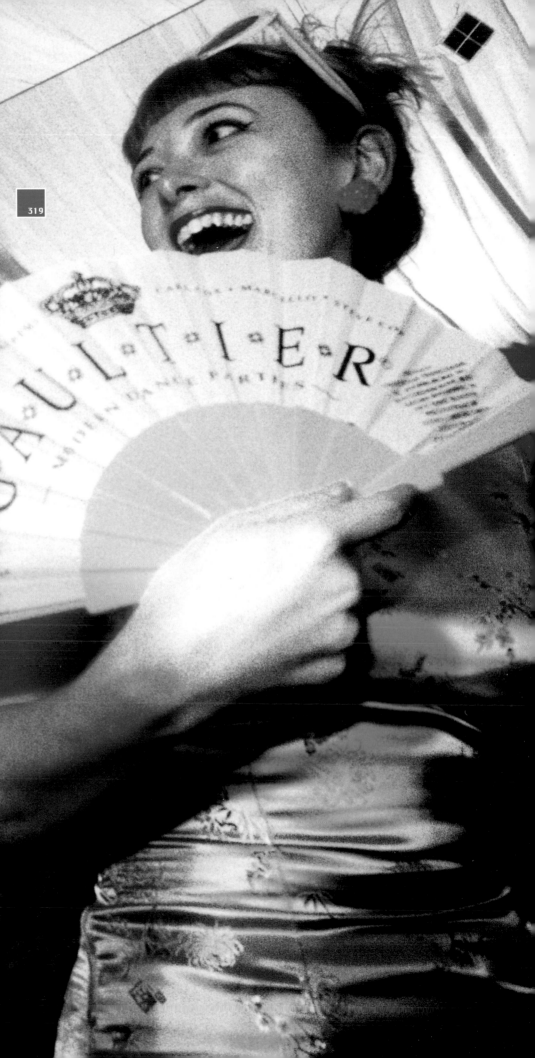

319

JOHN
KELLY
LIV3
+ WICKED

ƧACK

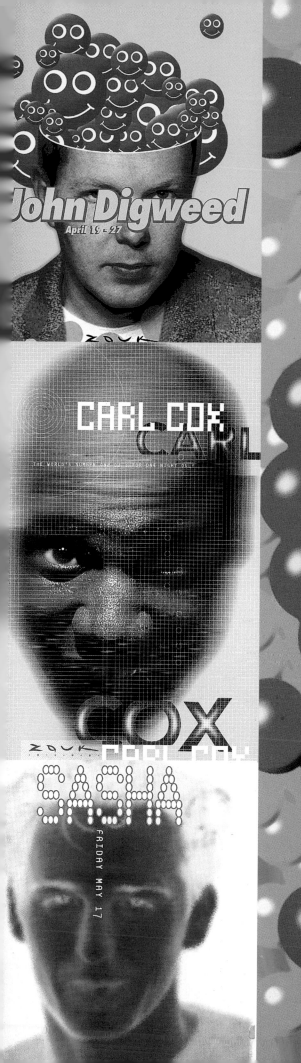

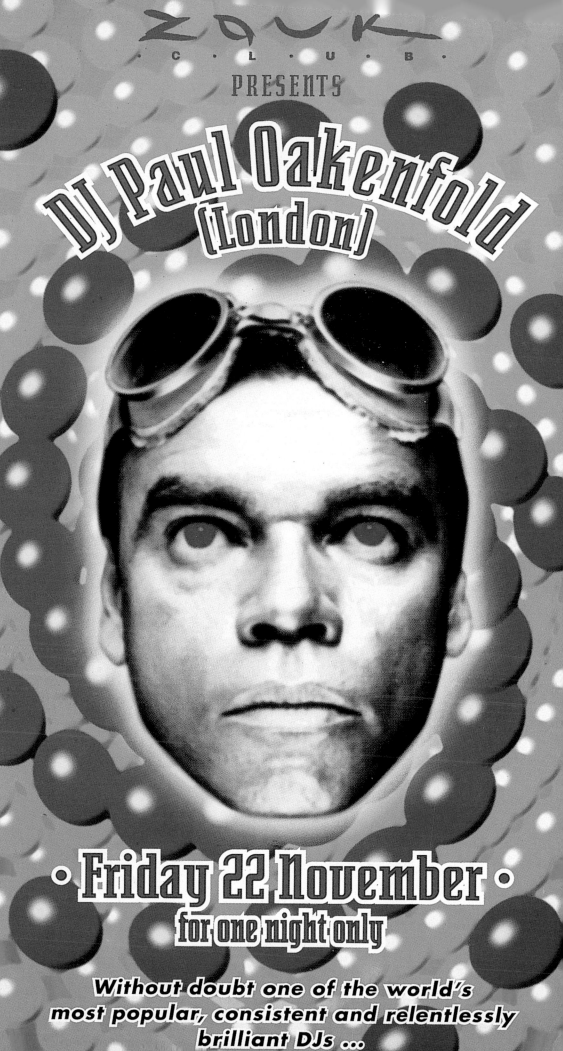